The Language of Forms

The Language of Forms

LECTURES ON INSULAR MANUSCRIPT ART

MEYER SCHAPIRO

Foreword by
Charles E. Pierce, Jr.

Introduction by
Jane E. Rosenthal

THE PIERPONT MORGAN LIBRARY • NEW YORK

This publication has been made possible by The Franklin Jasper Walls Lecture Fund, an endowed fund at The Pierpont Morgan Library. The lectures published herein were the first of the Walls series given at the Morgan.

LIBRARY OF CONGRESS CATALOGING-IN-PUBLICATION DATA

Schapiro, Meyer, 1904–1996
The language of forms : lectures on Insular manuscript art / Meyer Schapiro ; foreword by Charles E. Pierce, Jr. ; introduction by Jane E. Rosenthal.
 p. cm.
Includes index.
ISBN 0-87598-140-2 (alk. paper)
 1. Illumination of books and manuscripts, Medieval—Great Britain. 2. Illumination of books and manuscripts, English. 3. Illumination of books and manuscripts, Medieval—Ireland. 4. Illumination of books and manuscripts, Irish. I. Title.

ND3128.S33 2005
745.6'09410902—dc22 2004060195

Published by The Pierpont Morgan Library
KAREN BANKS *Publications Manager*
PATRICIA EMERSON *Senior Editor*
ELLIA BISKER *Editorial Associate*

Project staff
WILLIAM M. VOELKLE *Curator and Department Head,
 Medieval and Renaissance Manuscripts*
MARILYN PALMERI *Manager, Photography and Rights*

DESIGNED BY Bessas & Ackerman
COLOR CONSULTING BY Sally Fisher
PRINTED AND BOUND BY Herlin Press, West Haven, CT

FRONT COVER: *Liber generationis,* initial page of the Gospel of
 St. Matthew (Fig. 23; detail)
FRONTISPIECE: Meyer Schapiro
BACK COVER: Image of the Man, symbol of St. Matthew
 (Fig. 9, detail)

PRINTED IN THE UNITED STATES OF AMERICA

CONTENTS

FOREWORD

It was Frederick B. Adams, Jr., the second director of The Pierpont Morgan Library, who decided that Meyer Schapiro should inaugurate the Franklin Jasper Walls Lecture Series in 1968. Walls had been one of the founding Fellows of The Pierpont Morgan Library in 1949. He was particularly concerned with the Library's lecture program and served on the Lecture Committee of the Association of Fellows. It was only after his death in 1963, however, that his testamentary plans were revealed. According to his bequest, a major portion of his estate was given to the Library to support lectures relating to the fine arts, iconography, and archaeology and their publication.

Mr. Adams had excellent reasons for choosing Professor Schapiro, whose towering genius, broad knowledge, and influence in the area of art history and theory were already legendary. Thus the Walls Fund not only afforded him an opportunity to present his inspired, new ways of seeing and understanding Insular manuscript production to a larger public but also provided the means by which these scintillating lectures would be printed, benefiting not only those who had been unable to experience them firsthand but subsequent generations of scholars as well. It also provided the Library with a way to honor Meyer Schapiro's multifaceted achievements and to express its gratitude for the many years of support he gave to it, sharing his vast knowledge and enthusiasm with Belle da Costa Greene, its first director, and Meta P. Harrsen, who in 1948 was appointed keeper of manuscripts—not to mention her successor, John H. Plummer, now curator emeritus, and current curator William M. Voelkle, both of whom had been taught by Schapiro when they were graduate students at Columbia University. Meyer Schapiro was named an Honorary Fellow of the Library in 1992.

The lectures were given over three dozen years ago, and many have wondered if their publication would ever be realized. As late as 1994, Schapiro, who died in 1996, wrote, "I hope I shall be able to bring out in the next years several further collections of my old and more recent studies that have been presented in lectures and seminars at Columbia University and elsewhere." I was thus pleased, gratified, and not a little overwhelmed when it seemed, in 2002, that the lectures might be published after all. The turnabout was largely owing to the impetus of Schapiro's wife, Lillian, who, after her husband's death, was determined to get the Walls lectures published. In order to achieve her goal, she sought the help of Jane Rosenthal, an art his-

tory professor at Columbia University and herself a Schapiro student. In searching for a publisher, Rosenthal contacted the Library. Given the importance of the lectures and our understandable desire to see the first Walls Lecture Series in print, I was delighted to hear from her. Thanks to the efforts of many, but especially Jane Rosenthal, the lectures, at last, are in book form. We are grateful, too, that Dr. Bernard Meehan has permitted us to reproduce so many miniatures in color from the Book of Kells, for they have added immeasurably to the publication. We hope that Meyer Schapiro would have been pleased with the outcome, and that his keen—and timeless—analysis of and appreciation for the unique accomplishments of Insular manuscript art will continue to open the eyes of those searching for a fuller understanding of the subtlety, sophistication, and quality of that art.

CHARLES E. PIERCE, JR.
Director, The Pierpont Morgan Library

INTRODUCTION

It was through the medium of the oral lecture rather than the printed page that Meyer Schapiro "published" his revolutionary study of Insular manuscript painting, which essentially, in the words of one art historian, "rewrote the standard textbook notion of the history of that art."[1] None of the lectures, which were delivered to academic and public audiences over two decades, was issued in print, nor did Schapiro publish their contents in the form of articles. The three works he did submit for publication focused on single, art-historical issues—the Irish contribution to Insular book art, the origins of the cross carpet and four-symbol pages in the Book of Durrow, and the decoration of two types of initials in a manuscript in St. Petersburg[2]—all of them peripheral to his main concern in the lectures with the identification and explication of the aesthetic features of the art. We were thus left with no original printed record of Schapiro's most significant contribution to the history of Insular art, a critical gap that has at last been filled with the publication of the lectures that Schapiro gave at the Morgan Library in 1968. Coming as they did after years of study, the lectures represent the culmination of his work, and the length of the series enabled him to lay out fully and in detail the methodology, evidence, and arguments he employed, including the numerous sensitive and probing analyses of individual works through which he demonstrated that Insular manuscript art, traditionally regarded as irrational, barbaric, and even ridiculous, was in reality completely rational, highly sophisticated, and the most accomplished of the arts of the period.

Schapiro began by taking a totally new approach to Insular book painting, rejecting the classical standard of nature by which the images were being

judged and found wanting, and studying them instead on their own terms through a critical analysis of their forms. He rebuked the critics, who dismissed the flat, stylized, oddly proportioned Insular figures as crude and childish, for applying the norm of naturalism to an art that looked inward rather than to external nature for its source. In a book review written at the beginning of his study of Insular manuscript art (see note 2), Schapiro succinctly took the author to task for characterizing Insular figures as clumsy and artless: "Because of a dogmatic norm of naturalism, foreign to this art, . . . M. Masai is able to speak of the 'stylization' of the latter [the figures] as 'excessive,' inartistic, and absurd. This standard of nature is an obstacle to critical insight into the art as a whole." Removing that obstacle, Schapiro set out in the lectures that followed to rehabilitate this disparaged art by revealing its true nature through a "careful critical observation" of its images.

To carry out his study, Schapiro employed the new set of classifications for analyzing images that he had developed earlier in his work on Romanesque sculpture. These included field-frame and figure-ground relationships and coordinate-discoordinate systems of order. Their power and effectiveness are evident in the analyses of individual works in the first three Morgan lectures. He also, like the critics, invoked the traditional standards by which the art had been condemned, but applied them in an entirely different way, as a foil to show how Insular artists pushed beyond the limits of these norms to arrive at totally new, more complex and challenging conceptions, in one case, of ornament, in another, of the frame, to cite two particularly striking examples. The most impressive feature of his analyses, however, was the remarkable method he employed "for discerning the structure" of images through close, step-by-step scrutiny of the individual formal components of a work, noting their particular qualities and interrelationships, the manner in which they were grouped, the way these groups were organized into larger structures, and finally the mode in which these structures were composed within the whole—a method that moved outward from the detail to the finished work. He compared this to the experience of listening to music whereby "we attend to actual sequences, variations, recurrences, and larger relationships" and, at the same time, we are taken back to the individual "purposive choices" made by the artist in its creation. It is a method that reveals qualities of the work not immediately apparent in a scanning of the whole, like the ambiguous relationships and tense juxtapositions of the ornament of a Lindisfarne carpet page. In this close scrutiny, Schapiro was concerned not only with the structural function of forms but also with their expressive content arising from their particular qualities of line, shape, and color as well as their relationship to other forms. A line may be described

as soft, loose, tense; interlace as entangled, pulsating; and a carpet page as "an expression of a state of feeling" to which the viewer responds and that "we are now inclined to suppose might have inspired the creation of [the] work."

In the last three lectures Schapiro turned from the analysis of individual images to consideration of their art-historical and cultural context. In comparing the images with works in other schools, he again took (what was then) a new approach, one concerned with the active side of the absorption of foreign art as opposed to the notion of passive influence. Instead of reconstructing the genealogy of a motif to determine its derivation, as was usually done, he used earlier examples to show how the motif was transformed by the Insular artist in order to identify the individual or original features of the work. He also expanded his investigation beyond the usual concern with types and motifs to include compositional modes and looked not only for similarities of form between works but also for "relationships that depend on meaning and expression." Finally, in asking how the extraordinary flowering of Insular manuscript art was to be explained, he raised a question that previously there had been little attempt to answer. So both his approach—seeking the "preconditions and circumstances" that would help us understand this art—and the results of his study were unprecedented.

The publication of these lectures not only provides us with an invaluable historical document but also with the opportunity to "listen" once again to Schapiro's incomparable, revelatory analyses of images through which he taught his students, myself included, to see. Others can now follow the spellbinding lecturer as he works his way through an image, pointing out contrasting color spottings, divergent and convergent pairings, the discordant juxtaposition of competing systems—making us see what we had not, infecting us with his enthusiasm, his pleasure in exploring, and his delight at a new discovery, sometimes expressed through a broad grin or a chuckle. Much has been written about the splendid *Chi-Rho* page in the Book of Kells, but only Schapiro described it as "a work that . . . provides the eye the richest, most entrancing field for exploration of any medieval work we know." He concluded, "The whole appears so vast, relative to the small units, that it seems a cosmos, an immense landscape. Indeed, traversing and exploring it we discover human figures, animals, and even a droll play of cats and mice."

≈·≈·≈

Schapiro delivered the Morgan lectures extemporaneously, as was his custom, so the text did not exist in written form originally. The lectures were recorded, however, and a transcript was made in order to prepare a publication. Schapiro worked sporadically on editing the transcript in the following

years and was still in the process upon his death in 1996. Four years later, I was asked to take over the preparation of the manuscript by Schapiro's wife, Lillian, who was supervising the publication of her husband's *nachlass*. By checking the transcript against the tapes, I identified the changes Schapiro had made to the spoken words, which included minor revisions usually meant to clarify the meaning of the text or to cast it in more formal language and, on occasion, the introduction of an expanded and more detailed analysis of a given work. The only major change occurs in the third lecture, in the section dealing with the impact of Insular ornament on later art, where analyses of works illustrating the continued influence of the Insular treatment of the frame in subsequent art are inserted among those cited as examples reflecting Insular conceptions of ornament. The source of the first insertion (III, pp. 61–63; Fig. 39) is unknown, but the other four (III, pp. 64–68; Figs. 41–44) are taken verbatim from Schapiro's unpublished University Lecture, delivered at Columbia in 1973. These insertions, like the other changes, have been preserved.

Schapiro also intended to add an extensive series of footnotes to the lecture—his published works are characteristically copiously annotated—but completed only a few. These are incorporated in the endnotes (nos. 5, 6, 29, 30, 37). I am responsible for the rest, which for the most part supply the specific bibliographical references not provided in the transcript for the numerous citations and quotations from the works of others cited throughout the lectures. At the request of the Library, I also furnished a new title for the series to replace the original *Early Medieval Book Art* and wrote the captions for the illustrations. In the text itself, I felt justified in substituting the term *Insular*, the current designation of the art of the British Isles of the seventh and eighth centuries, for the now obsolete term *Hiberno-Saxon* used by Schapiro, not only because the latter designation would be unfamiliar to many readers, but also because it reflects the earlier partisan polemic over what were the Irish as opposed to the English contributions to the art. *Insular*, on the contrary, is neutral and inclusive and better reflects Schapiro's view, as stated in the sixth lecture, that the art should be approached "as a whole" and the "complex of cultures" involved should be regarded as "a unity in the sense that they have common qualities and communicate with each other." Also, I have added a few words in several analyses to help the reader locate the particular elements of the work under discussion, which Schapiro indicated in the lecture with a pointer and the word *here*.

I am deeply grateful to Lillian Schapiro for the invitation to participate in the publication of the lectures and extremely indebted to Robin Sand, Schapiro's longtime assistant, who provided all the needed materials and answered all my questions concerning Schapiro. Among the Morgan Library

staff, I am especially obliged to William Voelkle for his continuing support of the endeavor and his efforts on its behalf, including working closely with me during the last stages of the preparation of the text. Finally, I would like to thank Library staff members Karen Banks, who supervised the project; Patricia Emerson, who edited the text; Ellia Bisker, who provided administrative support; and Marilyn Palmeri, who obtained all the photographs, as well as the following for their help in tracing bibliographical sources or for information about objects: William Ashworth, John Blair, Richard Brilliant, Christopher Chippendale, Michael Crowe, Klausse Eckerle, Richard Kuhns, Patrick McGurk, Ann Taylor, and Peter van Alfen.

<div align="right">

JANE E. ROSENTHAL
December 2004

</div>

1. David Rosand, "Semiotics and the Critical Sensibility: Observations on the Lessons of Meyer Schapiro," in *Social Research,* 1978, vol. 45, pp. 36–51, at p. 37. This perceptive analysis is based on the unpublished University Lecture Schapiro gave at Columbia in 1973. Also, in the same volume, see John Plummer's essay, "Insight and Outlook," pp. 165–66, for Schapiro's lectures as oral publications.

2. The works are, respectively, a review of François Masai's *Essai sur les origines de la miniature dite irlandaise* (1947) in the *Gazette des Beaux-Arts,* 1950, vol. 37, pp. 134–38, reprinted in *Selected Papers of Meyer Schapiro* III, 1979, pp. 225–41; an article entitled "The Miniatures of the Florence Diatessaron," in *The Art Bulletin,* 1973, vol. 55, pp. 515–30; and "The Decoration of the Leningrad Manuscript of Bede," published in *Scriptorium,* 1958, vol. 12, pp. 191–207.

I. FRAME, FIELD, AND FIGURE

I propose to treat in six lectures[1] the book art, that is, the paintings, drawings, and ornament in manuscripts produced during the seventh and eighth centuries in Ireland, England, and Scotland and by emigrant Insular monks who had established themselves in monasteries on the Continent. I shall not try to cover completely the history of that school of art—for me one of the most attractive in Western Europe in those years and one of capital interest for the understanding of the principles of the art that followed. I must say from the outset that my concern is not essentially with the history of those Insular schools nor with solutions to the problems of authorship, localization, and dating that scholars have long debated. I wish rather to bring out certain aesthetic features of this art through close study of its forms and by means of comparisons with the work of other schools in order to make more evident the individuality, original character, and inventive imagination of Insular works. To this end, it may be fruitful to concentrate on a few pages from those manuscripts, suspending judgment as to when, where, and why they were done and in what tradition. Let us scrutinize the works themselves, to acquaint ourselves more fully with their structure, their formal arrangements, and minute detail.

In the middle of the nineteenth century, Insular manuscript art was admired for its skillful, intricate ornament but also was seen with distaste for the artist's inability to represent the human or animal figure. John Ruskin, at that time the most passionate and observant English writer on art, expressed his dislike of this art and pointed especially to the fact that it was committed to a geometrical, conventionalizing of all forms that excluded

Opposite: Fig. 1. Image of the Lion, here the symbol of St. John. Book of Durrow, Northumbria or Iona, second half of seventh century. Dublin, Trinity College, MS 57, f. 191v.

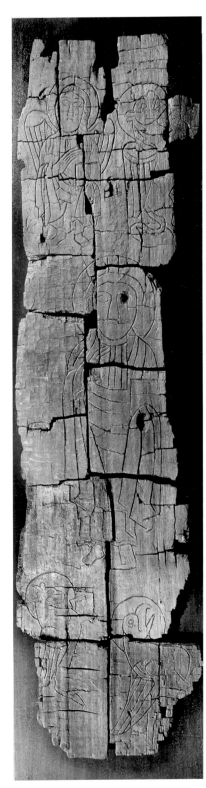

Fig. 2. Christ and the symbols of the four evangelists. Incised figures from the lid of the oak coffin of St. Cuthbert, 698. Durham, Library of the Dean and Chapter of Durham Cathedral.

nature, which, therefore, led to sterility.[2] Perhaps because he knew these works chiefly through reproductions in books like Westwood's[3]—which, having passed through the hands of the engravers, exhibit that hardness and dryness of most facsimiles of medieval art in the prephotographic period— he was unable to sense the qualities of expression and finesses of form to which we respond today.

But I believe these qualities are also more evident to us whether in the original or in photographs because our sense of the aims and achievement of this art has been awakened by the art of the last fifty years. The tendency now, however, is to view Insular illuminations as if they were twentieth-century abstractions. As a result, even that formal structure that appeals to us today is misread in reproductions and descriptions that falsify these works by incorrect or incomplete quotations of passages like the omitted phrases or simple words essential to the rhythm, meter, and color of a poetic text. This fact will be more evident through a number of the comparisons that will be made.

I shall begin with a feature of Insular art strange to our own taste. It is on a page from a Gospel manuscript, the Book of Durrow, now preserved in Trinity College, Dublin, which is commonly believed to be the oldest of a series of masterly books of the seventh and eighth centuries. On that page (Fig. 1) a lion (rather than the usual eagle), the symbol of the evangelist John,[4] is represented as a horizontal figure in a vertical frame. Conventional art lessons would correct this. A teacher would tell the child who chose to frame a drawing in this way: "You must turn it around and set the figure in a horizontal frame for it to be properly adapted to its field." One might account for the anomaly by the format of the manuscript page itself: constrained by the major vertical of the page, the frame had to correspond as well to the vertical mass of the writing facing it on the opposite page, even as the form of the figure preserved the lion's natural horizontal axis. But this is hardly a convincing explanation.

In the Insular art of this period there are enough examples in which the lion is turned vertically in order to fit a vertical format. One instance is the lion (top right) on the wood cover of the coffin of St. Cuthbert (Fig. 2), a work produced in Northumbria shortly after the saint's death in 698. Also in the Book of Chad (Fig. 3), a manuscript of the early part of the eighth century, the lion symbol in the upper right quadrant is adapted to a vertical space. And, in a later Irish manuscript (Fig. 4), in a format like that of the Book of Durrow, the animal forthrightly assumes a vertical posture that we cannot explain as a naturalistic choice. He seems to climb on the right inner edge of the frame. If then the artist of the Book of Durrow adopted for the lion a horizontal axis, we may assume that the choice was purposive and a necessary artistic solution with a particular aesthetic value and expressiveness.

Fig. 3. Four-symbol page. Book of St. Chad, Northumbria (?), first half of eighth century. Lichfield, Cathedral Treasury, s.n., p. 219.

Fig. 4. Image of the Lion, symbol of St. Mark. Gospel Book, Ireland (Armagh?), early twelfth century. London, British Library, MS Harley 1023, f. 10v.

We can approach the problem of choice of orientation in another way, by considering the effect of a correction normalizing the work. Through a rearranged photograph in which the horizontal lion is placed in a horizontal frame (Fig. 5), you may better grasp the interplay of figure and frame in the original work. Although the horizontal figure now agrees with the broad horizontal axis of the field, a whole series of important relationships and qualities present in the original form have been lost. The change is not simply a shock visually. It also has the effect of disorganizing the original whole. Seeing the latter (Fig. 1) beside the corrected version, you observe that the frame in the original is divided into separate closed vertical and horizontal bands, not usual in a frame. The two horizontal bands are the more pronounced in their large interlace ornament, with strong light and dark contrast and a scale of units closer to the shapes, color contrast, and proportioning of elements of the horizontal lion. That correspondence is carried through in a minute searching of the smallest details. Note in particular that in the original vertical bands of the frame the interlace ornament is thinner and looser than in the horizontals; there is a further relaxation of the interlace ornament at the middle, just at the level of the lion, as if the interlace, passing the figure, is affected, and its density and energy are changed by the approach to a large, strong body.

That concord of frame and figure disappears in the corrected version. The former horizontal panels become weaker vertical elements, and the loosening of the axes of the white interlaced bands corresponds to nothing within the lion's body. Effective continuities and pairings of form, certain deliberately chosen accents in the original work, are lost if one redesigns the figure and frame to accord with each other to satisfy an obvious and, I would venture to say, common taste for the parallelism of the axis of a major figure and the major axis of its framed field. We cannot regard their anomalous opposition in the original work as a negligence or perversity or attribute it to an insensitive taste: it contributes a decided energy and directedness to the movement of the animal in opposition to the forms around it. These qualities, reinforced by certain of the forms, do not appear in the corrected version, even though it preserves the same elements.

Having read it in this way, with the help of the experimental change, we turn to the color of the original to see how it enters into the conception. In the animal's body, the main mass of color, the pelt, is green and red, marked by a secondary pattern of yellows with voluted ends—very strange, inorganic forms that resemble the coiling of the interlace. A diagonal axis also appears in the strongly marked yellow filling of the white interlace in the frame and the yellow interlace knots in the horizontal bands above and below the lion. The tail,

Fig. 5. Image of the Durrow Lion with the frame changed from vertical to horizontal.

coiled above the animal's back, lends more compactness to the horizontal figure; it begets at the same time a movement forward and backward, like that of the interlace in the horizontal bands of the frame. The interlace is of the same thickness as the tail, unlike the slender interlace bands on the vertical sides. The color of the legs has been partitioned so that the four paws form a distinct series in horizontal sequence, related rhythmically to the circular units in the bands above and below. Small elements in the fillings of the interlace—paired white wedges with contrasted axes—have their counterparts in the creature's pelt, and tiny dots in the vertical interlace bands recur in the fine dotting that gives a distinctive texture to the lion's jaws and head. In addition the background of green in the nearby central knots of the vertical interlace ornament is tied to the contrasted red and green patterning of the animal's pelt. One can go on exploring many more details, all of which, I believe, will disclose the minuteness and finesse of the controlled design and the artist's extraordinary boldness in adopting a solution that in its immediate aspect has a quality of violence—of violation of an expected accord.

To characterize this mode of composition in which there appears a conflict among the major axes of figure, field, and frame, but in which some elements are paired or grouped with an effect of strong cohesion and mutual

reinforcement, I shall use the term *discoordinated*,[5] as opposed to *coordinated* but also as distinguished from *disordered* or *dissonant*. It is a type of order in which two or more systems of forms are juxtaposed, yet at specific points are in striking accord or continuity with each other.

Other details make the correspondences between the isolated figure of the lion and the ornamental frame especially clear (Fig. 1). The curves of the head and snout of the animal are related to the curves of the interlace, particularly in the loosened segments in the middle axis of the frame. The thinly drawn black outlines of the animal are found again in the interlace ornament, and the pattern of dots decorating the lion's head and a segment of his belly recalls the play of dots in the border aligned on the thin interlace bands set against a yellow ground that changes to green in the neighborhood of the lion. This is not a normal process of ornament; usually, in borders, a decorative motif is repeated with little change. Here, on the contrary, we are aware of the frame as an articulated object with marked internal contrasts responsive to nearby forms in the larger field it encloses, and in turn affecting the aspect of the whole.

On a second page in the Book of Durrow we see another type of relationship but one that belongs, in a broad sense, to the same mode of artistic imagination and design. The representation of the man as a symbol of the evangelist Matthew (Figs. 6, 74) is a stiffly symmetrical figure, encased in that tightly fitting robe that also covers his arms and therefore makes him appear even more immobile. The robe is covered with a dense, profuse ornament of tiny squares and oblong units marked with crosses, Xs, and dots, grouped in strictly symmetrical sets from head to foot. All the larger forms contain the same kinds of elements, and some are checkered. All are seen as vertical and horizontal units of the same scale, but, in accord with the strict bilateral symmetry of the face and hair, they build up larger sets of these units in different number on the vertical axis defined by the long centered orphrey on the priestly robe. The image gives an impression of the most elementary ornament. But if we read the succession of these regular units from top to bottom, we recognize an effort of variation, as in the parts of an organic system. The small common units compose blocks of a larger order with a choice of components differing in number, filling, pattern, and shape of field. The blocks are assembled on superposed levels, with each level divided symmetrically along the vertical axis thus emphasizing the bilateral symmetry of the robe, the posture, and the stiffly regular head and hair.

That rigidness of the figure, which applies also to the head in its frontal aspect with strictly symmetrical features, changes abruptly at the feet. Here, unlike the symmetry of the head and costume, in which one side is a mirror

image of the other, there is a repetition in one direction that is another principle of ornament involving a different type of movement and play of elements. That twist of the feet surprisingly contradicts the persistent bilateral symmetry maintained from the crown of the head to the hem of the robe in so many details. If we wish to correct it, however, or at least test its sense in an alternative solution, which we have done by rearranging the feet (Fig. 7), making of them a symmetrical pair in agreement with the rest of the figure, there appears a new form that looks more banal, less satisfying, and inconsistent with the spirit of the constructed body. If the feet in the original are disturbing, the corrected montage version is obvious and uninteresting.

How was the artist able to deform, or deviate from, the whole system of the figure at the feet and yet convince us that it is a necessary part of the whole? It depends ultimately on the relation of the figure to the frame. The frame has been so designed that its ornament, in decided contrast to the rigid figure, is a winding form that moves from right to left around the whole. It is anything but symmetrical or stable. The play of color further reinforces the movement of the interlaced bands and underscores the reversal of the axes of the individual units of interlace, which rise diagonally from right to left in the horizontal sections of the frame and from left to right in the vertical sections. The pronounced qualities of that ornament—openness, involution, entanglement, repeated movement, and interaction—are strongly opposed to the qualities of the immobilized figure of the man but consistent with the twisted feet. The feet, however, which turn to the right, stand in marked contrast, not only to the figure in its stiff frontal aspect but also to the ornament in the border, which moves in the opposite direction.

If we try to test the role of that interlace, which seems to turn away from the figure and to move in opposition to it, we have only to reverse the pattern of the frame while keeping the feet as they are (Fig. 8). We see then that the part of the ornament nearest to the feet of the figure, in the horizontal lower band, now moves in the same direction as the feet—a much weaker, less contrastive, less memorable form than the original one that advances in the opposite direction and gives an extraordinary life and tension to the relations of figure and frame. Yet they correspond in many respects. The

Fig. 6. Image of the Man, symbol of St. Matthew. Book of Durrow, Northumbria or Iona, second half of seventh century. Dublin, Trinity College, MS 57, f. 21v.

Fig. 7. Image of the Durrow Man with his feet made symmetrical.

Fig. 8. Image of the Durrow Man with the direction of the interlace of the border reversed.

connection with the figure is realized through small coordinating devices. You see, for instance, that the figure is encased in a border of two thin lines. It is precisely such lines that form an inner border on the interlacing pattern of the frame. Through that similarity of outline, the figure coheres with the frame as much as with the empty space between them. The rounding of the head and shoulders also ties the figure to the segments of arbitrarily colored interlace bands that alternate in color from curve to curve. Another example of this artist's acute sense of form and spacing are the little triangular wedges of two sizes, which seem to be scattered throughout the frame in a regular rhythm and through their pairing produce diagonal couplings and movements throughout the whole. Finally we see echoes of those wedges in the fillings of the checkerboard of the figure's robe with its contrasts of light and dark colors and in details of drawing on the head.

Through these experiments with the original works, which I hope have not spoiled them for you or led you to entertain doubts as to the character of the originals, a number of features have become more evident. We may generalize these by saying that in the Book of Durrow—and we shall see this in other manuscripts as well—the frame is not a neutral enclosure or uniform construction that can be applied indifferently as nowadays when old picture frames are so often put on modern or nineteenth-century paintings regardless of their style, but rather, the frame belongs to the work in an intimate way and shows that participation through the fact that it is articulated, that it changes from picture to picture, that it is given ornament that varies from point to point. In other words it has a certain resemblance to the organic world or to the world around us, which is made up of very different complex objects to which we, as living beings, respond in our own motions. Therefore, we may say, anticipating a later development of this idea, that the frame is not just an enclosure but also a milieu, and one that is closely bound to the figure in many respects.[6]

The second manuscript, as magnificent as the Book of Durrow, is the Echternach Gospels in Paris, a manuscript that once belonged to the Anglo-Saxon monastery of that name in western Germany, a great center of missionary activity at the beginning of the eighth century, to which this manuscript has been ascribed, though it may possibly date to the late seventh century. In this codex the picture of the symbol of the evangelist Matthew (Figs. 9, 35), labeled *Imago hominis* (Image of the man), shows an even more radical development of the flexibility of the frame in relation to the figure. Here the frame does not stay put but moves into the space of the figure, forming four great clamps like a vise that holds the figure rigidly in place. The bending frame not only intrudes into the field of the figure—it is filled with close knotwork that winds and crosses itself. The large figure, on the other hand, maintains a strict vertical posture as if completely dominated by a single, compressing force, a posture that is also expressive in the context of the sacred book he holds, whose open pages are inscribed with the first words of the Gospel of Matthew, *Liber generationis ihu xpi* (Book of the generations of Jesus Christ). Moreover the script on the book mediates between the qualities of the frame and the figure through its own angularity and curves.

If the frame, in intruding into the space, can only move at right angles, the figure has no rectilinear forms; it is all curves, of a remarkable vegetative character, as if put together from plant forms consisting of shells and kernels, the lowest of which are strewn with seedlike dots. Here contrasts are in constant play. If the figure is rigid, the frame moves; if the frame is rectilinear, the figure is all curves; if the frame is continuous and of a piece, the figure is broken up and composed of separate parts; if the frame is homogeneous in

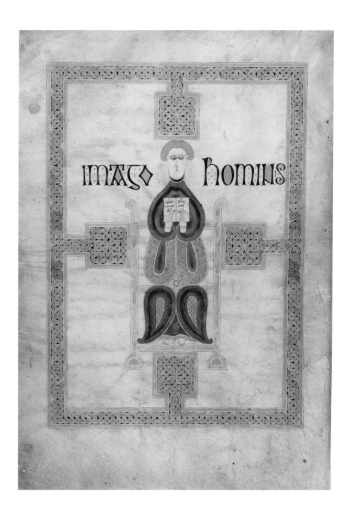

Fig. 9. Image of the Man, symbol of St. Matthew. Echternach Gospels, Northumbria or Echternach, late seventh or early eighth century. Paris, Bibliothèque nationale de France, MS lat. 9389, f. 18v.

its interlace the figure has a shell and core, an inside and outside. This remarkable play of contrasts is maintained also in coordinated details with an amazing fineness and sureness. Notice between the lowest palmettelike segments of the figure and the middle zone the concave lozenge enclosing a little circle and flower. Precisely the same lozenge form reappears in the inscribed *o* of *Imago.* The other *o,* in *hominis,* assumes a rounded shape more like the rounding of the head and the upper body. One can explore this figure even more deeply than those in the Book of Durrow and discover further planned correspondences and contrasts.

It has been supposed that what I have described as the intrusion of the frame into the field of the figure is not really a development of the frame but rather an artistic device for pressing the man against a cross. Indeed it has a considerable likeness to a somewhat damaged painting of the Crucifixion in another Northumbrian book, in the library of Durham Cathedral, one of the oldest surviving Insular manuscripts, probably of the late seventh or early eighth century (Fig. 10). There Christ, who bends his arms at right angles to extend them along the horizontal arm of the cross, is bound by the form of the cross in a manner reminiscent of that in the Echternach image (Fig. 9). However, the concept in the Echternach manuscript is not at all that of a cross. In form it may resemble a cross, but the mode of constraining the figure, which it clamps in place, and its continuity with the surrounding frame through the interlace filling convince me that it has a role other than that of symbolizing a cross. The frames in the two works differ in another respect: while in Durham the limbs of the cross radiate from the figure of Christ, widen, and press against the narrow strip of the frame, in the Echternach work, the frame, upon entering the field of the figure, widens and presses against the head of Matthew and the sides and base of his chair. I believe that the contrasting role of the frame enclosing the Echternach man, like the frames of other pictures in the book, which advance into the space of the picture with a similar freedom and flexibility, show the artist used the frame as an independent means of expression and not simply to shape a familiar symbol.

How important the frame is for the expression of this image will be seen if we remove those clamps and make the frame more obvious and, I

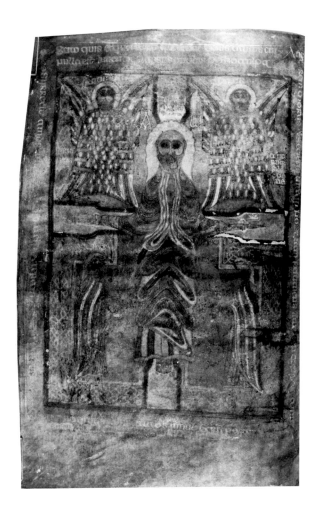

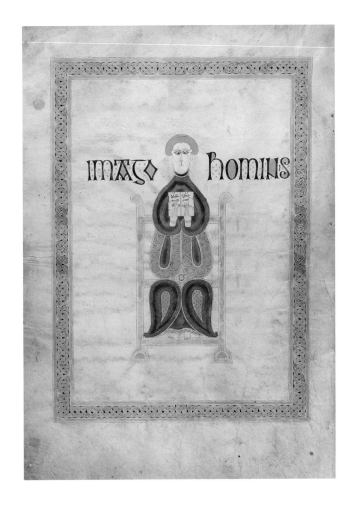

may add, more banal (Fig. 11). But even divested of the clamps, the frame still responds to the central horizontal and vertical axes that govern both figure and field by lengthening the units of interlace at the midpoint of each of its four sides. Moreover the darker color of these units is related to that of the cores or kernels in the nearby parts of the figure.

In an article in a leading avant-garde magazine for twentieth-century painting in France, published some thirty-five years ago, the Echternach Man was reproduced without those clamps and without the frame altogether, even without the inscription, so much did the figure by itself (see back cover) appeal to the writer. One may speak of that reproduction as a quotation from the original book but one that sacrificed a fundamental invention of the artist, a new way of realizing the immobility of the figure and his nature as an evangelist who ceremoniously displays his open book. The figure is the symbol of the evangelist as author fused with the image of the evangelist enthroned in a void.

On a second page of the Echternach Gospels, as beautiful as the first but altogether different in character, is the symbol of Mark, the rampant lion (Fig. 12). A rampant lion is an elegant, elastic creature, freely moving, expansive. His

Fig. 10. Crucifixion. Gospel Book, Northumbria, late seventh or early eighth century. Durham, Cathedral Library, MS A.II.17, f. 38v.

Fig. 11. Image of the Echternach Man with the clamps removed.

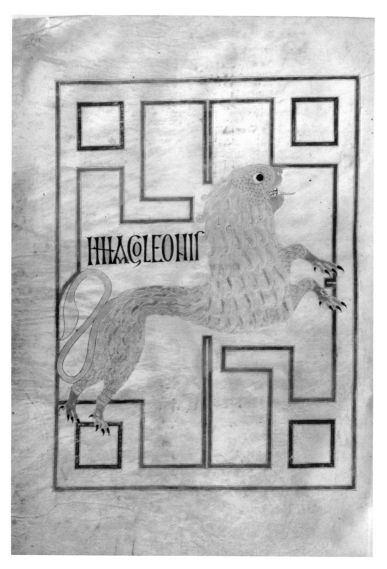

Fig. 12. Image of the Lion, symbol of St. Mark. Echternach Gospels, Northumbria or Echternach, late seventh or early eighth century. Paris, Bibliothèque nationale de France, MS lat. 9389, f. 75v.

body is covered with an ornament of hair consisting of a single curled motif repeated from the head to the legs in a simple rhythm with delicate changes. He is set within a framework of narrow red bands contrasted with the purplish ones of the squares in the four corners but corresponding in color and width to the red outer frame. That meandering red band takes its origin from the main frame, the outer one, at a point behind the animal's tail. Except for that line of entry into the field, all parts of the frame are straight lines that meet at right angles. The bands move only in perpendicular steps as do the bands of the frame in Fig. 9. At the same time, the lion, all curves gracefully adapted to its space, appears as a stepped construction, with horizontal head, vertical neck, and horizontal body, and with hind legs nearly vertical. It is a more active, live, embodiment of the perpendiculars of the framework around it.

Here the frame seems to possess the field; it finds its way into all the reserved spaces; it makes forays into the ground through these corridors, coming close to the lion but not crossing it. But where the animal provides a little opening between its forepaws, there is an attempt to enter that pocket of space. Also, at the lion's hind parts the unique diagonal band of the frame barely touches the tail. But the animal itself breaks into or traverses the frame at several points. The snout and the lower loop of the tail partially overlap it, and all four paws project beyond it, the lower two extending down to the anchoring square in the left corner of the field. The rigid is opposed to the rounded and flowing, but the rigid line, too, is carried throughout the space. The frame serves the figure while competing with it for the space of the field. In that respect it is analogous to interlace ornament, a continuous band that winds throughout a space, so that a particle which could move with the interlace would eventually pass through the whole field like a molecule in a gas.

Observe, too, the colors of the figure and the frame, e.g., the darker color of the paws of the lion and the contrast between the black of its claws and the red and yellow pattern on its body. The elegant, calligraphic contours of both

lion and frame make one think of the letters of the inscription, a beautiful sequence of lines. Note, for example, the slanted crossbar of the *m* in *imago,* which is placed close to the one diagonal element in the rigid frame. The artist's attentiveness to the value of each element in the work, his ability to devise variations from part to part to produce correspondences, and with these a perpetual opposition and interplay of unlike elements—in other words, this practice of discoordinate forms that in the end appear well ordered, yet retain their movement in free play—these are essential features of the artist's style.

A third instance of the artist's freedom in the imaginative handling of the frame independent of an illustrative or symbolic purpose, yet highly expressive in effect and no less significant than the message of a canonical symbol, is the page with the figure of an eagle, the emblem of John (Fig. 13). The slender red bands, which, if isolated from the main rectangular frame and seen together, might suggest a cross, are inward extensions of the frame, with a

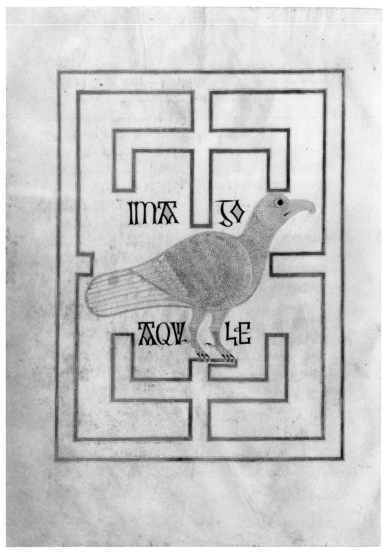

Fig. 13. Image of the Eagle, symbol of St. John. Echternach Gospels, Northumbria or Echternach, late seventh or early eighth centuries. Paris, Bibliothèque nationale de France, MS lat. 9389, f. 176v.

difference between the upper and lower. The lower provides a support, a perch for the giant bird, a short horizontal that moves outward, and the upper ones are adapted to the space allotted to the bird. This rivalry of field, figure, and frame—a three-sided interplay—is a new quality in the art of the Christianized barbarian northern world. It appears in the greatest works with that sureness and surprising inventiveness we admire in great works of art.

Small details disclose another aspect: the draftsman's refined penmanship in building up the surface and texture of the eagle through a varied density of tiny dots. The artist who establishes horizontals and verticals so boldly in the frame and encases the figure in that strong contour also is able to adopt an entirely different scale of units and, by progressive variations in that endless manifold of little points, to produce a rhythm of alternating darker and lighter bands on the wing. I call your attention also to a beautiful and witty solution, in the letter *l* of the word *Aquilae:* we see it both as part of the word and as a

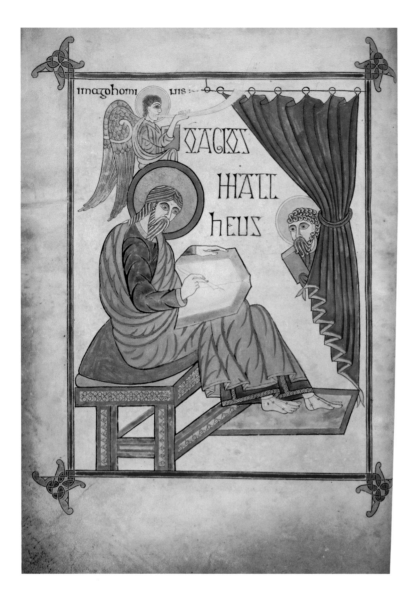

Fig. 14. St. Matthew. Lindis-
farne Gospels, Lindisfarne,
late seventh or first quarter of
eighth century. London,
British Library, MS Cotton
Nero D.IV, f. 25v.

framelike segment whose stepped base echoes the right-angled corners of the frame immediately below and on either side of the eagle. In the word *Imago* the *g* resembles the pattern of the eagle's claws.

A third manuscript, a Gospel Book of which the origin is better known than the previous two, comes from Lindisfarne, a great center of Irish and Anglo-Saxon monasticism during the seventh and eighth centuries. From a later inscription, probably recording information that had long been preserved with the book, we are able to say that this manuscript was done either just before 698 or in the two following decades. Here, in the portraits of Matthew (Fig. 14) and John (Fig. 15), the situation with respect to the human form is entirely different. The figures of the evangelists, together with their symbols and one accessory figure whose meaning is mysterious, betray in many details their direct dependence on a model that belongs to a quite different school.

We are fortunate to have a work that might have served as that model or at least permits us to say that a work like it was the model. It is the famous Bible manuscript called the Codex Amiatinus, which was completed before 716 in the Northumbrian twin monasteries of Wearmouth and Jarrow, where the great scholar and theologian Bede lived nearly all his life. The codex, now in the Laurentian Library, Florence, was copied from a Bible brought from Italy some years before by a Northumbrian abbot. Certain old texts convince us that the original from which this copy was made had been in the library of the Italian scholar and statesman Cassiodorus in the sixth century. I shall not go into the details of these historical relationships; they are among the most remarkable discoveries in the modern study of ancient manuscripts, the result of brilliant deductions by an Italian scholar, G. B. de Rossi (1822–1894), which were later confirmed by new evidence.[7]

The frontispiece of the Amiatinus Bible (Fig. 16) shows Ezra, who is named in an inscription above, transcribing the text of the Bible while sitting

on a little bench in perspective with his feet resting on a footstool. This figure of Ezra served as the model for the Lindisfarne Matthew (Fig. 14), unless we assume there was an intermediate copy of the Ezra that was transposed into the Lindisfarne image of Matthew. For our purpose, however, what is important is not the precise historical connection but the artistic relationship of these two works.

The Bible was made in Northumbria by monks who were able to write an Italian hand, unlike the native Insular hand employed by the scribes of the Lindisfarne Gospels. The Anglo-Saxon artist who was responsible for the miniature of Ezra, probably a contemporary of the painter of the Lindisfarne Gospels, thinks in terms of the frame as a window or enclosure that opens on a boxlike space in which figures are set back in depth, where there is light and shadow and some partial perspective suggested through the convergence of lines or through establishing planes at an angle to the picture plane, such as those found in the furniture and the doors of the bookcase in the background of the Ezra portrait. There is also a considerable overlapping of forms, suggesting they exist one behind the other in depth. The artist also clearly distinguished between the ground plane of the floor and the plane of the wall behind the bookcase. His work was based ultimately on Roman pagan art of which I show, as an example, a little picture of the love gods as shoemakers (Fig. 17), a rococo fantasy of Roman painters at the beginning of our era. The gods are seen at the lower left working at a table. One sits in the posture of the later Ezra and evangelist. A big armoire with samples of their labor stands opposite them, and a shelf with the finished shoes appears in the background. All are set above the ground line of the frame in a depth that is familiar to us because our own pictorial tradition, until the beginning of the twentieth century, employed the framed window view.

In the Lindisfarne Gospels (Fig. 14), the artist abandoned this window view and eliminated depth by placing his forms in the same frontal plane as

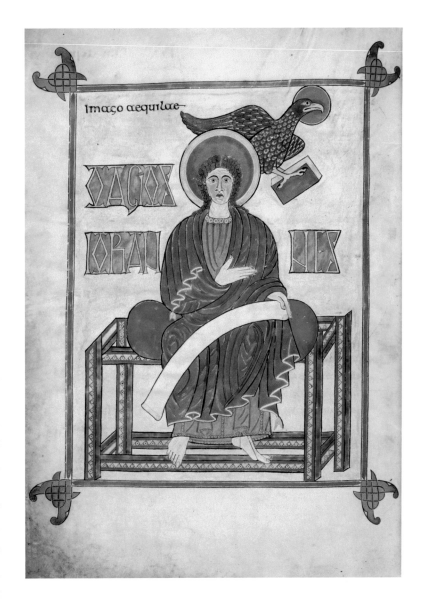

Fig. 15. St. John. Lindisfarne Gospels, Lindisfarne, late seventh or first quarter of eighth century. London, British Library, MS Cotton Nero D.IV, f. 209v.

Fig. 16. Ezra. Codex Amiatinus
(Bible), Wearmouth/Jarrow,
before 716. Florence, Biblioteca
Medicea Laurenziana, MS Ami-
atinus 1, f. V.

Fig. 17. Love gods as cobblers.
Fresco from the House of the
Stags, Herculaneum, ca. 60–79.
Naples, Museo Nazionale.

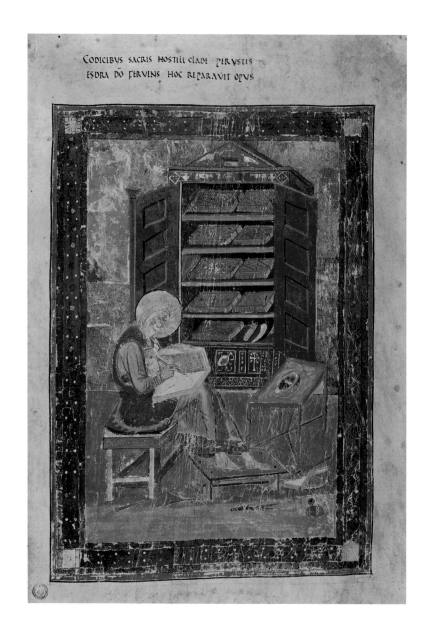

CODICIBVS SACRIS HOSTILI CLADE PERVSTIS
ESDRA DO FERVENS HOC REPARAVIT OPVS

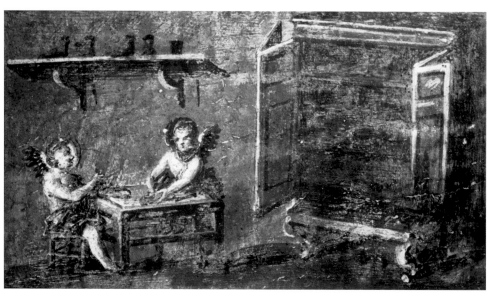

the frame and by removing all indications of the room in which they were set. The bench, brought down to the lower corner and attached to the bottom border, may still be seen as extending back into space, but this is denied by the footstool and the trumpeting angel. Both of these forms overlap parts of the curtain hanging from a rod attached to the frame and therefore appear to be located in front of the frame. This is true of the evangelist as well, whose figure overlaps both the angel and the stool. The frame itself is not just a rigid construction of verticals and horizontals: it is a ductile element with loose ends knotted together, and the corner finials are set diagonally in accord with the large diagonals in the composition. The frame is a slender, relatively bodiless form of thin parallel threads that reappear in the figure and in other parts of the scene. The artist of the Lindisfarne Gospels treats the drawing of the figures as if they are of the same pictorial substance as the frame and as if the lines of the bench, the footstool, the curtain, and rod all belong to the same system as the frame. Here then an assimilation of figure, field, and frame, which you have seen in more tellingly inventive forms in preceding works, has been applied in a painting that in many respects is faithful to a realistic conception. It is not strictly realistic, of course, though the artist strives to simulate the natural shape and posture of the figure and to record details such as the carefully drawn fingernails and the proper position of the hand holding the pen.

Unlike the previous miniatures we have seen that consist of a single, powerful symbol of the evangelist enveloped by the contrasting frame that reinforces the image in various ways and produces a pervasive movement in the field, the Lindisfarne portrait of Matthew contains the additional forms of the angel and man behind the curtain. As the result of this filling of the field with accompanying figures partly suggested by theological interpretations of Matthew's symbol and his inspiration, the whole lacks the typical concentration of the earlier works. The contrast between figure and frame is further compromised in the Matthew portrait by the attempt to unite two different conceptions of their relationship.

However, in the sparser composition of the portrait of St. John in the Lindisfarne manuscript (Fig. 15), where writing replaces several of the accessory objects of the Matthew picture, the forceful character of the unaccompanied symbols in the preceding manuscripts reappears in the figure of the evangelist. It is realized through the position and posture of John, with his marked vertical axis, and the buildup of forms that moves vertically up from the feet of the evangelist through his body and head then curves to the right in the figure of the eagle, whose halo touches the frame. This big, sweeping movement, which is echoed in the scroll held by the evangelist, is all the more

expressive when seen against the zigzag edge of the mantle across his legs and against the strong verticals and horizontals of the bench. It also permits us to see every opposition to it, in the curves of the mantle and in the flanking forms, as more significant and expressive. Together, the undeviating, upright posture of the figure and the upward movement of forms suggest the inner strength of the evangelist. The finials, the small projections at the corners of the frame, which are more pronounced than in the Matthew page, help tie the figure, the symbol, and the inscription to the frame, first by the implied extension of their diagonal axes, which would pass through all the forms and intersect at John's raised hand located at the center of the field; second, through their green and orange color scheme, green being found again in the tunic of the saint while orange is used in a number of areas, including the two halos, eagle's book, and background of the inscription.

Our last example is the page of St. John in the Book of Kells (Fig. 18). In this image a new aspect of the frame appears, unknown in the manuscripts of Lindisfarne, Echternach, and Durrow. Here the frame has a somewhat architectural character, as if composed of big blocks of masonry set beside and above one another, but there is also an effect of marquetry or inlay in each of these blocks. Shaped as crosses at the midpoints of the four sides of the frame and as stepped *L* forms reversed and inverted in the corners, they produce projections on the outside of the frame as well as on the inside, thus the movement of the frame is alternately toward the figure and away from it. But the outward projections of the cross blocks disclose a still more fascinating invention. You can make out the fragmentary form of a head above the projecting top of the cross in the upper horizontal border; two hands extend beyond the middle cross blocks, and two feet are suspended below the bottom one. It is as if the frame does not close the picture; a larger world outside and behind the frame embraces both it and the objects framed. Note that the page was trimmed on all four sides by the binder in the nineteenth century as were all the leaves of the manuscript, and in doing so he cut off the head and one hand (at the right). The double extrusion and intrusion of the frame is transfigured by the unframed extension and openness of a figure that in its cross posture, symmetry, and rigidity resembles St. John. The latter's feet, spread horizontally and therefore different from any other feet we have seen in pictures until now, fill the narrow spaces in the upper angles of the cross block, below which the similar feet of the outer figure, conjecturally identified as Christ, extend precisely parallel to the feet of John.

Within this concept of the frame, a new extension of the older idea, there is also an inner structure of contrasts that is no less remarkable than in the Book of Durrow and the Echternach manuscript pages. Whereas the rec-

tangles, crosses, and diagonally sym-
metrical stepped forms that fill the
frame are rectilinear throughout, in
the middle field there is a rich play of
symmetrical curves in the evangelist's
garments and in his grand halo com-
posed of concentric bands filled with
ornament. Three small discs appear on
either side and at the top of the halo,
the top one being a half circle, and all
make contact with the inner stepped
border segments. The outlined band of
that red inner frame belongs to no par-
ticular unit of the border but mean-
ders around the whole of the inside,
while another rectilinear band, this
one blue, meanders around the out-
side. But the latter is not altogether
continuous in the rectilinear sense. At
the four corners it splits into strands
that build up the dense, interlaced
finials that project diagonally from the
frame. Notice also how the painter
maintains contacts inside the field. For
example, the top of John's pen, which
is as large as a scepter, bends as it

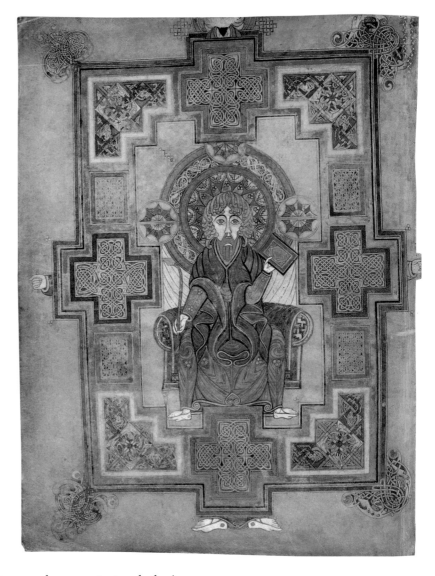

comes into contact with his halo and then reaches over to touch the inner
band of the frame. At the base of John's throne on the left is a tiny mysteri-
ous form that you might mistake for a foot of the throne; it is, however, an
inkwell in which he dips his pen. The book he holds tilted up in his left hand
is snugly fitted between the inner circle of the halo and the frame: the point
of one corner slightly overlaps the frame, while the side of the volume that
contacts the inner circle of the halo is subtly curved, a delicate departure
from a straight line, as refined as the curvature of the steps of a Greek tem-
ple. There are other details of a similar inventive wit by which forms are made
to respond or correspond to others.

Also notable in this compact, bilaterally symmetrical work are the dif-
ferences in the shape and size of the four finials: the two on the left are taller
than the broad forms on the right, and the four range in scale from the small-
est at the upper left to the largest at the upper right. The resulting unexpected

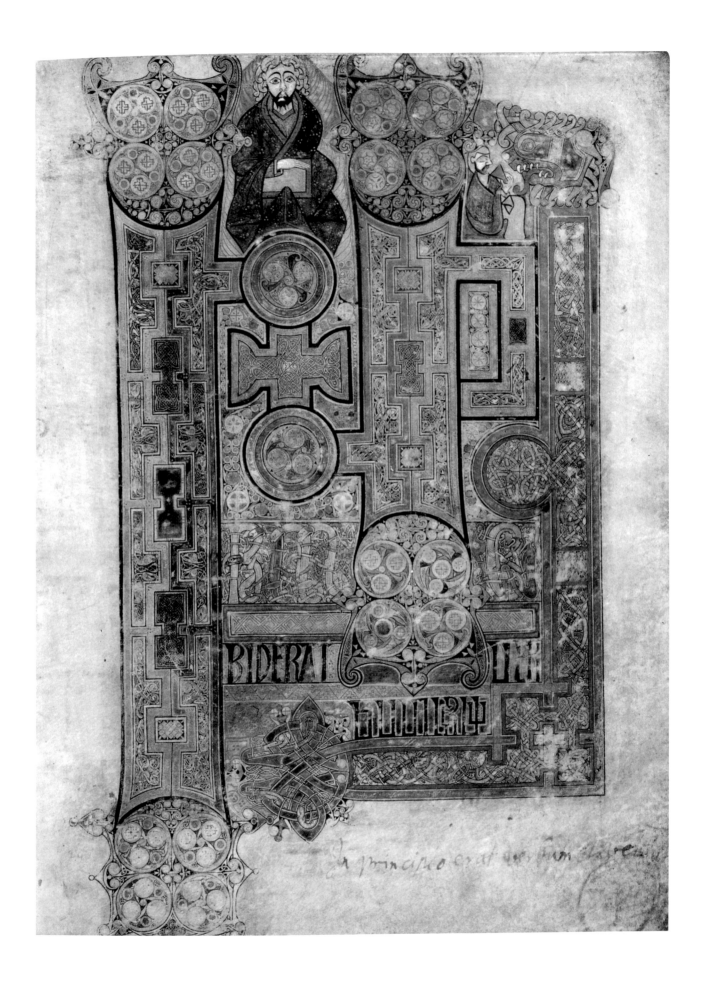

asymmetry of the diagonal finials is related to the opposing diagonals of the arms of John, which thrust in two different directions from the body but do not weaken the hieratic character or emblemlike stability of the evangelist. The asymmetry of the finials can also be understood as a response to the asymmetrical design of the adjoining first page of John's Gospel (Fig. 19), where the huge initials *INP* of *In principio,* the opening words of the text, are taller on the left than on the right and the text is only partially enclosed by the frame. The initial page further responds to the forms of the evangelist page in many features: cross patterns, repeated circles, half circles, and smaller segments of circles are found in both. There are also relationships of a subtler kind in the mode of partitioning that I need not go into here; they become evident in a closer reading of the forms.

In this lecture I have tried to show that Insular book painting is far from being an art of ornament in which figures are submitted to rigorous rules of geometrical construction and follow the principles of repetition and symmetry characteristic of other styles of ornament. Rather, the drawing of the figures and accompanying details, such as those in the frames, have qualities that we associate with reality, nature, and the empirical world: articulation, organic continuity, and subdivision, response of objects to their surroundings—the interplay of neighboring parts. (In these respects, this art hardly warrants Ruskin's contemptuous judgment.)

In the next lecture, I shall deal with ornament alone, with those magnificent designs called carpet pages, sometimes containing a gigantic cross around which the ornament is built. I shall try to show how that ornament is constructed, what principles it follows, and in what respects these are related to the principles governing the composition of the figured pages.

Opposite: Fig. 19. *In principio,* opening page of the Gospel of St. John. Book of Kells, Iona (?), ca. 800. Dublin, Trinity College, MS 58, f. 292.

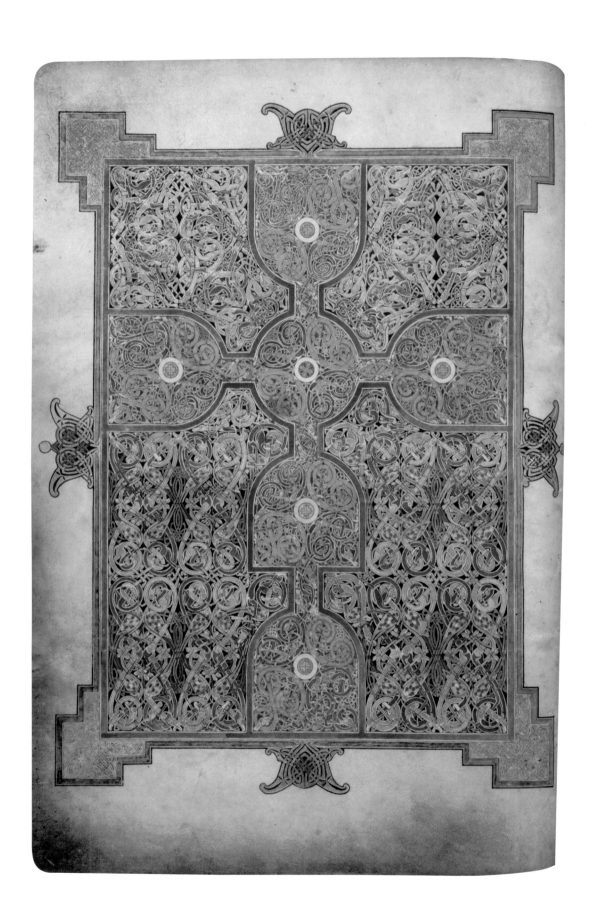

II. THE CARPET PAGE
AND THE GIANT INITIAL

In this lecture I shall consider paintings that are not representations, the so-called carpet pages. The name itself already implies that we are looking at a work in which the characteristic structure is that of ornament—the regular repetition of one or two motifs to form a predictable ordered whole. From a small segment of the work we are sometimes able to reconstruct the whole. From half or even a quarter of the work, we often can infer the rest as a regular repetition or reflection. It is an art so legible, so elementary in its structure that it can be described by a mathematician. But this is not the typical mature ornament of the Insular school. On the contrary, we shall see that in these carpet pages and in those grand pages dominated by a single large initial or by three or four such letters, monograms like the *Chi-Rho* of *Christi*, the *INI* of *Initium*, the *INP* of *In principio*, and the *LIB* of *Liber*—words highly suggestive to the imagination of a devout scribe or layman—the mode of expansion of an ornament in the field displays an inventiveness, a sustained play and paradox, with reversals and a perpetual shifting from one mode of grouping to its opposite. We ordinarily think of these characteristics as more essentially pictorial than ornamental, as an expression of our encounter with nature, with a complex reality, even though, in this art, as I have said, the forms themselves seem to be contrary to a naturalistic style. Yet, if we attend not only to the separate motifs, such as the spirals, interlace, and key patterns but also to their mode of combination, their places in the field, and the contacts of units with each other—in other words, if we attend to what may be called the syntactical as distinct from the lexical aspect of the ornament—we shall discover some inventions

Opposite: Fig. 20. Carpet page. Lindisfarne Gospels, Lindisfarne, late seventh or first quarter of eighth century. London, British Library, MS Cotton Nero D. IV, f. 26v.

of form that are not obvious or inherent in the familiar concepts of orna-ment as a regular expansion of a small repeated unit in a definite enclosed field and as a subordinate means of embellishing a larger valued object.

Before I turn to examples, I must say that in speaking of these ornaments as forms, I do not mean to deny that they also have a meaning, but at this point in our discussion of forms, we may suspend our interest in meanings, in sym-bols. Yet keep in mind that an ornament, while without a coded meaning or symbolism, may still have expressive qualities and connotations arising from its qualities and their context, the relationship to the field, and the connection with the object it decorates as an occasion for celebration or expression of the sacred. It is possible then to find points of contact between qualities and struc-tures of the ornament and certain meanings, beliefs, and values of that time. But I reserve the discussion of these aspects of the art for later lectures.

The first example I have chosen for the study of the structure of a carpet page is a large one in the Lindisfarne Gospels (Fig. 20). It encloses a cross that stands out against a background of intricate ornament. When I say it stands out, I count on your recognition of the main pattern as a cross. It is obvious that in a field of regular geometrical marks devoid of representation, the recog-nition of a simple familiar sign, like a numeral or a letter of the alphabet, will give that mark a more pronounced face, a greater pregnancy, to use a modern psychological term, than any of the purely geometrical marks. Familiar mean-ing lends a particular weight to our perception of a form. Here the cross stands out more than its actual shape and detail would warrant, for in scanning the page as a whole and then its details separately, you will see that the ornament filling the cross is not so distinctive, not so marked in contrast to the sur-roundings as to confer on the cross the predominance that a figure ordinarily has with respect to a ground. The ground here—the framed surface around the cross—is no less intensely ornamented and has many interesting shapes and rhythms. It is, I think, more fascinating in its shapes than the filling of the cross. What makes the cross so pronounced is the red line traced around it, isolating it from the neighboring field. But that red line continues into the outermost frame and bounds the reserved areas outside the cross. The reserved spaces beside the upper parts of the cross are shaped like shields or escutcheons that are as clearly symmetrical fields as those parts of the cross. If the cross is composed of rectilinear shapes and convexities, like an inverted bottle, those background spaces are formed by complementary rectilinear shapes and con-cavities. The escutcheons will appear even more decidedly as a symmetrical pair if we fix our attention on their diagonal axes. Each escutcheon is itself symmetrical and that inner symmetry, like the symmetry of the pair, is sus-tained by the finials in the two upper corners of the frame. These are stepped

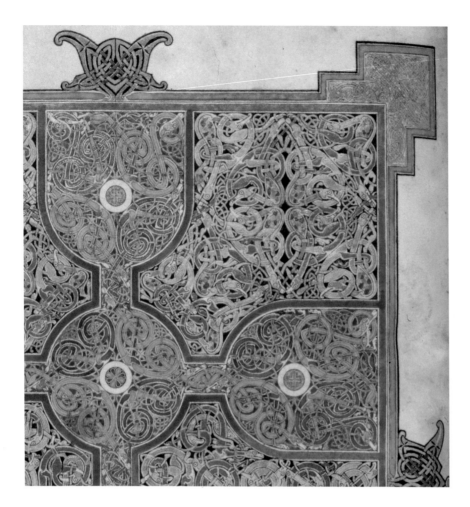

Fig. 21. Detail of the upper quarter of Fig. 20.

forms that follow the horizontal and vertical axes of the frame, but each is also symmetrical with respect to a diagonal axis, an axis to which the filling of those finials conforms.

Let us examine a detailed photograph of the upper quarter of the page (Fig. 21) to make out more clearly the structure of the ornament of those escutcheons. It is an intricate play of entangled birds and beasts drawn out into prolonged bands that are interlaced with one another. The form, which at first seems entirely capricious, discloses, when looked at more closely, some remarkable regularities and correspondences; yet we cannot easily isolate these correspondences because every element is a member of more than one pair. The groupings of a regular or symmetrical character are not perfectly closed; they interlace with neighboring units with which they form strong couplings. That continuity or entanglement of the units in any small part of the page is a principle sustained throughout the whole.

But that is only a small part of the story. If we try to approach the order of the whole more analytically—analysis here does not mean imposing abstract schemata from outside but is a method of discerning the structure,

just as in listening to music we attend to actual sequences, variations, recurrences, and larger relationships—we notice elements such as the paired ones, like the letter *C* and its reverse, which also appear below and on the other side as symmetrical counterparts. This whole region is symmetrical radially through these four units; and the longer diagonal axis, from the upper corner down to the concavity where it touches the circle of the cross, is marked by symmetrical units that are entangled and obscured by other forms. At any rate we recognize a symmetry with respect to the two corners and the diagonal axes. The artist, however, designed this tangle in such a way that a central vertical seam results, a rhythmical succession of five dark lozenge-shaped spots, concave in outline, and parallel in axis to the vertical of the larger field. It competes strangely with the diagonal axes of the escutcheons.

In the Greek world symmetry had meant a clear, closed grouping of two or three units: a middle one and two flanking ones or two opposed units forming a distinct pair. On the Lindisfarne page the symmetry is of a pairing that cannot be isolated distinctly and is imbedded in forms of an asymmetrical, continuous, even endlessly knotted type.

Another striking feature of this work is that the components of the cross—the large bottle shapes and the central circular one—are filled with four similar *C*-shaped units, curved inward spirally, as in the escutcheons; but unlike the latter, the symmetry of these units, through the accents of color, does not conform to the symmetry of their fields (Fig. 20). In the bilateral pairing the artist favors a rightward diagonal axis, in sharp opposition to the vertical and horizontal axes. The lighter turquoise-green curves prevail over the reddish curves and are still more pronounced because of the light color of the tiny circle placed in the middle between them. That circle as a center is more like the units on the rightward diagonal axis than like the darker ones on the other diagonal. In accord with obvious tendencies in grouping, in our perception, we see the lighter axis rather than the other. The effect is repeated in all six segments of the cross. Though symmetrical and perfectly stable, and though placed centrally in its field, the cross, through its ornament and color, has a bias in one direction. It seems to move more to the right, toward the facing page of text, than to the left, and that rightward movement is a recurrent axis throughout the page.

In the lower half of the work (Fig. 20), in the two rows of ornament consisting of *S* curves, you can see again the effect of the light elements against dark, resulting in the dominance of the continuous diagonal movement from left to right. This asymmetry introduces a note of unrest in the whole and a conflict with the symmetry of the great cross.

Having observed earlier the symmetry of the upper escutcheons, we would expect a corresponding symmetry below. But in fact these lower, more complex

fields are filled with an equally dense interlace of coiling beasts and birds, with limbs marvelously prolonged, as if made of an extremely ductile substance, an ornament saved from the chaos of entanglement by a more legible emerging pattern of limbs, of paired, voluted 9s and 6s that seem to cross each other and form a great *X*. Their color is so disposed, however, that the light tone is always on the upper right member and lower left, again giving greater force to the repeated rightward movement. So, instead of the symmetry implied by the reversal and inversion of the units, as well as by the symmetry of the fields, there is an asymmetrical repetition, a translation across the whole lower ground. What seems to be laid down as a principle of form in the upper half of the work is denied in the lower. But that contradiction exists already in the cross itself, a centralized, symmetrical form filled with symmetrical ornament but colored asymmetrically. The artist has carried the effect to a point of such finesse—through a calculation perhaps more of the eye than of reasoning—that the tiny disc at the center of the cluster of four spiraliform units in each bottle-shaped field contains a cross, but the central medallion encloses an eight-petaled blossom designed so that its axes and alternately dark and light petals on a dark ground present a dominant *X* tilted upward to the right. So at the heart of the great cross, at the intersection, in a barely visible closed unit—the smallest in this amazingly complex whole—the artist has planted a micro- or nuclear model of his method of discoordinate design.

These are some characteristic features of that ornament. Figure and ground are almost equal in strength; a symmetry presented in one aspect of the work is negated in another; a persistent fantasy enlivens and makes more surprising all parts of the work that are repeats, i.e., have elements found in other parts of the work. It is an individualizing variation within a rigid framework.

The same principles appear in the design of the finials of the borders. I have remarked earlier that the red outline of what we call the figure is part of the continuous red border of what we call the ground. On each side the border is divided equally by the horned finials. Through that division the artist has produced a discoordination of field and frame. While the finials above and below are in strict alignment with the vertical of the cross, and those in the four corners maintain in their stepped form the rectilinear shape of the large field, the finials on the vertical borders are not in line with an important horizontal in the work. They are marked by little knobs that are not found in the two finials above and below. Through that treatment of the finials, however, the diagonal symmetry of the upper escutcheons appears stronger, I believe. There is stronger reference to the diagonal than if the finials had been aligned with the horizontal arms of the cross.

If you wish to test that interpretation by experiment, we can consider an altered version of the page (Fig. 22). The finials have been raised to correspond

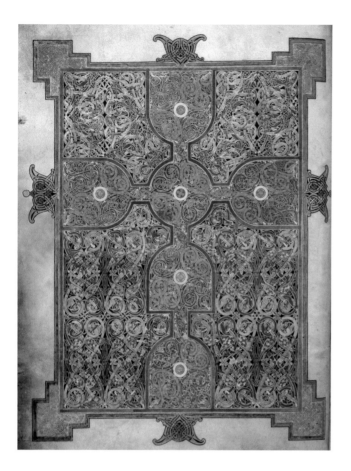

Fig. 22. Carpet page in Fig. 20 with the placement of the two side finials altered.

Opposite: Fig. 23. *Liber generationis*, initial page of the Gospel of St. Matthew. Lindisfarne Gospels, Lindisfarne, late seventh or first quarter of eighth century. London, British Library, ᴍѕ Cotton Nero D.IV, f. 27.

to the axis of the cross. What is the effect of the shift on the work as a whole? The relationship to the big diagonal escutcheons is lost. The relation of the diagonals on the arms of the cross is also weakened, and in consequence the lower half of the work balances the upper much less than it does in the original form. In the latter we see that the finials contribute to qualities and accents in the body of the work itself, in the cross as well as in the reserved ground beside the cross.

This lengthy analysis of one carpet page may seem pedantic and tiresome. Yet even without such analysis, which is like the close reading of a poem, we enjoy in that page the marvel of its sustained intricacy, the artist's power of keeping forms active throughout, qualities that are genuine features of the work. There is evident here a planning of the whole in which the large and small forms were brought into harmony in a contrasting play; variations were invented within a framework where each unit enters into the form of the whole in significant and mutually reinforcing ways and as a satisfying source of surprise.

In the same book are other full-page designs that are not carpet pages in the sense of enclosed fields with a large symmetrical pattern or with a clear distinction between a dominant motif, such as a medallion or an emblem, and the field in which it is set, but where the ornamentation, bound to a letter or word, acquires a set of characteristics new to painting as well as to ornament. These inventions in the field by artists of the Insular schools are among the most fruitful in the history of medieval art and perhaps influenced the direction of sensibility even after the Middle Ages. Such pages do not follow automatically from the cult of the sacred book or from the need to dramatize the initial at the opening of a text, though these are important factors. There is also, I suppose, a personal identification with the word and letter but under conditions in which artist and scribe together are involved deeply and emotionally in a great project of demonstration, of magnificent display, and glorifying of the sacred word. While the form is the outcome of a process of development during a period of one or perhaps two generations, the particular conception in the Lindisfarne Gospels is, I think, a leap of genius. There is nothing quite like it in the preceding manuscript art nor in that which followed even though later artists tried to emulate it.

How shall we describe the form of the page in the Lindisfarne Gospels (Fig. 23), where the opening letters of the words *Liber generationis* and the text

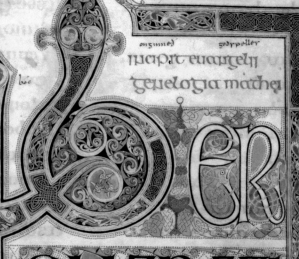

that follows are graded in size, richness of ornament, and type of rhythm? We may apply to it a term that has been used by the philosopher Alfred North Whitehead (1861–1947) in another context: *ingression,* the process of entering into in a powerful, dynamic, and musical way.[8] This aspect of ingression in a written text has been felt by the artist, who, in playing with the idea on other pages and building on the experience of previous artists who had approached it less boldly or without prevision of its larger possibilities, was led to create an *L* that rises outside the stream of letters and extends across the *i* and into the *b.* The *L* is crossed by the *i,* which descends past four lines of writing and is followed by the *b,* which rises above the *i,* but turns into itself; after that the letters *er* and *generationis* become successively smaller. The energy of pronouncement, the volume of the letters, decreases—their mass declines—but the writing becomes more and more rapid. There is a visible acceleration of movement until the words finally burst through a little frame at the side. At the end the letters bump into each other, they joggle up and down, they do not have enough room in their movement out of this confining space into the regular stream of text on the following page. It is the only example I know in all medieval art of such a sustained fantasy of ingression, in which differences of magnitude, intensity, frequency, rapidity, and richness and complexity of forms have been developed in a continuous way. It is a hymn to a text, one might say, an occasion of solemn approach, a kind of introit in which each letter owes its size and some unique features of form to its place in the sequence.

The action of entry into a text, the advancing movement, as marked by this grand, stately expression of the primacy of the initial letters, requires for its realization a frame, an obstacle—not as an enclosure but as a barrier to break through, to transcend. Not only has a partial frame been produced below at the right and at the bottom, it has been opened to make way for tiny letters. But also at the left side a dented segment of a frame gives way to the projecting knobby ornament on the long tail of the *i.* The frame yields everywhere to the word and the letter. The distinctive energy and élan of the initial are made manifest through boundaries that are broken through or forced to give way in one or another fashion. There are also fillings of the ground, which are of great beauty; I call attention to the differences between the spaces inside and around the *b,* all the more striking because of the voids of the nearby spaces and of the channels between a letter and a bit of frame. In the forms of the letters are many curious inventions of detail, alternations of the round and the straight, the short and the long. Each letter was conceived as an individual in one of its variations.

The mode of conception, which dramatizes as well as energizes the script, has its counterpart in the representation of the human figure in

Fig. 24. Battle scene. Carved whalebone panel from the lid of the Franks Casket, Northumbria (?), first half of eighth century. London, British Museum.

motion. A surprising example is in a combat scene rendered on the lid of a little bone box, made after 700, probably in Northumbria, the so-called Franks Casket (Fig. 24), with runic inscriptions. The tallest fighter is preceded by a series of advancing warriors, each more bent and smaller than his predecessor. Next to the building on the right, the last fighter lies on the ground with a figure bent over him. This kind of progression from a large to a tiny element appears often in medieval representations and especially in images with a hierarchical ordering of the figures. It is already an established feature of Insular art, as we shall see in other works, in which the same unit of ornament appears in different magnitudes on the same field. The device permits a greater flexibility than that allowed by classical ornament.

The carpet pages are, in many features, unlike any textiles that we know from this time or later. Though one can point to obvious similarities to other styles, these are not sustained in large syntactical forms such as I have described. The carpet pages were, for the Insular artists, a challenge to produce a distinctive, individual, decorative page before each of the Gospels and the book as a whole. That prefatory page later was to become an important field for the inventive fantasy of medieval artists. But it was in the early Insular school that the decorated frontispiece acquired its fascinating elaborateness of invention.

On another carpet page of the Lindisfarne Gospels (Fig. 25), a principle of design appears that is related to what we have seen in the first carpet but is realized with entirely different units. Here, the great cross is formed of stepped rectilinear forms that are unlike the bottle-shaped units, big curves, and central medallion of the other carpet. The cross is set on a checkered ground of interlace ornament that, through an arbitrary coloring of the square segments, produces a competing play of warmer and cooler colors, lighter and darker tones, yellow against red. Each segment is formed like the others of winding strands of a restless and entangled interlace, the opposite of the blunt, direct pattern of the solid red and black squares of a checkerboard, which are perfectly stable, uniform blocks of decoration.

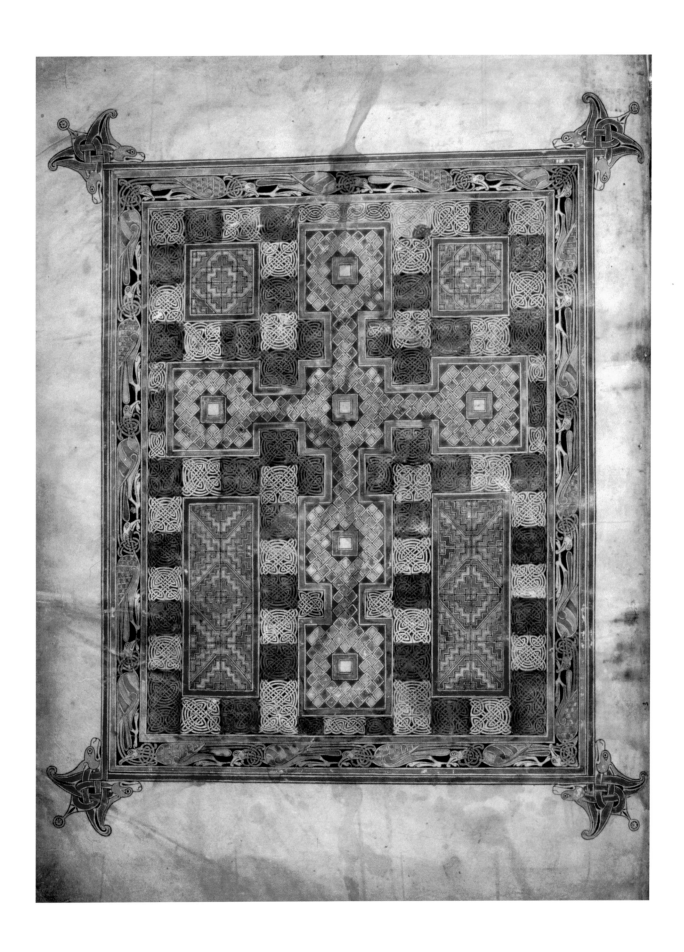

Another pronounced feature is the use of rectangular panels in the field around the cross, smaller ones above the crossarm, longer ones flanking the stem. The longer are seen through their ornament and frames as standing out vertically, like the great cross, from the background of the checkerboard; but the ornament of the background has such strength of contrast in itself that it is hard to isolate figure from ground. It is not simply that the latter is a negative field seen against the positive form of the cross: the cross itself sometimes appears to sink into the field of ornament, covering it in places, and the domino-like blocks placed at its sides to fill out the space around the cross therefore function as figures like the cross. Thus three modes of ornament compete with each other here. Furthermore the cross itself is filled with ornament in a lozenge pattern: fine crystalline squares set on end form a continuous zigzag pattern that conforms to the square shape of the projections it fills on the arms of the cross. Lozenge forms also appear in the panels flanking the cross, but there the lozenge shapes are more marked than they are in the squared zigzag pattern on the cross. Finally around the border of the field is a sequence of birds fitted snugly into a narrow space. Their posture is uncharacteristic: they lie horizontally or climb the sides vertically, each biting the leg of the one in front of it in a chain of bird biting bird. While the field as a whole is strictly symmetrical from side to side and roughly symmetrical above and below, the ornament of the border seems to move in one direction clockwise, upward at the left, downward at the right.

The finials, slender and with fine ornament of beasts' heads and interlaced bands, are elegantly placed to correspond to the fillings of the cross and the small side panels with their diagonals. And if the red and yellow fillings of the ground also tend to form ambiguous crosses of a larger order—a yellow spot surrounded by four red spots in a cross pattern—we also see those spots as sets of alternating color, corresponding to sets on the other side, which are placed somewhat lower. There is then no coincidence of the rhythm of these two but a delayed correspondence, as it were. The checkered elements that appear most regular will reveal a pattern of diagonal, crisscross units when looked at closely. The interpenetration of the diagonals with the larger square or rectangular elements is sustained in details, from the tiniest to the largest, and even in the finials, which, placed at the point of junction of the vertical and horizontal, are resolutely diagonal in composition as well as in axis, a striking example of a pervasive principle of design in this school.

A third carpet page from this manuscript (Fig. 26), one of the most splendid of all, brings out another quality of the art. The finial system, which we have seen in the first of the three Lindisfarne pages already discussed

Opposite: Fig. 25. Carpet page. Lindisfarne Gospels, Lindisfarne, late seventh or first quarter of eighth century. London, British Library, MS Cotton Nero D.IV, f. 2v.

(Fig. 20), is applied here, though the filling is not identical. The cross is of
square proportions, i.e., the vertical and horizontal members are of equal
length, but the field is oblong, leaving around the cross unequal residual
spaces that call for elements of another shape and grouping. I shall not go far
in the analysis of this work, but I call attention to the beautiful filling of the
interspaces through lozenges formed by small meandering key patterns, end-
less in line, corresponding in their axes to the lozenges in which they are set.
These lozenges vary in size and color: some of the tiny ones are dark, others
are light; the same is true of the larger forms; however, the largest of the dark
lozenges (e.g., the fourth and tenth blue ones from the left in the bottom

row) are still smaller than the biggest light lozenges between the ends of the T-shaped arms of the cross. In addition to these variants, two are joined immediately above the top arms of the cross to produce a complex figure that reappears below the bottom arms of the cross, but there are also more surprising combinations. What is remarkable is that the variable elements of the ground form groups that, taken together, are symmetrical and determine in their strong contrast a more pronounced effect than the cross, which is the main object of veneration and the theme of the page as a whole. The approach to equivalence in richness of figure and ground and often the greater stress on the ground of which the rhythm is more marked, lively, and varied through the elaboration of a single, obvious motif is distinctive to the art. It is not simply a matter of a ground pattern in a reserved space, a sort of complement or negative left by the main figure, but rather the reserved space has become a field with the same intensity of contrast and degree of articulation and interest as the main figure, sometimes acquiring an even greater attraction than the dominant emblem that has shaped the space reserved for these surrounding motifs. We may speak of the whole as a multiple instrumentation or many-part music, in which the accompanying parts are often more beautiful than the main line or just as beautiful, with equally distinctive melodies, harmonies, and rhythms; at times these coincide with or flow into the forms of the main figure, at other times they resound independently and even conflict with them in sharp dissonances, but they always attract us through the quality of the shapes and rhythms.

Up to now I have considered pages from a manuscript that belongs to an already advanced stage of this art. We can follow its growth from the second half of the seventh century to the beginning of the ninth as a fertile art; after that point, however, though there is some inventiveness and much charm, it ceases to produce the splendor and intensity of forms that we have found in the Lindisfarne Gospels and the manuscripts I showed in the first lecture.

Already in the earliest surviving carpet pages, those in the seventh-century Book of Durrow (Fig. 27), where larger units are employed and a strong, clear effect of the main accents and axes is sought, we see that the artist is fully at home with this complex game of axes, with the free play of symmetry and repetition and their transformations. He elaborates the same element in different sizes; he contrasts the shape of a field and the shapes of its filling and also begins to use the diagonal finials as elements of expression and coordination. The outer border is broader in the horizontal strips, narrower in the vertical, and seems to consist of another substance, although filled with an interlace pattern that, as it moves back and forth from the horizontal to the vertical sides, changes its tune from the rounded to the pointed in response

to the contrasted axes of the inner frame, which, unlike the usual homogeneous frame, is made up of closed, independent panels, each calling for a different treatment. We have seen the division of the frame into panels in the beautiful page of the lion in the Book of Durrow (Fig. 1), where the closed horizontal segments are filled with bold yellow, red, and green interlaced knots and the vertical ones with delicate, orange-dotted white bands. In the horizontal interlace of the frame of the carpet page, the lighter yellow stands out against a darker, more recessive red, and the yellow gives a decided rightward trend to that passage of ornament. We note the same idea in the lower panel, though it is realized in a somewhat different way and may, from certain points of view, have another effect on the eye. That strong effect will not appear in the same degree on the vertical sides because of the alternation of the yellows and reds, with green fillings in both. In the middle field, however, the interlace that continues the knotted bands of the frame reappears with a larger unit, with angular turns, and on a black ground; the black emerges in small unstable lozenges and narrow seams along the main vertical axis, quite like the succession of blacks in the escutcheons on the Lindisfarne page.

These devices in the Book of Durrow are perhaps an immediately preceding stage in the development of the carpet pages of the Lindisfarne Gospels, though one can imagine several intervening stages. Notice also in Fig. 27 how the oblong panels around the middle field do not confine it but are parted at the mid-axes to allow the interlace bands to flow from the outer border through the narrow gaps between those panels and fill the central field like a liquid in a system of connected containers. This treatment is associated with differences in the mode of filling of the horizontal panels above and below. The left panels, both top and bottom, are sharply contrasted to those on the right in their type of decoration. We see, too, that a correspondingly strong contrast exists in the vertical panels of the inner frame, but in this case, the difference occurs between the upper and lower panels on each side rather than between those on the right and left. If the artist groups a difference of right and left in one set, he will group it between top and bottom in the next set with a corresponding character.

In each of the left horizontal panels, a grid of five vertical units cut by a transverse bar is filled by two rows of stepped *X*s, which together form an array of large intersecting lozenges. In the corresponding right panels, a more complex symmetrical group of two large units with a narrow one between them, there is a more intricate and minute rhythm of diagonally crossed elements.

Of the vertical panels, the upper pair agree strictly, but the lower and upper have different patterns of ornament. Note in the lower vertical pair

Opposite: Fig. 27. Carpet page. Book of Durrow, Northumbria or Iona, second half of seventh century. Dublin, Trinity College, MS 57, f. 125v.

the diagonal grid, a black and white openwork effect, and the kinship of the diagonally crossed strips with the ornament of the horizontal panels and the lozenge forms. The color of the interlace bands in the main field produces a series of diagonal grid lines but also multipatterned grids via color and direction.

A second page from the Book of Durrow (Fig. 28) is apparently emblematic, though I am not certain that the artist intended the intersecting arcs and knots in the middle circle as a cross. The artist tried to fill the rectangle in such a way that the forms are circular and more or less diagonal in axis; he prolonged the interlace bands to form knots of yellow so placed as to produce sets of three in diagonal relation to each other, thereby leaving red circles that make up triangular sets of three. He prolonged other bands that cross in zigzag and change color as they enter the adjoining circle. In this style, which is so often regarded as primitive ornamentation, color is not matched with form so that each distinct form, closed and complete in itself, has a color of its own. Rather, just as the apparent round unit is only a partially isolated segment of a continuous trailing line that winds throughout the field, so the color of any of these arbitrarily distinguished circles does not correspond to the boundary of an object but is like a strange tattooing that diverges from the standard practice in most primitive art in which tattooing is adapted to the main divisions of the limbs, the muscles, and skin. Here there has been superimposed on the pattern of circles and diagonals a coloring with another order of distribution. It determines a rhythm and accents of a different principle than the pattern of those linear forms. The inclination of so many of the couplings of yellow to the upward right, which creates an asymmetric diagonal stress despite the uniformity or equivalence of directions in the interlace, can be understood, no doubt, through the conception of the page as part of the twin-page field of the open book. For on the next page (Fig. 29), the first two letters of *Initium* form a great dominant *N*, which includes the initial *I* in its doubled left shaft and by its asymmetry entails a rightward and upward drift. Note also that the alternating segments of dotted and plain interlace that fill the initial band are found again in the outer frame of the carpet page. So we may view these two pages as conceived together. The same artist perhaps designed the initial as well as the carpet page before it. But in that case the notion of the carpet ornament as a textile pattern with a closed frame adapted to an isolated field becomes inadequate for understanding its design.

A final example from the same book (Fig. 30) is one of the most intricate and beautiful yet also the clearest among the carpet pages. Here a densely ornamented medallion has been set in a square and the square in an oblong with little apparent correspondence between the design of the great central

Opposite: Fig. 28. Carpet page. Book of Durrow, Northumbria or Iona, second half of seventh century. Dublin, Trinity College, MS 57, f. 85v.

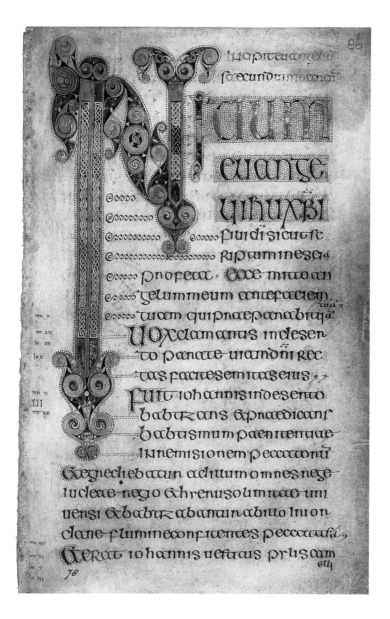

Fig. 29. *Initium*, opening page of the Gospel of St. Mark. Book of Durrow, Northumbria or Iona, second half of seventh century. Dublin, Trinity College, MS 57, f. 86.

Opposite: Fig. 30. Carpet page. Book of Durrow, Northumbria or Iona, second half of seventh century. Dublin, Trinity College, MS 57, f. 192v.

piece and the rectangular partitioning of the field as a whole. It may be likened to an architectural plan in which a centralized dome crowns an oblong space and in such a way that the contrasted parts are not only distinct but also closely tied through various details. Here a little cross in a disk marks the midpoint of the central medallion. But were we to prolong the axes of the cross, vertically and horizontally, they would not yield a clear correspondence to the complex ornament filling the rest of the medallion, which consists of three symmetrical knots of green, red, and yellow interlace separated by three white framed disks. The disk at the bottom and the interlace knot at the top do lie on the vertical axis of the cross, but the other two disks and knots are located on diagonal axes above and below the horizontal axis. Thus the cross remains isolated in its field, and yet, through the whiteness of its ground, it is related to the frames of the other three disks placed between the interlace knots, and through the repetition in the interlace knots of the red, green, and yellow used in the outer borders, the cross is integrated with the fields beyond. Note the axial connections of the vertical of the cross with the axes of the animal sets in the outer bands. There are further discoordinations in the enclosing panels: in the paired vertical ones, in which the animals pursue each other, each bites the haunch of the animal before him; the foremost one bites his own paw and moves upward at the right, downward at the left, as if in a counterclockwise procession around the field. But they are abruptly cut off by the horizontal panels where another combat begins between interlaced self-biting creatures. Each is a horizontal *C*, a twisted form entangled with a corresponding one horizontally and vertically. A yellow animal bites its own hind leg; interlaced with it is an identical red animal but with its head reversed. Four such pairs are entangled laterally with each other in both inner panels. On the outer panels we are challenged by a more intricate pattern with five pairs of interlaced beasts. Here, the upper beast is not reversed below but repeated, contrary to the expected symmetry. In the medallion, however, there is a recurrent order in

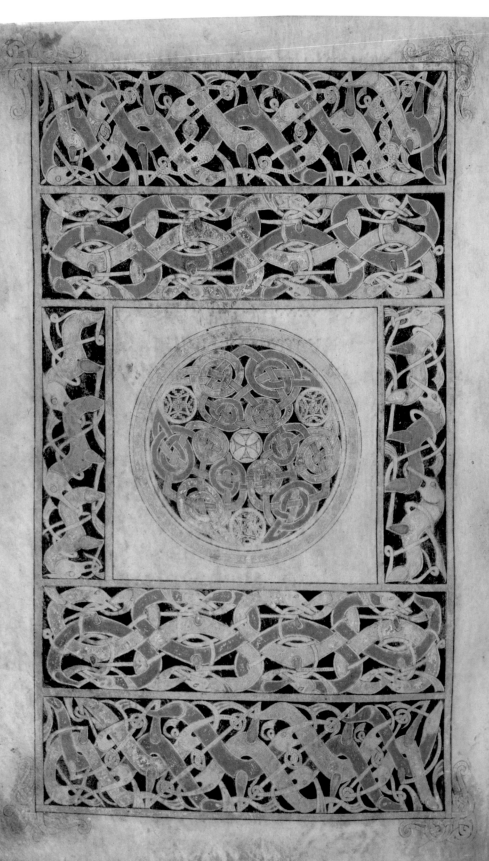

the pairing of the rounded segments of interlace in knots, yellow against red, repeated in a loose symmetry, and designed so that all these knots fit compactly in the space between the small central disk with its cross and three outer disks. The ingenuity of this whole page of ornament is extraordinary; it would repay an artist today the trouble of retracing its design in detail and observing the care with which the interspaces have been defined and the colors applied with arbitrary shifts from one to another on the same strand. In the vertical borders we observe in sequence a yellow animal with a green foreleg, a green animal, then a second yellow animal with a green foreleg. Note the artist's method of design through scattering different pairings of smaller and larger units within a regular bounded space.

I turn last to the culmination in the great initials of the Book of Kells. The best known page is perhaps the one with the *Chi-Rho* (or *X-P*),[9] which has assumed an extraordinary exuberance in this manuscript (Fig. 31). It is a work that has always delighted and fascinated the viewer; it provides the eye the richest, most entrancing field for exploration of any medieval work we know. Small as it is, the page has grandeur through its exploitation of scale—from the microscopically small units to the large—and their development and combination in complex groups of progressively greater size. Here the frame has become secondary: we hardly feel it as an element that is broken or traversed; in fact, it is in direct contact with the *Rho* and the *i*. In the *Chi-Rho* of Kells, unlike the *Liber generationis* page of the Lindisfarne manuscript, the interspaces that form the background with their irregular boundaries and flow of arabesques, spirals, and projecting forms are no less detailed and rich than the letter. The whole appears so vast, relative to the small units, that it seems a cosmos, an immense landscape. Indeed, traversing and exploring it we discover human figures, animals, and even a droll play of cats and mice in the lower part (Fig. 32), about which I shall speak in a later lecture with reference to their meaning. I confine myself here to the forms alone.

The artist proceeds from the preeminence of a single monumental letter. The curved legs of the *Chi* are contrasted at their crossing with abrupt and rigid diagonal elements, which have been absorbed into the body of the letter. Inside the field defined by the legs of the *Chi*, he has elaborated the terminal parts through spirals and filled the interspaces with large medallions that enclose smaller ones. These medallions are fields of spiraling forms, which, in their continuous movement from the core to the bounding contour and in their return to the core, are complete, self-contained worlds. One can assemble a dense series beginning with the smallest medallion and through successively larger ones reach the greatest of all. Certain of the latter enclose a rich series of small medallions like the great circular finial at the bottom of

Opposite: Fig. 31. *Chi-Rho* page (Matthew 1:18). Book of Kells, Iona (?), ca. 800. Dublin, Trinity College, MS 58, f. 34.

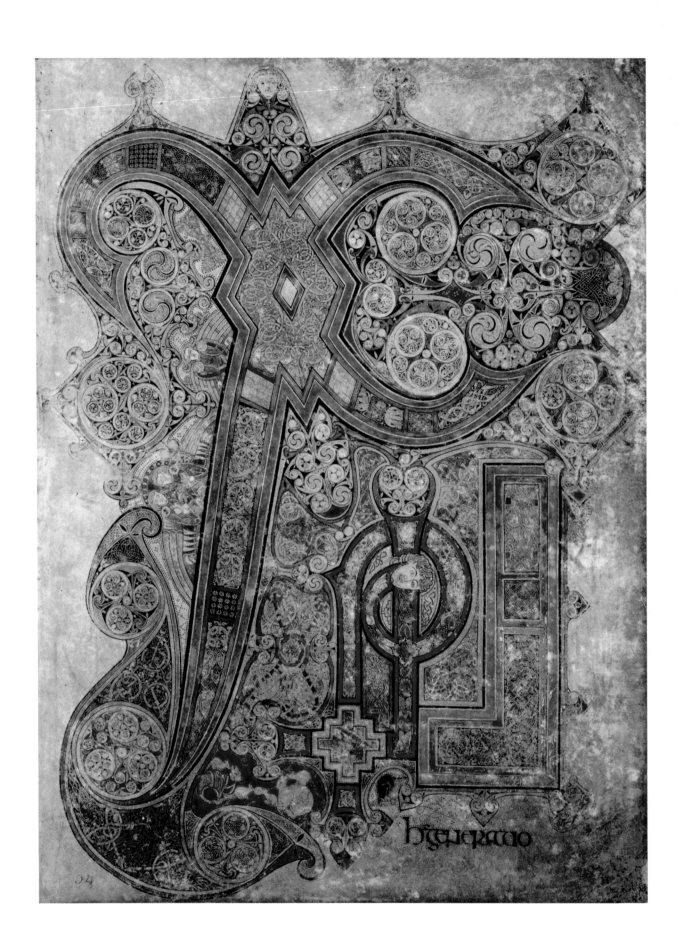

hgeneracio

the long leg of the *Chi* on the left side, in which these large medallions are surrounded by much smaller ones and filled with yet smaller ones that alternate with the tiniest of all. This conception of an articulated whole with large units containing as elements smaller examples of themselves suggests an organism in which the limbs are made up of smaller replicas of limbs and so on in turn until the very smallest. But it is not a truly organic system; cells are not formed like tissues or tissues like organs or organs like a whole body. In this art the passage from the smallest to the largest unit depends on the recurrence of the same element in many sizes; a motif of ornament also appears in different sizes, with an interplay between frames or other enclosing forms and restless, seemingly unbounded elements within them. In many places we come upon forms that seem unenclosed and are attached with capillary subtlety to some definite edge.

Before I consider further details of the *Chi-Rho* page, I wish to return to its starting point in the Book of Durrow (Fig. 33), where the *Chi-Rho* and the *i* are already larger than the letters that follow. It was a practice during the fourth century in Greek manuscripts (Fig. 34) to isolate and enlarge the first three letters of a text with an effect of ingression in the successive narrowing

Fig. 32. Cats and mice from the *Chi-Rho* page, Fig. 31.

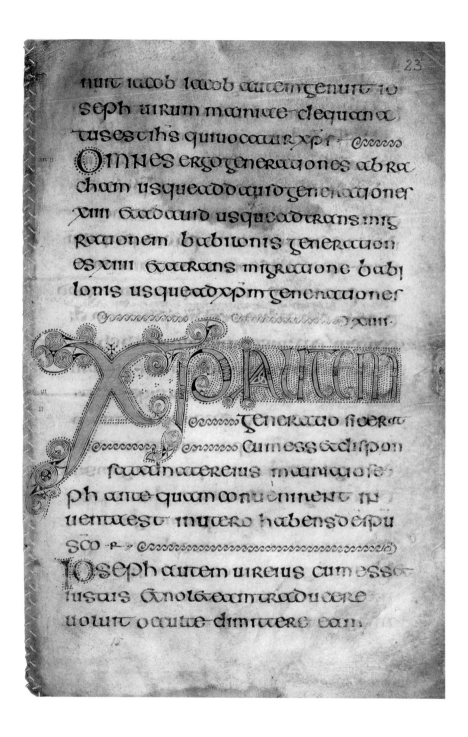

and shortening of the letters as they enter the stream of the text. The same practice was followed in written correspondence, as can be seen in this mid-fourth-century letter from Ausonius to Apa Papnuthius, in which the first three letters are enlarged. In the Book of Durrow, we also observe that a single letter may occupy the space of three or four lines of writing and the finials have become a means of free elaboration like the so-called alleluiatic neumes in singing, in which a terminal note is prolonged in a seemingly endless

Fig. 33. *Chi-Rho* page (Matthew 1:18). Book of Durrow, Northumbria or Iona, second half of seventh century. Dublin, Trinity College, MS 57, f. 23.

hallelujah. This method of expansion is associated with another characteris-
tic feature, namely the use of dots to outline the letters and fill the spaces
between them. The Durrow *Chi-Rho* also provides an example of an inter-
lace knot within the triangle of the letter *A* (Fig. 33). These features, relative
to classical art or sixth-century Italian initial ornament, reveal a novel
impulse toward elaboration of the terminal elements and interspaces of let-
ters, one that will culminate in the Book of Kells.

In addition to the letter expansion and use of dots, another distinctive
feature of the Kells *Chi-Rho* (Fig. 31) is the rich framing of the individual
forms, where borders are elaborated, often with four or five bands of color,
sometimes even more, and are strengthened by the evident movement of the

frame, which is more pronounced than the movement of any of the forms it encloses. There is a hierarchy of individuality and strength of features in the frame, an outgrowth of the qualities I have described earlier. In the lower part of the same page, the *Rho* terminates in a human head; finials are multiplied in a way that reminds one of decorated pages in manuscripts of the Koran; and in the corner, embedded in the sharply defined residual field, cats and mice play with a wafer, the eucharistic host (Fig. 32).

I shall not go into the meaning of these details now nor try to analyze further the wealth of forms and the modes of combination. It is clear that in the Book of Kells the main characteristics of the carpet designs and the *Liber generationis* page of the Lindisfarne Gospels have been considerably transformed (Figs. 21, 23). The *Chi-Rho* has become an object by itself, detached from the letters and words that follow; it does not embody, as did that page of the Lindisfarne Gospels, its function of initiating a text. Perhaps the sacredness of the monogram of Christ suggested this form, but that was not the only reason, for in other elaborate initial pages of the manuscript we find the same tendency toward closure and the elimination of a dominant axis— the extravagant design seems both strewn and sharply confined, heavily framed and yet without a completely enclosing frame of the whole. These qualities give a curiously static character to what in other respects appears a marvelously animated, perpetually growing, changing design. There is no longer a major axis of the whole or even a play of two or three axes as in the earlier works. It is the culminating stage of this great style of formal invention in carpet pages and initials.

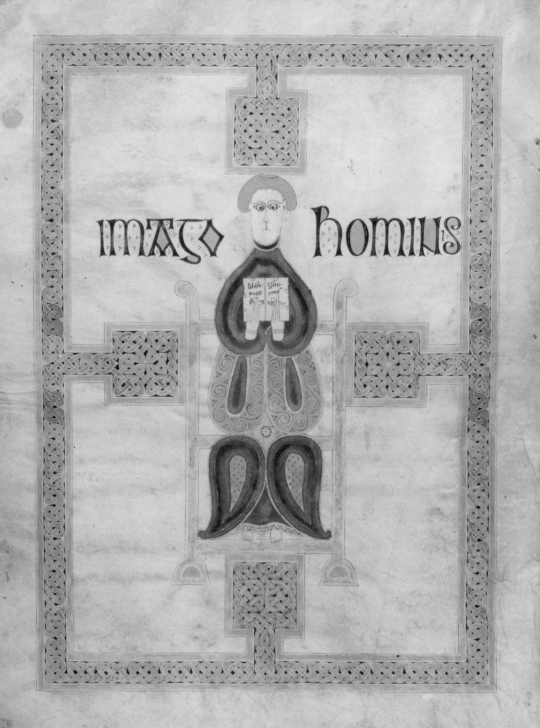

III. IMAGE AND ORNAMENT

During the nineteenth century there was a double standard in judging Insular art: it was praised for its ornament but regarded as inferior in representation. It was admired as the product of devoted, assiduous, often ingenious craftsmen, yet considered the expression of a barbaric, still childish mind that had not yet acquired a sufficient knowledge of nature. Ornament as an "adherent" art was assigned a double function: to bring out the character of an object of use by accenting its main constructive forms and to enhance a valued, precious artifact through an added richness of surface, an abundance of small, finely patterned detail.

The chief formal characteristic of ornament that distinguished it from the arts of representation was regularity through repetition of a key unit to cover a surface more or less completely. The Book of Kells was admired above all as a wondrous example of artistic industry. The artist produced an uncountable number of repeated units in a small space with a magically sustained, assiduous precision. Though identified historically with a primitive or barbarian stage of culture, his work could satisfy the taste of a modern industrial society that led the world in advanced technology; its self-conscious outlook appears in the answer of the scientist John Herschel (1792–1871) to the question "Why do we regard all molecules of a substance as having exactly the same weight, shape, and size? Because we are Englishmen; we manufacture a standard product and expect nature to do the same."[10]

This view of ornament, as essentially a subordinate art whose value was not intrinsic but lay in its relation to the object it adorned and whose beauty resided in the controlled regularity and endless replication of an ornamental

Opposite: Fig. 35. Image of the Man, symbol of St. Matthew. Echternach Gospels, Northumbria or Echternach, late seventh or early eighth century. Paris, Bibliothèque nationale de France, MS lat. 9389, f. 18v.

motif, was not adequate for Insular artists. They also associated ornament with a requirement of representation, namely, that it take as its model nature in its variably detailed, complex structure, with different levels of organization—the tiny, the middle-sized, and the large, the organic and the surface form.

Because the figures in Insular art are often drastically deformed, and the artist took amazing liberties with the postures and proportions of the figure, the nineteenth century regarded the art as unnatural and therefore irrational. While admired as ingenious in its ornament, Insular art looked crude or bizarre in its figural representations. We have seen, however, that Insular painters, draftsmen, and decorators, in full-page paintings as well as in initials, had extraordinary skill in adjusting fine details to one another and inventiveness in unifying forms that at first appear to be in sharp conflict, so that contradictions or reversals of the expected relations are finally reconciled through surprising, often extremely subtle correspondences and analogies of shape. Underlying the whole is an ideal of movement, contrast, and complexity of form that goes beyond the familiar norms of ornament founded on repetition and symmetry. I shall deal with that concept again in the following lectures when I discuss the models of this art and their transformation. We shall see how older types of ornament, available to and copied by Insular artists, were changed in essential respects in order to produce a distinct, altogether original style.

The concept of ornament is also linked in our minds with a lower level of expressiveness and intensity. The repetitive structure seems inorganic, crystalline, in contrast to the varied articulation and perpetual transformation of the stable higher living organism that is adaptable to a great variety of postures and contingencies. As an art based on the regular recurrence of the same motif throughout a field, ornament is less apt to excite our awareness of the individuality of things and the interactions in a world made up of countless unlike objects. This view of ornament as a mildly agreeable, surface-embellishing art without intense expressiveness and inadequate to our sense of reality as open, challenging, and individualized also may account for the change in the twentieth century, when architects chose to eliminate ornament. They regarded it as dispensable, an excrescence upon what is most essential or effective in the style of a building, namely, the large forms that arise from constructive necessities and express a new ideal of harmonious order in which parts remain individual yet well fitted to each other and the whole.

This reaction to ornament must be seen, however, beside an opposite one, the modern rediscovery of ornament as an expressive countercomponent. In Cubist painting in particular we are struck by the bold and fresh use of bits of ornament as elements of a whole that also includes representation

but impresses us through its freely constructed aspect. It is a revival of ornament as a carrier of strong values of line, color, and spacing and as a provider of contrasts with unornamented surfaces, making it part of a totality in which the ornamented is just as valid aesthetically, just as effective, as the unornamented parts. Taken together, the two modes cohere and yield possibilities that were not given in an art that sharply separated ornament from figuration. More recently, since the 1950s, painters have revived the concept of repetition of simple forms adapted to a field but not adherent in the old sense of decoration, in which, for example, a panel with a small repeated recurrent geometrical unit filling the surface was applied to an ivory box or to the wall of a building. Artists have found new values in repeated regular forms and strong colors, in types of design that would have seemed in older times essentially ornamental rather than organic. What looks like ornament in recent painting has, nevertheless, features of contrast and surprise, even of caprice within what otherwise appears regular. This gives individuality to the work as a self-sufficient whole.

To bring out more clearly the characteristics of Insular art in which ornament as such—that is, the features we regard as belonging to repetitive decorative design—may become a strong element of expression and may also individualize a work, I show again the painting of the man in the Echternach Gospels (Fig. 35). At first sight the ornament appears to compress the figure, which is not only clamped by the ornament but also exhibits a rigidity that makes it more closely resemble a fabricated object than a live, growing part of nature. Yet in opposition to these features the figure imparts a lively quality through its vegetative forms, the semblance of shell and kernel, as well as the successive variations from its head to its arms and to its central and lower parts. A legible process of change can be followed within the main axis, a transforming rather than a repetitive sequence. From that play of the rigid, the swelling and growing within the figure, there arises an exalting presence, a ritual solemnity of gesture and of the full complex being of the figure, a quality not found in the interlace that moves around it, although that, too, has a suggestion of the living because of the intricate turning of its flowing forms.

Let us compare it with a work that obviously was influenced by it, a painting (Fig. 36) in a Gospel Book in the treasury of the Cathedral of Trier, not far from Echternach, where our first manuscript was once preserved. It is fairly evident that without knowledge of the latter, the artist who made the Trier miniature could not have arrived at his result. He lived during the eighth century, in a milieu where the leading painters on the Continent, like the leading clerics, were missionaries or their pupils from England and Ireland.

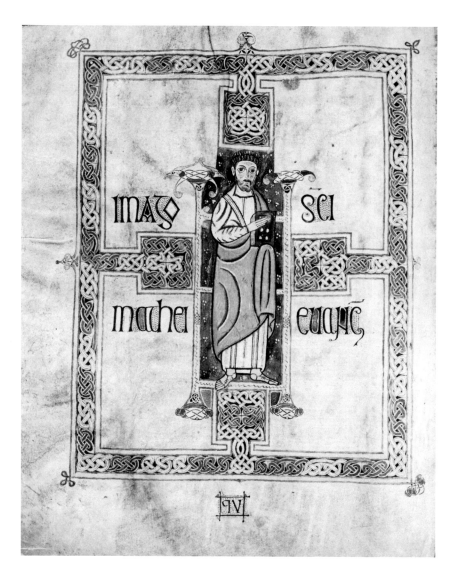

Fig. 36. St. Matthew. Trier Gospels, written and decorated in part by an Insular scribe/artist, Echternach, second quarter of eighth century. Trier, Domschatz, Cod. 61, f. 18v.

Opposite: Fig. 37. Temptation of Christ. Book of Kells, Iona (?), ca. 800. Dublin, Trinity College, MS 58, f. 202v.

In adhering to a late classical form—an inherited conception of the asymmetrical figure holding a book in a veiled hand, with the lines of the costume accordingly asymmetrical (even the feet with their slight difference in perspective go back to a classical model)—the later artist has lost or sacrificed the essential poetry of the more imaginative form of his Insular model. The latter (Fig. 35), built up with ornamental units, has for us more life and is more convincing and pure as the expression of an idea of the sacred figure. The meaning has changed in the copy (Fig. 36); the model represents the man, the symbol of the evangelist, the other (Fig. 36) depicts Matthew, the Evangelist himself; there is perhaps a difference also in degree of imaginativeness in the distance from the object designated: one is a symbol, the other an emblem or icon of a symbolic figure.

In the image of the lion in the Echternach codex (Fig. 12), the surrounding ornament and ornamentalized features of the animal are treated in a way that underscores the qualities that for us have a stronger and deeper suggestion of nature, movement, and articulations of a living body and an environment. Even more remarkable is the conception of that meandering, stepped form around the figure, its milieu—that red band with corridors, recessions, and advances. The artist conceived it everywhere as rectilinear but symmetrical diagonally. The lower right corridors correspond to the upper left ones, creating a diagonal axis that crosses the diagonal axis of the lion. Here a replication of one form in another serves to build up an energetic contrast to a figure that has no such lines but within its body displays an alignment of its members that we also see as vertical and horizontal.

There is another aspect of ornament important to consider: its use within a narrative picture in the regular grouping of components in varied sets. Each set is like a field of ornament but as a whole appears as an indi-

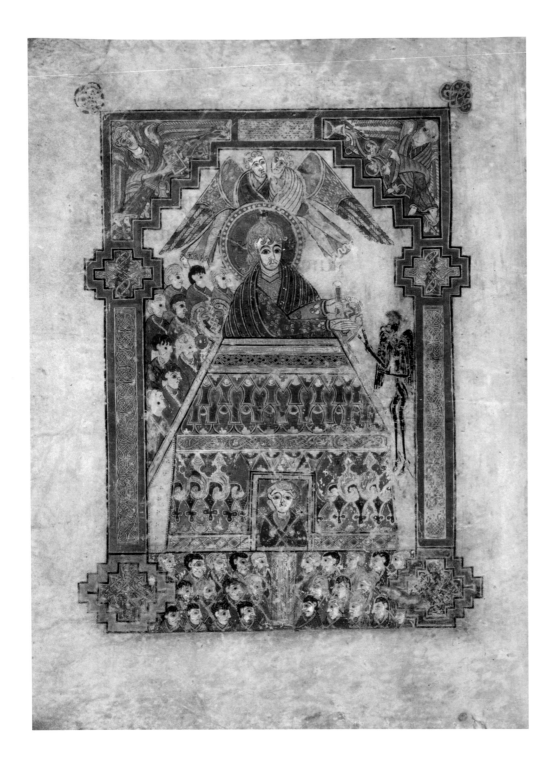

vidual region of the picture. In the lower part of the painting of the Temptation of Christ (Luke 4:9) in the Book of Kells (Fig. 37), on what we take to be part of the frame, is an enigmatic grouping of figures staged in rows. The figures at the left are turned to the right; those at the right are turned to the left. Together they form symmetrical groups with respect to a common vertical axis. Above them is a building, the temple from which Satan challenges

Christ to throw himself, trusting in God or the angels' help. That building is
no simple construction: the surface of the wall and roof is richly clothed with
patterned imbrications and tiles, meanders, interlace, and other geometric
forms. It is a type of exterior decoration of which few traces survive in actual
buildings. But in a drawing in a southern Italian manuscript of the late eighth
century (Fig. 38),[11] a church in the monastery of Cassiodorus, the Vivarium,
is represented with the outer walls and towers densely decorated from ground
to roof by great bands of interlace and geometric motifs. It has been conjec-
tured that churches in Ireland and elsewhere, of wood or stone, were once
painted brilliantly with such designs. The ornament in the Kells painting of
the Temptation (Fig. 37) would appear then as both an attribute of the build-
ing and as a pictorial effect within the painting. On the wall the rhythm and

order of the ornament are like those of the symmetrical sets of figures; on the roof it is an unbroken series of repeated units, which in their overlapping rows resemble the overlay of rows of figures below the building. Another type of ornament is applied to the ends of the roof ridge, where a pair of monstrous finials project as in Scandinavian buildings and Viking boats. A central figure on the facade holds two crossed scepters—which creates an ornamental effect but is a different mode of pairing in which the diagonals parallel the converging sides of the roof.

We come finally to the zone of action, with Christ and Satan. Here there are three large, unique components. At the left is a group of nine figures in uniform profile, much like those at the base of the temple but without counterparts on the other side. Christ and Satan are opposed to one another, though hardly as equals; strongest and least ornamental in spirit is the contrast of the black and the colored, of the expansive, broad, majestic Christ and the skeletal, phantasmal, black Satan as described in visionary writings of that time. We sense in this contrast an effort of balance, but it is a pictorial balance of individuals, closer to our impression of reality in naturalistic art; the forms of the two figures are not reversible or interchangeable, as in ornament. At the very top two angels who minister to Christ crown the scene with their symmetry, a quasi-ritual order. Above them the frame of the scene, a stepped border, is itself an arched form, a constructed enclosure of the sacred building below. On this page, units of ornament varying in mode of combination—pairing, symmetry, centralized design, and simple repetition—are applied in a context in which the main figures are the least regular. It is precisely this aspect of the use of ornament in Insular art that becomes important in the highly expressive, imaginative narrative painting of the Middle Ages and appears even in recent art in a figural context. The tradition was perhaps initiated by Insular art. We are not certain, however; we do not know enough of the variants in Continental art of the same period, and shortly after, to be able to measure the contribution of each school. But Insular artists created impressive examples that fascinated later artists and inspired them to develop in the contexts of their own style a related type of expression, exploiting the powers of contrast and suggestive analogy inherent in those forms.

A more complex adaptation of the frame to a scene is the enclosure of the drawing of God cursing the serpent and addressing Adam and Eve in the Anglo-Saxon manuscript of Caedmon's paraphrase of Genesis (Fig. 39). This frame, formed partly of architectural elements and partly of a tree, is surprising in its arbitrariness. The column on the right, smooth and cylindrical, rises from a base at the ground line and bears a capital shaped like a pot; the

other column, half the height of the first, is drawn above a tree that seems to support it and is covered by interlaced foliate scrollwork issuing from the jaws of a beast's head that serves as a capital. From the two capitals, which rise to different heights, springs a trefoil arch or what may be described as two arched segments with a gabled trefoil between them. The two segments are of unequal span, and the trefoil, which is off center, is set like a niche head above the figure of the Lord, who extends his hand to the left to curse the serpent. The tempter stands erect on its tail, as described in Jewish commentary and especially by Flavius Josephus (ca. 37–ca. 100), whose retelling of the story in Greek was known in the Christian West through a Latin translation.[12] Farther to the left, the serpent crawls on the earth, close to the column. With its coiling tail, forked tongue, and ornamented skin, the creature becomes one with the interlaced foliage of the column and its beast's head capital. The trefoil of the arch and the symmetrical ornament above it, together with the gable, are focused on the cross-nimbed head of the Lord. In the scene below, the Lord reappears in strict frontality at the right behind the upper boughs of a central tree, this time addressing Adam and Eve, who kneel and look up to God. The tree behind Adam supports the left column on two tall boughs that cross each other, like Adam's legs. A third branch is intertwined with a branch of the central tree; together these two branches shape an arch over Adam, like the greater constructed arch above God in the upper scene. On the other side Eve is drawn at the foot of a third tree beside the right column; a branch of this tree inclines toward a branch of the central tree to form an arch over Eve's head; two other branches cross the column at the right. The leaves with which the two figures veil their naked parts unite them with the trees, but God's costume also displays in its outlines the closest affinity with the foliate forms around him.

It seems evident to me that the frame of this image in the Genesis manuscript owes its character to the composition of the figures and trees that represent the garden of Eden. The alternative explanation—that the artist fitted the figures to a preexistent frame by various adjustments—is highly unlikely. He could have adapted the scene to the exigencies of a field defined by a simple rectangle, but anomalies and asymmetries in the frame would not have participated so decidedly in the structure of the pictorial narration.

A brilliant example of the expressive use of ornament in a representational image is the page with the evangelist Luke in the Codex Egberti (Fig. 40), which was produced in Germany, at Reichenau, in the tenth century. Luke's rigid body, his intense gaze with eyes close together, and his compression in a narrow space make an unforgettable image. His animal symbol appears directly above his head, holding a scroll whose zigzag form duplicates

Opposite: Fig. 39. God Cursing the Serpent and Addressing Adam and Eve. Caedmonian Genesis, Canterbury (?), ca. 1000. Oxford, Bodleian Library, MS Junius 11, p. 41.

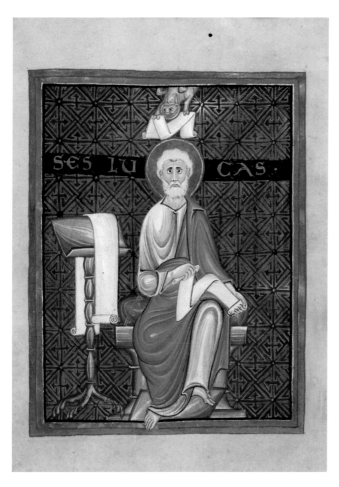

Fig. 40. St. Luke. Codex
Egberti (Gospel Lectionary),
Reichenau, ca. 980. Trier,
Stadtbibliothek, Cod. 24, f. 5v.

that of the scroll in the evangelist's lap. That great vertical of the figure topped by his symbol is crossed by the strong horizontal axis of the inscription *Sanctus Lucas,* which appears on either side of the evangelist's head at eye level. The intersection of these two axes emphasizes the head of the evangelist and occurs virtually at the spot between the eyes where psychologists have localized the felt, though invisible, presence of the soul or the self—not in a physiological sense but in fantasy—as the site of the strain of concentrated thinking and perceiving.

Behind and around the figure is a complicated pattern, a labyrinth of squares and zigzags. These form crosses at the junctures (contacts) of the squares and zigzags to produce a meandering form that recalls Insular key patterns. That ornament of the ground evokes still another mode of attention: we see crosses everywhere, but we cannot fix the pattern or follow it through; we are soon lost within it. The effect is strange, vaguely hypnotic, unlike the distinct, more legible figure. Such a conception perhaps would not have arisen without the original achievements of the artists in England and Ireland during the seventh and eighth centuries.

In the following centuries, when figurative representation became more naturalistic and reacquired certain lost classical practices, and artists began to picture the human body in action and strong emotion, in contexts with a legible narrative, these Insular inventions of form that I have described as lying outside the requirements of narrative imagery and religious symbolism still had an impact. During the tenth to twelfth centuries, artists in England (and later those on the Continent), who less frequently used the particular interlace or spirals or other types of form and frame used during the seventh and eighth centuries, were inspired to invent frames that went beyond the classical idea of the enclosing border as a simple regular enclosure or as an isolating and enriching visual element.

A drawing of the Crucifixion, from a Sacramentary now in the library of Rouen, France (Fig. 41), is one of the most intensely expressive of the period. It was made in England about 1020. The pattern of the frame is clearly an extension of the imaged cross that is multiplied in the four corners. The frame becomes a field of intense movement, of curling, congested, and spiral forms, an overflow of emotion expressed in the drawing of the Crucifixion, with the weeping Mary and sorrowing John, emotions for which the

artist found suggestive indications and analogous shapes in rendering the intricate folds of the garments. Not only is the frame a field for elaborating the cross; the holy ground on which the Crucifixion is set reminds us of the ornamental grounds in the cross carpet pages in the Lindisfarne Gospels (e.g., Figs. 20, 21). It is a freer rendering of turbulence and excitement, the counterpart in nature of the strained emotions of the figures in the Crucifixion. In more recent times we can find parallels to this kind of spontaneous invention of forms without a clear representational counterpart in certain works by Kandinsky from around 1912 and 1913 and in the impassioned paintings of Pollock, de Kooning, and other artists active in the early 1950s. In medieval art it was made possible, I believe, by the heritage of previous experience with forms in which both field and frame participate forcefully in expressive representation of the human figure. The enclosed figurative graphic forms in the field are not adapted strictly to the shape of the field as a whole; the frame, as I said, becomes an environment, an extension of the figures, a factor in their release of vehement feeling.

The frame under these conditions is also materialized. What had been a pure schematic border construction—what we would call today an abstract geometrical form—is clasped by, interlaced, and otherwise involved with the figures. Consider an image from an English manuscript of the twelfth century on the *Marvels of the East* (Fig. 42), which treats the fabulous creatures and monsters mentioned in old Greek and Latin ethnographic writings and travel accounts. A species called the Blemmyes or Acephali—headless creatures whose eyes, nose, and mouth are on their chests—are a favorite figure in the travel texts of the Middle Ages. This creature was represented earlier in what would normally be a neutral frame without expressive sense; but here he clasps the frame as if it were a doorway, an

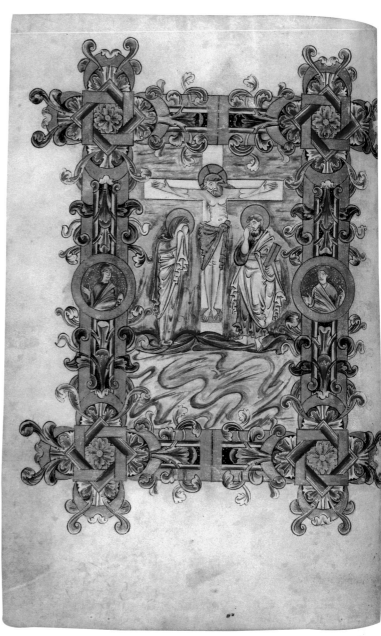

Fig. 41. Crucifixion. Sacramentary of Robert of Jumièges, Canterbury (?), early eleventh century. Rouen, Bibliothèque municipale, MS Y.6, f. 71v.

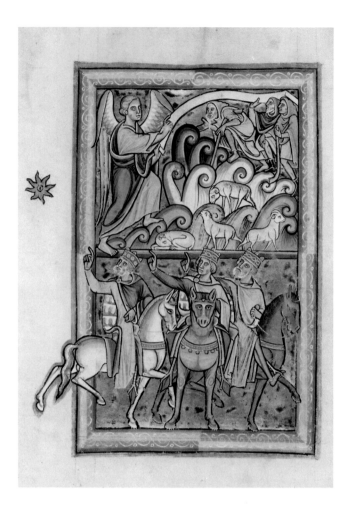

Fig. 42. Acephalic creature. *Marvels of the East*, England, ca. 1120–40. Oxford, Bodleian Library, MS Bodley 614, f. 41.

Fig. 43. Annunciation to the Shepherds and Journey of the Magi. Psalter of St. Louis, North England, ca. 1190–1200. Leyden, Universiteitsbibliotheek, MS lat. 76A, f. 16v.

extension of his own body, a piece of furniture, an object of manipulation. It is an unclassical conception of the frame that had once been a fairly neutral element. Again, this was made possible by the innovations of the Insular artist in the preceding centuries.

Another instance is the practice during the twelfth and thirteenth centuries of regarding the frame as a traversable element in a larger field in which figures move behind and across the frame. In the representation of the journey of the three magi in the Psalter of St. Louis in Leyden (Fig. 43), the magi point to the star that guides them to the newborn Christ in Bethlehem; above, the angel announces the birth to the shepherds. The three mounted magi have entered this field from outside, crossing the frame; they turn their heads and point to a star depicted in the high open margin, a star that is in line with the scene in another framed field. That conception of the entire page with its two scenes in the enlarged pictorial space is reinforced by the correspondence of the form of the star to the central figure among the magi—the horse, which is foreshortened, moves out toward the viewer. His head and ears are like the silhouette of the upper part of the star. Hence, space, as

extending upward, outward, and forward, is suggested long before there is systematic construction of perspective space in the Renaissance manner. We see again, in this miniature painting, which was done in England around 1200, how artists built upon what had been abstractions or standard schematic constructions and used them as a means of evoking new effects of openness, real space, movement, and action beyond the enclosing frame of the image and its surface.

All the works I have shown until now are in manuscripts. It may be that the features I have described originated in the special conditions of the manuscript with its wide margins and the association with writing and decorated initials. But I am not sure that was the case. We observe that in the twelfth and thirteenth centuries, when, after a lapse of many centuries, buildings were again decorated with monumental sculpture as in the ancient Greek and Roman world, sculptors representing large scenes enclosed them with arches, which in turn receive figures. These often belong to the same cycle of episodes as the central tympanum and serve to carry the many facets of the story beyond the limits of the frame. The word *page* is sometimes employed by historians metaphorically to describe the sculptured facades of this time. They call them great pages, as if the artists just wrote or inscribed the pictures on them. In the tympanum of the central portal of the church at Vézelay, Burgundy (Fig. 44), the sculptor depicted the outpouring of the Holy Spirit with Christ in the center, flanked by the apostles; in the margins are scenes of the apostles as missionaries engaged in preaching the word. Above on an archivolt are the signs of the zodiac and the labors of the months, together with various droll, exotic, or domestic figures. Below, on the lintel, is an immense array of the peoples of the world who were reached and won for Christ by the preaching of the inspired apostles. Among them are monstrous figures such as the one I showed before. Notice how the figure of John the Baptist, which is set on the trumeau, rises into the lintel beyond its border. To the right of his head, two figures, much taller than the others on the lintel and engaged in conversation—Peter and Paul perhaps—extend into the field of the tympanum. The giant Christ, with arms extended, as the rays of the Holy Spirit issue from his hands and encourage the apostles in their evangelical mission, rises still higher, beyond the expected crown of the semicircle of his own frame—his head forces the frame to detour around it. The figures beyond the tympanum are set on the radii of their compartments, but as the curved rising frame turns they adapt themselves to it, changing their stance in cunningly graded steps or movements until they stand on the circumference. Above are figures that keep rotating or revolving around a point as the archivolt itself turns. So the frame becomes the orbit of a motion

Fig. 44. Christ Commissioning the Apostles. Central portal of the narthex, abbey church of Ste.-Madeleine, Vézelay, ca. 1125.

like that of the heavenly bodies, carrying the apostles on their world mission inspired by the pentecostal emission of the Holy Spirit imaged on the grandiose tympanum.

The motion of the figures, which shift positions with respect to a supporting ground, is apparent, and the enclosed fields and their contents are graded from a small to a large and then a still larger unit. The radial connections are with different centers, for the sculptured portal has, beside the eruptive axis, numerous figures in rotation and revolution. It is a multicentered system, an ordered universe of moving parts. The portal is shaped in accordance with a spiritual perspective in which the distance from Christ determines the size of the figures and their number, religious weight, or significance. This large conception was prepared by the abstract, arbitrarily constructed forms of field, frame, and figure in Insular art, three or four centuries earlier.

Fig. 45. *Madonna of Canon van der Paele*. Jan van Eyck, Bruges, 1434–36. Bruges, Groeninge-museum.

I have said that such Insular conceptions can be observed in later medieval and Renaissance types of ornament. I shall digress in order to consider later works in which ornament was employed in a context of extremely refined and searching representation, though from a different standpoint plastically and decoratively. In one, Jan van Eyck's *Madonna of Canon van der Paele* (Fig. 45), for example, the artist depicted a richly decorated Oriental rug at the Virgin's feet. The pattern he chose, with its angular, rectilinear, and circular motifs and the divisions into smaller triangular components, can be read as consonant with the flow of drapery at the Virgin's feet as well as with Mary and the child and the ornament of their surroundings. The breaking folds of her mantle yield a seemingly casual rhythm of imbricated rectangles and triangles, shapes emerging from under one another, the contacts generating still other forms. All are regular, even though we cannot reduce the

Fig. 46. *Madonna of Chancellor Nicolas Rolin*. Jan van Eyck, Bruges, ca. 1433. Paris, Louvre.

play of drapery to a strict geometrical grid. Yet the components of the grid in the ornament of the rug below, along with certain of their relations of light and dark, strongly remind us of the patterning of the folds. It is a harmony of two systems of form, one more regular, the other more intricate, and, as in Milton's verse on the planetary movements, "regular when most irregular they seem."[13]

In the *Madonna of Chancellor Nicolas Rolin,* also by Jan van Eyck (Fig. 46), a principle of ornament is applied in another way. Repetition of a small surface unit in nature is accepted as a means of suggesting affinities in articulated objects of a most diverse character and thereby realizing a more complex unity of forms. Observe in Chancellor Rolin's hands (Fig. 47) the five fingers with their tiny joints and wrinkles and then look upward toward the distant landscape; you will discover a row of five hills that progress from

broad to narrow and, moving outward from them, parallel fields. The masonry that appears behind the praying hands forms a corresponding striation. The little hills and bits of shrubbery also remind us of the fine inflections and changes in the surface of the skin, perpendicular to these lines. That invention, which is characteristic of van Eyck, is one that resembles ornamental repetition in earlier medieval art.

Another example in the same painting is the treatment of the great crown above the Virgin's head (Fig. 48). A work of art, covered with ornament, has been placed over a figure whose spreading hair moves in regular rhythmic lines analogous to the folds of her robe and the angel's wings. More interesting is the similarity of the tiny details of the crown—the countless precious granules and filigree—to the distant architecture behind the child's head. These buildings, though placed in the distance, appear as a crown of jeweled detail, of fine ornament framing the figure of the infant Jesus.

In both of these works, ornament was applied in perspective as a part of the reality of the scene on the lower near planes of the three-dimensional space.

Although such use of ornament is often cited in distinguishing Flemish art from the broader constructive and austere forms of Italian painting—

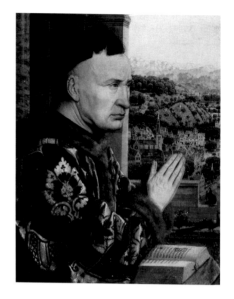

Fig. 47. Detail of Chancellor Rolin in Fig. 46.

Fig. 48. Detail of the Madonna and Child in Fig. 46.

the Netherlanders sought a unity of the natural and the artificial through a common minuteness of represented parts, a richness and preciousness of finely detailed surface in objects near and far—the Italians also applied ornament in expressive counterpoint to the figures, albeit on a different scale than in Flemish art. The masters often decorated a particular object or figure in contrast to the bare surface and large articulation of other varied elements in the same scene. An example is Giotto's grand fresco of the *Presentation of the Christ Child in the Temple* in the Arena Chapel in Padua (Fig. 49). A tall, slender column ornamented by a grooved spiral coiling from base to capital in many repeated turns stands between the

Fig. 49. *Presentation of the Christ Child in the Temple.* Giotto, nave fresco, Arena Chapel, Padua, 1305.

child and Mary. The infant, who is held by Simon, extends an arm to his mother and turns back to her, as if resisting his sacrificial mission. It is not the vertical form of the column but its grooved gyrating ornament that re-enacts the posture of the child twisting in the arms of the priest; it also resembles the wavy locks of Simon's hair and beard as well as the exaggerated diagonal form of the drapery over the arms of the prophetess Anna on the right. In addition, the folds of the figures' robes serve as both ornament and expressive structure.

There are other examples in Giotto of such use of ornament, which we distinguish sharply from the ornament as it appears in van Eyck. Still we observe through these works that the aesthetic of repetitive form can appear in an illustrative dramatic context. It can appear also in a finely, newly discovered, emerging naturalistic one; it can also be the bearer of a certain view of the unity of nature in which the similarity of things is a highly poetic

metaphorical analogy of the tiny shapes that we find again and again in the play of ornament and figure in Insular art.

The relations of ornament and image are not reducible, however, to a single principle or obvious practice or habit of artists in this school, and I cannot in the small space of one or two lectures even begin to analyze and classify different types of relationships. I would like to call attention rather to the importance of considering ornament and relationships of that kind not so much from the point of view of the origin of the motifs, which can often throw light upon the character of the art by comparison with an earlier stage, but within itself. I believe there is much to be learned and much to be enjoyed through these discoveries in the study of the mode of combining, of bringing about a coherence of an ornamental form and a figurative form, the transpositions of one into the other. This is particularly true of Insular artists, who were so extraordinarily fertile in devising new relationships of this kind.

We can observe, for example, the great contrast between the character of the living body in Insular art—I refer now to the figure as the subject of an image, isolated for its own sake—and the qualities and structure of the ornament (Figs. 1, 6). The figure in this art has impressed observers, especially those who have come to it from the study of later medieval, Renaissance, or modern art, as rigid, lifeless, or unnatural. On the other hand, the ornament has an evident mobility, a great freedom in coiling, winding, crossing, overlapping; in the production of interlace, knots, labyrinths, and dense spirals, all restless and unbounded forms. Most often, as an effect of this persistent mobility of the unit forms, the whole may appear illegible or intricate. The elements are recognizable: we see what there is, we have a sense of their quality, but we cannot easily describe the motif. In looking at a particular thread or band, we can't grasp its relation to other parts. It is so entangled that we lose track of the separate lines and their course. In contrast, the figure presents itself to us as thoroughly legible, fixed, even rigid. I say *rigid* not in a pejorative sense but to characterize a large form dominated by a single axis, though that is not a strict account of the art. I discussed earlier the importance of the twist of the feet in the Durrow man (Fig. 6) as introducing a note of conflict and paradox in the whole page and not just in the figure. I remarked on the relationship of that anomaly to the directions of the ornament within the frame. Insular ornament, it was recognized long ago, possesses qualities of continuity or endlessness. We can set up a typology of motifs, beginning with distinct units and building up from them motifs of a larger order, more complex in a quasi-biological sense, like the passage from cell to tissue to organ until we reach a stage in which we can no longer isolate a distinct constituting element. The ornament is made up of one endless

Fig. 50. Three diagrams of eight-strand interlace from Baldwin Brown, *The Arts in Early England.*

strand. It is not, however, a chain—in a chain you can distinguish links though you cannot take them apart. The endlessness of the Insular ornament is analyzed in a diagram (Fig. 50) I take from a book by Baldwin Brown,[14] following an excellent study made over sixty-five years ago by Romilly Allen,[15] who published the first systematic account of the structure of interlace patterns. This ornament is not only endless, the continuous endless strand forms a closed confined whole. Writers on early Christian and late classical art have made much of the concept of the "endless rapport," the type of ornament that in spreading throughout a field meets a frame and is cut by it: the frame isolates a segment of an ornament that looks as if it has been intercepted by the border. If the ornament is of rosettes, then in the corners or along the frame are quarter or half rosettes and the tips of rosettes. We imagine all of these continuing beyond the enclosed field. In Insular art, on the other hand, endlessness is associated with closure, with the boundless and complete. It is as if any element that we detach—and we do so arbitrarily, for it is not really an element—any segment of these strands will, if followed, appear to pass through every region of the field, just as gas particles are described by physicists as probably passing through every part of a bounded space under particular conditions in a closed system. Here, moreover, you can see in the diagram how the artist, by introducing "breaks" at certain points, reversed the direction of the interlacing band and gave a more labyrinthine character to the whole while retaining its symmetry. He composed units of a larger order, units with six or more such breaks that form a regular pattern, but even these do not permit you to read the whole ornament more clearly. If

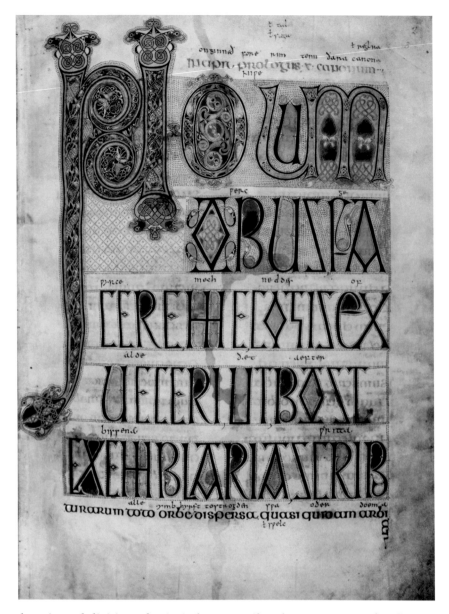

Fig. 51. *Novum opus*, initial page of Jerome's preface to the Gospels. Lindisfarne Gospels, Lindisfarne, late seventh or first quarter of eighth century. London, British Library, MS Cotton Nero D.IV, f. 3.

there is a subdivision of units it does not affect the appearance of endlessness and intricacy. Closure and symmetry are preserved in this process of elusive subdivision. In the figure at the right, you see a third solution in which more breaks are introduced and the units seem to be more legible in their pairing, yet tracing these will give you more trouble than the first or second solution.

This is a typical solution, the ABC of the Insular artist's mode of design. The spiral and interlaced animal forms can be derived from the same principle. In the Lindisfarne Gospels, in a great initial page (Fig. 51), the artist filled the vertical bars of the *N* with entangled birds. In each of the rounded forms of what was originally a diagonal link between the vertical bars, you see encoiled in a spiral pattern the long neck and head of a large bird whose body lies outside the spiral and the hindquarters of the bodies of two small animals

Fig. 52. Canon Table. Lindis-
farne Gospels, Lindisfarne, late
seventh or first quarter of
eighth century. London,
British Library, MS Cotton
Nero D.IV, f. 15.

that metamorphose into bands that emerge from the
spiral to frame the ornament on the vertical bars. The
extremities of both birds and beasts are extruded into
continuous, often knotted, endless bands, even in a
narrow enclosed field. But most often it is not the
"endless rapport" found in early Christian designs.
Observe in the O how the twisting spirals, joined to
each other in a perpetual motion within a framework,
retain an aspect of closed circles, definite and simple.
At any point, we can count the number of coils or spi-
rals, but once we try to follow their paths, we are lost.

The same principle appears in the decoration of
columns of the Canon Table frames in the Lindisfarne
Gospels (Fig. 52): a shaft has been treated more as a
slender band of flat ornament than as a solid architec-
tural member. Between its borders the birds seem to
float one above the other, each biting the creature
before him. What does the uppermost creature do? It
bites itself, so that the series of biting bodies is a closed
chain.

Even where there is no filling with interlace
bands, knotted animals, or spirals, the artist will devise a unit with the con-
tinuity I have described. On the colophon page of the Codex Amiatinus (Fig.
53), the arch, capital, column, and base have been ornamented with a light
band that passes through them down to the base, curving, expanding, and
thinning with the forms of the enclosing parts. Although the whole simu-
lates a constructed architecture made up of separate members that press
upon each other, it has a continuous core, a kind of marrow—a long cellu-
lar passage through which the ornament passes, not respecting any joints,
unlike the ornament in actual buildings or on the representations on Canon
Tables and frontispieces of manuscripts of the sixth century (Fig. 54). In these
the arch is a distinct constructed member, with its own decoration—painted,
stuccoed, gilt. The capitals and their impost blocks are treated with a differ-
ent ornament and color. The columns are sharply set off from them by an
astragal, and the bases form another distinct series below. Indifferent to that
classical Mediterranean canon of architecture, the Insular artist, by a caprice,
introduced a motif that moves throughout the whole, without regard to the
boundaries of larger parts or the divisions within a constructed form.

The labyrinth of densely packed continuous, coiling, and emergent
forms, often a wilderness of animal bodies in motion—crowded, crossed,

+ CENOBIUM A D EXIMII MERITO

UENERABILES AL UXTORIS

QUEM CAPUT ECCLESIAE

DEDICAT ALTA FIDES

PETRUS LANGOBARDORUM

EXTREMIS DEFINIB· ABBAS

DEUOTI AFFECTUS

PIGNORA MITTO MEI

MEQUE MEOSQ·OPTANS

TANTI INTER GAUDIA PATRIS

IN CAELIS MEMOREM

SEMPER HABERE LOCUM

entangled, and biting each other—has an expressive character that is strange to Renaissance art and to most art before the modern period.

The quality of feeling naturally attributed to the simulated bodies also depends on inherent qualities of the smoothly drawn lines, their intricacy and crossing, the perpetual unrelaxing entanglement of lines and breaking up of the background space. We can understand this form and respond to it all the more because of the art of our own century, but it must be said that, long ago, a viewer who was not constrained by a classical standard of order in art and by the demand for clarity and simplicity in the closure and distinctness of drawn forms could have and did respond to such painting as an expression of a state of feeling, which, though we cannot put it into words, we are now inclined to suppose might have inspired the creation of that work.

This style of ornament leads us to ask what was originally felt or thought about this art. We have from that time few native texts about such works of art. I shall read to you one in which ornament is described: a passage from an Irish saga of the ninth century, the story of Táin Bó Fraích (*The Cattle Raid of Fraích*). The old Irish literature—this is true of Anglo-Saxon literature as well—delights in descriptions of objects of art, especially of those

Fig. 53. Colophon page. Codex Amiatinus (Bible), Wearmouth/Jarrow, before 716. Florence, Biblioteca Medicea Laurenziana, MS Amiatinus 1, f. IV.

Fig. 54. Canon Table. Gospel Book, Italy, sixth century. Vatican, Biblioteca Apostolica, MS lat. 3806, f. IV.

that are attached to the heroic human body—helmets, swords, buckles, brooches, jewelry—all that gives authority, luster, and fascination to the instrumentalities and equipment of the human being. The reference to such artifacts is often charged with admiration and wonder, not simply for a craftsman's mind and skill but also for the sheer phenomenon of each work of art as unique and unlike anything in nature.

> [The musicians are performing on] harps of gold and silver and white bronze with figures of serpents and birds and hounds on them. Those figures were of gold and silver. When the strings were set in motion, those figures (the serpents, birds, and hounds) used to turn around the men. They play for them then, so that twelve of the people of Aillel and Maev die with weeping and sadness. Gentle and melodious were the triad, and they were the chants of Uaithne. The illustrious triad are three brothers; namely, Gol-traiges (Sorrow Strain) and Gen-traiges (Joy Strain) and Suan-traiges (Sleep Strain).[16]

The poet distinguished then three types of music with three kinds of melody, associated with three moods, extreme moods pertaining to extreme states of being. What is remarkable is that as the harpers pluck the strings to produce the music, the listeners see the ornament on the harps and the hounds and birds and serpents move, too, encircling the harpers, as if participating in both the performance and the action and mood of the music. This rare text is suggestive for the creation of the ornament and images in the Books of Durrow, Lindisfarne, and Kells. These, too, issue from a sensibility that not only responds to the ingenious and minute, to the endless restless form that teases, exerts, and astounds the eye but also has the power of inducing feeling; it involves the attentive onlooker in the ceaseless play of bodies, the entanglement, the devouring and the pursuit, the qualities of the fearful as well as of the rhythms and order of the whole.

The qualities of the mobile and endless that I have described do not exist, however, as a self-sufficient form from which one can derive all the qualities of the art. Like other styles with a distinctive unity and fertile variations, this one also has its counterquality arising from a structure entirely opposed to the forms I have described. We cannot look at the cross carpet page in the Book of Chad (Fig. 55) without becoming aware of a persistent counterprocess of imposing unities of a larger, more stable order upon the interlaced bands—grids of moving animals, key patterns, and spirals—by arranging the ornament in rectangular blocks, placing a heavy frame around them, and allowing neither the rectangular nor interlace element to break the closure of the more simply framed forms. Notice how, in the carpet page from the Lindisfarne Gospels (Fig. 25), the lines forming the key patterns

Opposite: Fig. 55. Carpet page. Book of St. Chad, Northumbria (?), eighth century. Lichfield, Cathedral Treasury, s.n., p. 220.

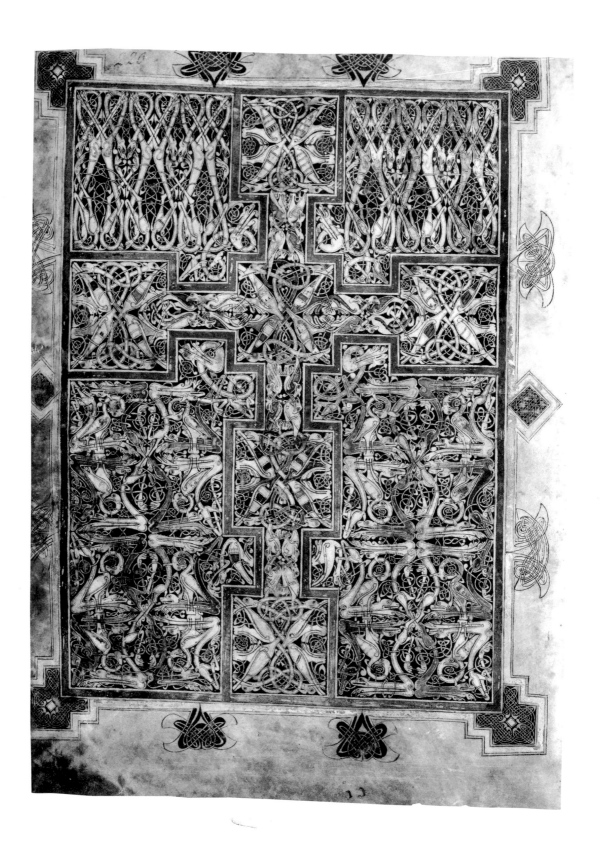

that fill the cross with little lozenges do not appear to pass beyond the frame as they would have in many works of late classical and early Byzantine art or in many modern designs, but rather, the artist had the lines meet and withdraw from the frame to produce an angular counterspace that plays against the triangles within. And he subdivided the continuous forms of the interlace filling the field around the cross by alternating the color of its knots between red and yellow. Correspondingly, in the frame, the chain of birds biting each others' feet turns and continues at the corners but in a rectangular grouping adapted to the changed conditions of the field. It is a continuity, but one that respects an a priori form, stable and square, in contrast to that of wild movement and endlessness of diagonal detail. Even in the finials, the wonderfully drawn dogs' heads cling to the horizontal and vertical framework.

A beautiful, ingenious page from the Book of Durrow (Fig. 30) offers a delightful freedom in the play of the rectilinear and curved and in the distribution of colors, which do not match the patterning of the interlace but are applied freely to produce a broader, distinct rhythm. In the central medallion, where each band of interlace changes color as it weaves over, under, and around the others, the spotting of colors is of a different frequency, another beat, and has a greater force than the units of interlace.

In judging the coherence of ornament and figure, we must take into account not only the correspondence of shapes—the ornamental features in the figure and the figurative ones in the ornament—but also a refined, precise draftsmanship common to ornament and figuration. It is a basic discipline of the art. That sure firmness of drawing gives a special strength and beauty to the work. The quality of the execution, hardly separable from the qualities of the whole, is a factor in the unity of the page. In the lion page from the Book of Durrow (Fig. 1), compare the drawing of an outline in the interlace bands with the outline of the head of the lion and compare the dots placed on that head with the dots on the interlace. Observe, too, the change from the tighter to the slacker interlace, in correspondence to the figure, which I discussed earlier. We also see in the color, in the ornamenting of the pelt, and in many other details, such accords in the execution as well as a unity of the small motifs and the scale of the work. There is a tautness, a decisiveness, an alertness to variation, which we shall recognize better in the figure if we notice that the layout of ornament, too, requires the artist's sustained attention to planning, to the adjustment to corners into which the unit motif does not fit smoothly and calls for a variant treatment in order to maintain the continuity and rhythm of the whole. Artists who in designing the ornament work with such inequalities and articulations of the field, in

drawing a figure, even if their approach is not naturalistic, attend with scrupulous judgment to every inflection of curve, to the exact spacing, the particular tenseness, softness or looseness of a line, just as they do in the interlace ornament. And the experience in rendering organic forms suggests to them ideas of variation that will reappear in the ornament as well.

Another beautiful example of the kinship of figure and ornament is the page with the eagle in the Durrow Gospels (Fig. 56), where the bird and the border share common yet not identical details and a common rhythmic alternation of colors is imposed on both the interlaced bands of the borders and the scalelike feathers on the eagle's body. These feathers are graded in size and number, becoming progressively smaller at the neck, underbelly, and legs in a subtle gradation that suggests the contoured roundness and modeling of the body in contrast to the flatter wings.

A common rhythmic flicker of dark and light binds the eagle's feathered body and the interlace bands of the massive border. From that dense regular knotwork has been shaped a pattern of alternating larger units of contrasting color arbitrarily imposed on the uniform structure of the bands. These larger units of color are roughly quadrangular on the horizontal sides of the border, triangular on the vertical sides, and correspond to each other in shape and number. The tiny interstices of the crossing bands that reveal the black ground are related in size to the spotting of light and dark on the eagle's legs.

What is most impressive is the sureness and felicity of lines; the details of the figure are as regular as the ornament. Distinctive terminal parts—the beak and the claws—are similar in shape. The mass of the body is not articulated organically, yet it is not identical to the ornament.

I now turn to another aspect of ornament in Insular art: the dense application of regular repeated units to the living body and its dress, transposed from a system of ornament to the human figure and its vestment. There are many clear and striking examples of this process, of which I shall select a few for analysis. The living form is represented as if made up of units of ornament or as if modeled as a whole on a type of ornament, though no particular motif has been copied precisely.

Familiar to students of medieval art is the Crucifixion in a Gospel Book in St. Gall (Fig. 57). The colobium of Christ, the long robe inherited from the early Christian art of Syria, is depicted here not in its traditional form as a sleeveless tunic but as a bolt of cloth wrapped and knotted around the figure. Its body is denatured, lost underneath the vestment of interlaced bands. Yet something of the constriction, torment, and agony of the body, with its layered structure of viscera, flesh, and skin, is suggested by the knotting of the robe. Without assuming that the artist was conscious of that idea, one may ask

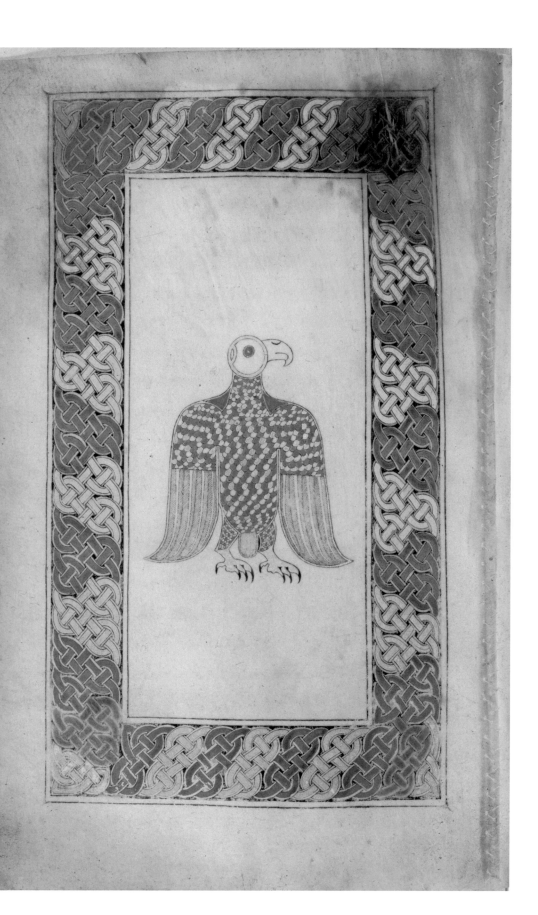

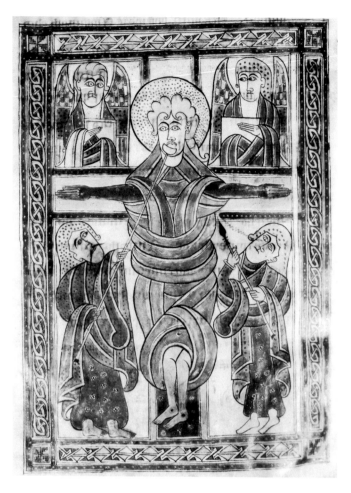

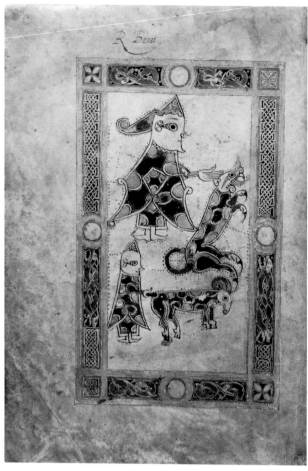

whether this conception issues perhaps from his identification with the suffering Christ. Is the latter half of the eighth century too early a date for such empathy with the flesh and blood of Christ? The twisted legs, the asymmetry of the feet in a style ordinarily given to ornamental repetition and symmetry leads us to pose the question even if we are not sure of the answer.

A drawing (Fig. 58) in a later Irish work, a Psalter in St. John's College, Cambridge, presents quite different features of ornament. The book is ascribed to the eleventh century, long after the great days of Insular art, and its drawings appear at first artless. They have in fact been rejected as works without style because the figures have little or no sense anatomically. To Ruskin they seemed no better than scrawls and doodles.[17] Yet if we regard a style of art as a definite, organized, recurrent set of forms, and an artist shapes a work consistently with forms of his own, we can say he has a style. An individual artist's style is not an impersonal habit of the hand acquired from someone else but a set of forms peculiar to himself, arising from his own nature, his learning, experience, and ideas. In the drawing of David grappling with the lion to rescue a sheep from its jaws—the sheep and a shepherd

Fig. 57. Crucifixion. St. Gall Gospels, Ireland, eighth century. St. Gall, Stiftsbibliothek, Cod. 51, p. 266.

Fig. 58. David fighting the lion and rescuing the sheep. Psalter, Ireland, eleventh century. Cambridge, St. John's College, MS 59, f. 4v.

Opposite: Fig. 56. Image of the Eagle, here the symbol of St. Mark. Book of Durrow, Northumbria or Iona, second half of seventh century. Dublin, Trinity College, MS 57, f. 84v.

are below—David's body is broken up into little cells, like those of cloisonné enamels with a clear regular pattern. A corresponding cellular form is applied to the animals and shepherd. The circular cells are much like the little discs in the border, which help to produce both a vertical accent and a horizontal axis with respect to the combat above. Remarkable also in this work is the artist's effort to compose by a method of repeated contacts. The limbs of the upper figure touch the lion and the head of the shepherd below; the latter touches the frame and the ram, while the ram touches the lion above. Where there is no contact, dotted lines are drawn from the head and leg to the frame. Every figure has contact with another that in turn touches the frame. Projecting lines and dots, a phantom around each figure, ensure that universal connectedness. This characteristic device has been transposed from the decoration of initial pages in which the artist, after having drawn the magnificent initials and the letters that follow, added a filling of fine dots, a patterned network that effects a contact among all components of the field. It is a quasi-magical reaching and touching, producing closure. We also may see it as a perseveration of the artist's pen throughout the field.

There is on the same page another kind of decorative design that deserves attention: the curious pattern of the ear. It resembles the design in Celtic art that archaeologists call a pelta motif. Here it is joined to the eye as if to form a single compound organ. We can understand that combined form through the pagan mosaics in Roman Britain and in the Mediterranean regions of the Continent (Fig. 59). The border of a mosaic is decorated by paired, joint pelta units enclosing a circular, knotted pattern in the middle. It is clear that together the eye and ear in the Insular painting form half of the motif in the mosaic. The form is typical of many heads and drawings in later Insular manuscripts. It is astonishing that an artist who has seen the motif on a pavement, where it is an "abstract" decoration of a border, should think of transferring it to a human face as a pattern of the joined ear and eye. I will have more to say about the pelta motif later, when I discuss the relation of Insular works to their models. The example in the David painting gives us an idea of a more general process of Insular artists in adapting nonfigurative ornament to organic bodily forms. We see it, too, in the conversion of drapery pleats and folds into interlace ornament as well as in the articulation of an animal's thigh by a marked spiral.

If in the preceding work, the artist, who was something of a purist, conceived of the image almost wholly in terms of a special vocabulary and calligraphic habit of dotting and connecting, without seeking a large resonance of meaning, in other works of the Insular school, and among them are the greatest, ornament was often used to build a strongly pronounced posture, gesture, or pervasive expression.

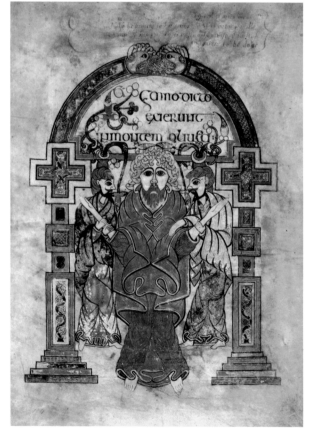

Fig. 59. Bacchus reclining on the back of a tiger. Roman mosaic pavement from Leadenhall Street, London, third or fourth century. London, British Museum.

Fig. 60. The Arrest of Christ. Book of Kells, Iona (?), ca. 800. Dublin, Trinity College, MS 58, f. 114.

Consider in the Book of Kells the page with the Arrest of Christ (Fig. 60), where he stands between two soldiers who clutch his arms with both hands. The centered victim is strictly symmetrical, the men are in profile, with strong, advancing forms, and above their heads, out of two vases, issue complicated foliate ornaments possibly representing two olive trees. If so, they may recall the two olive trees mentioned in Rev. 11:14, which Beatus of Liébana and others interpreted as two witnesses in the church spiritually representing the Law and the Gospel. Below, the folds of Christ's costume exhibit a notable arabesque of movement, symmetrical but wavy, a form that cannot be reduced to or derived from the natural play of drapery folds. It is an invented melody of line in which a current of feeling that is not expressed through gesture or the indications of a crowd around Christ is embodied in his vestment. The line is endless and wavy like an ornament but is treated as an attribute of a figure who commands our close attention. He is dominant through the color, the marked symmetry of his posture—

the raised arms and the parted legs form an *X* that may symbolize the name of Christ—and the strength of contrasts throughout. Fascinating, too, are the continuous symmetrical edges of the robe, a winding, coiling form that is more strictly centered and tied to the axis of Christ than are the coiled forms and symmetries in the freer wavy olive trees above his head.

So far I have spoken of the ornament and figures in the context of rectangular and arched fields and with reference to a set traditional theme. The achievement of Insular art and much of its importance for later art also rests on the discovery and exploration of new possibilities in the forms of script in the context of the manuscript page. It is in connection with the written word that a new type of imaginative, ornamental figuration arises. This is of such an extraordinary character that we must examine script as a species of form in itself, distinct from the style of representation of nature and the familiar filling of a field with regular ornament. Script, to be sure, is a kind of drawing. The penmanship we still practice is one of our ties with drawing as an art. It is obvious enough that in writing, or in just signing our names, we produce a linear pattern with individual features—it has a unique rhythm whether we are conscious of it or not. It also has a typical physiognomic, different for each writer's hand, that affects the viewer and incites a vague divination of character or mood. At least it impels us to see forms physiognomically, to consider the written mark, the line, as the expressive product of a human being, of a hand with certain distinctive capacities, in which may be seen traces of vital tendencies of the person. Script as an ordered system of forms is distinct from other kinds of ornament in that, on one side, it is a restricted set of standard units, subject to rules of direction, conventions for size, position, and shapes of letters; otherwise it would not be legible to others. On the other hand, these norms stabilize script, making it an effective public instrument and impose on the writer an ordered habit with the pen. All complex practice requires a degree of stabilization, for we cannot reinvent the means spontaneously for each occasion. It is also characteristic of script that every written word is a distinct object, and no two sentences have exactly the same letters, the same length, the same relation to the page. Writing, as it depends on a flow of thought that is largely unpredictable in detail, though it may achieve order through the density, offers a model field with a framework of regular functions, constraints, and rules but also with an immense variability from word to word, and from line to line. In writing a complete text you cannot replace one line by another as is possible with ornament or with the windows in an apartment house. Given this character, together with the meaningfulness of script, and given the importance of the opening words of a sacred text or a ritual along with the expressive pregnancy of the initial,

which as the first letter of the text contributes a fanfare or solemnity to the ceremonious reading, we see how the ornamenting of such fields of script elicits—from responsive and imaginative artists and from those who feel a close bond with the religious meanings and occasions—ideas and fantasies of form different in character from those of the framed page or of the illustration that, in telling a story, are bound to an already fixed model supplied in a text or in an existing image. In the Lindisfarne Gospels the same word, and even letter, may change in each occurrence (Fig. 61). We recognize the artist's persistent impulse in many gratuitous inventions of detail that do not affect our reading or interpretation of the particular word-sign. We do not understand *In principio* differently after inquiring into the specific forms of the letters *c, p,* or *o,* though *In principio* in this context has connotations that perhaps inspired the particular elaboration. We may compare the ornament with a song composed to these words. Here, for instance, at the lower end of the *c* in *In principio,* after the letter *i* has

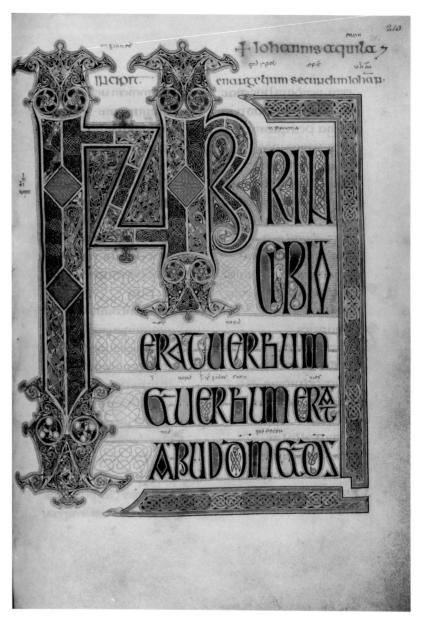

Fig. 61. *In principio,* opening page of the Gospel of St. John. Lindisfarne Gospels, Lindisfarne, late seventh or first quarter of eighth century. London, British Library, MS Cotton Nero D.IV, f. 211.

been sounded, a woman's profile extends on a long elegant stalk with which her hair is interlaced in a coil that ends in a spiral. These inventions are neither rational nor irrational; they do not come from external nature but from within, from human nature. But precisely what in human nature, and why in this time and place, is not easy to say. We have only a fragmentary knowledge of the artists' personalities, of their social world, their situation and traditions. But we are moved by these forms and qualities and enjoy them, independently of the explanations one may offer.

In the small field transformed by the artist through ornamented script and initials into a page of glory—a ceremonious entry into the text of the sacred book—we are surprised to see that for the artist whose work on the

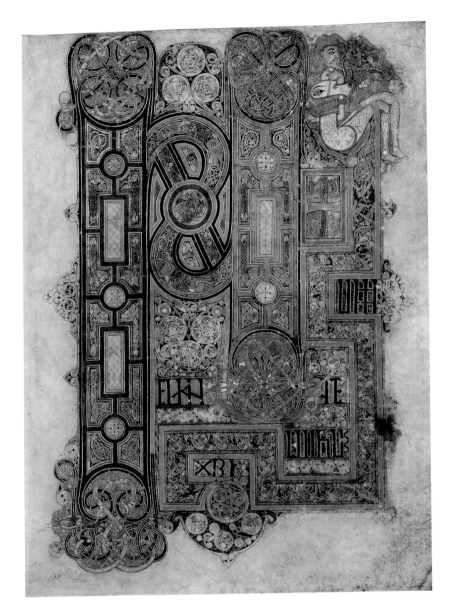

Fig. 62. *Initium*, opening page
of the Gospel of St. Mark.
Book of Kells, Iona (?), ca. 800.
Dublin, Trinity College, MS 58,
f. 130.

book is often part of his religious vocation as monk-scribe, the main objects of his fantasy, generated in the course of decorating that page and giving it a great splendor and life (Fig. 62), are often themes of violence, cruelty, self-torment, instability, entanglement of the body, and also sex, even of a perverse kind, and finally themes of an everyday reality outside the religious field. It is in these contexts of the unframed pages and the continually changing letters of which the meanings cannot be reduced to an ornamental sequence that we discover a new domain of fantasy rooted in feeling. We do not regard these forms as simply inherent in the motor and perceptual conditions of graphic design. It is not that the artist of the Kells initial page to Mark's Gospel (Fig. 63), having to complete a shape in a spiral form, saw it as a lion's head and, having drawn that head, saw as its completion a bearded profile figure who is crunched by the lion's jaws and who, at the same time, with his tiny hand, pulls the lion's tongue. Although these fantasies may provide forms that satisfy an artistic requirement, there must be, we suppose, other energies, other drives and interests, that lead to the emergence of such images and their execution in the context of the written page as a field open to free invention.

Such fantasy was to become even more important in the eleventh and twelfth centuries in Romanesque sculpture and initial ornament. The edges or crowning points, the margins and ends of fabricated objects, often call out a fantasy of an extreme or violent character, inciting the artist to externalize feelings, moods and daydreams that have little place in the religious context of the art other than the crucifixions, martyrdoms, last judgment, and hell.

On the Kells initial page to Luke, with the great *Q* of *Quoniam* (Fig. 64), the ferocious, open-jawed head of a lion, or monstrous animal, which thrusts

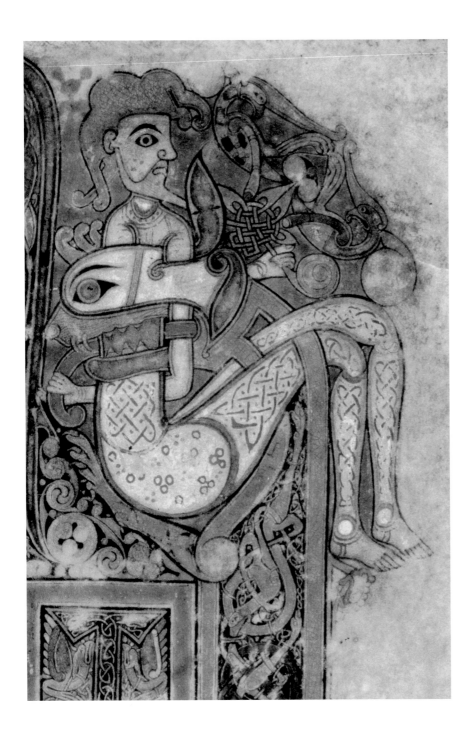

Fig. 63. Man in the jaws of a lion, detail of Fig. 62.

up from the top center of the frame, has the head of the little purple-clad man in its jaws. Far below, emerging from behind the base of the frame, are two dangling legs and a knotted tail that we assume belongs to the beast. It is a process of dismembering, but it also may be interpreted as analogous to the forms of pure ornament: just as the ornament begins at one point in the field and continues in distant parts of the work without clear connection, so one can construct a figure out of several wildly separated parts. But it recalls,

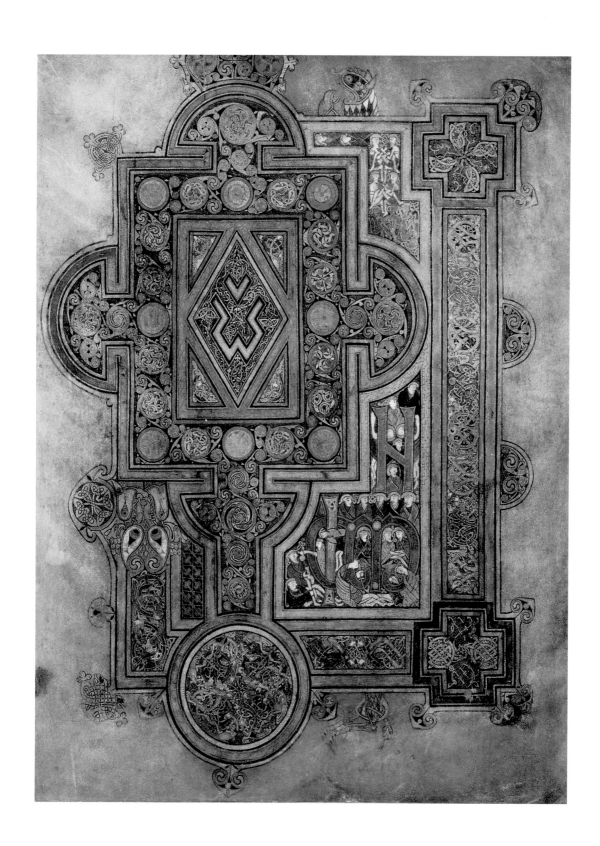

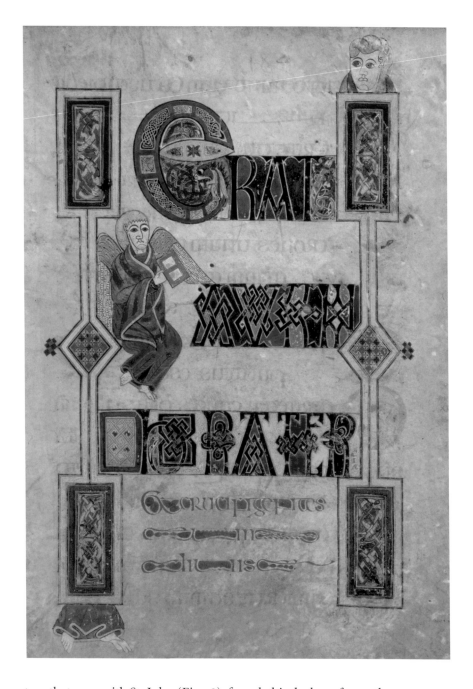

Opposite: Fig. 64. *Quonium quidem*, opening page of the Gospel of St. Luke. Book of Kells, Iona (?), ca. 800. Dublin, Trinity College, MS 58, f. 188.

Fig. 65. Text beginning *Erat autem hora tercia* (Mark 15:25). Book of Kells, Iona (?), ca. 800. Dublin, Trinity College, MS 58, f. 183.

too, that page with St. John (Fig. 18), from behind whose frame there emerges a figure of Christ. In the upper and lower fields to the right of the *Q* on the Kells initial page are pairs of embracing figures with entangled legs, some nude, others partially or fully clothed. In another example of that dismembering, on a page of large capital writing from the Book of Kells (Fig. 65), a bust of a figure rises from behind a bordered panel at the right that looks like a pulpit; the yellow border descends, diverges, joins, descends further, meets writing, continues downward. Finally, there emerge on the bottom left side, from behind the symmetrical counterpart of the right panel, the figure's legs

Fig. 66. Initial *T* of *Tunc* (Matthew 22:15). Book of Kells, Iona (?), ca. 800. Dublin, Trinity College, MS 58, f. 96.

and feet. This playfulness—it seems to us a humorous note—though we are not certain how much of it is intended as humor and how much is spontaneous imagery—is developed in the letters of the Book of Kells beyond anything we know in previous ornament and initial art. Perhaps this book or another of the same school was the great starting point of such initials, but there may have been manuscripts, somewhat earlier or of the same period, with this characteristic play.

On another page (Fig. 66) the *T* of the word *Tunc* is formed of a figure with head and limbs projecting and turned backward. The legs are crossed and tightly knotted, the figure grasps with entangled arms and clenched fists a bird that is beautifully drawn and speckled, but the whole cannot be seen simply as an ornament. The posture is not just acrobatic, it realizes a reference to conception of the body as an organism with limbs as flexible and ductile as the twisted and tangled interlace bands that are drawn out endlessly. In this art we are struck, too, by the frequent violence directed by a figure not against others but against itself, like the dog in an initial (Fig. 67) who bites his own foreleg and is entangled by his own tail and the spirally coiling body of another dog that struggles with him. Such forms had appeared earlier in the Book of Durrow in the vertical panels of the frame where the last of the chain of animals biting one another bites his own forepaw (Fig. 30). The conception here seems to be determined in great part by a preexisting inorganic ornament for its continuity and closure. Transferred to animal forms, the last loop enlacement had to be of the animal by

its own limbs. Even then it is noteworthy that the interlace has been embodied in self-tormenting and aggressive animal figures. The biting jaw is an essential feature in both, a motif important also in old Anglo-Saxon literature, as in *Beowulf*, with its devouring monster, Grendel.

In the tabulated list of the ancestors of Jesus from Luke 3:29–32 (Fig. 68): *Qui fuit . . . Qui fuit . . . Qui fuit . . .* (Who was . . . Who was . . . Who was . . .), the artist drew interlaced animals within the letter *Q* that begins each line. But in the space between the columns of words there is an elongated figure, an ambiguous form, human above, a tangle with fins below, probably intended as a sort of merman. He crosses and inter-twines his arms in grasping the spiky horizontal stroke of the word *fuit* with his hand. He becomes part of the writing and plays with it; the writing is an object, a thing of the same level of being as his fins. In the construction of this creature, the artist displays an evident interest in the transformation of the body from the upper to the lower zone. The same idea reappears in a horizontal figure (Fig. 69), which, again, is a hybrid fish-man. It is surprising and a chal-lenge to our sense of religious art to find in a Gospel manuscript produced in a monastery such a profane curiosity about bodily forms, especially the dis-tortion and playfulness found in the prolonged and twisted limbs.

Another example comes from an Irish manuscript of the ninth century in St. Gall (Fig. 70). The text is a treatise on language and grammar by

Fig. 67. Initial *D* of *Dicebat* (Luke 13:6) formed by two fighting dogs. Book of Kells, Iona (?), ca. 800. Dublin, Trin-ity College, MS 58, f. 243v.

Fig. 68. Merman, space filler. *Qui fuit semeon . . . Qui fuit Menna* (Luke 3:30–31), part of the genealogy of Christ. Book of Kells, Iona (?), ca. 800. Dublin, Trinity College, MS 58, f. 201.

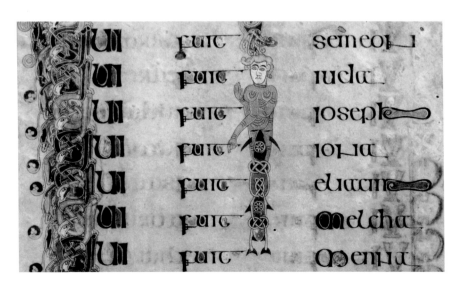

Fig. 69. Merman, line filler.
Book of Kells, Iona (?), ca. 800.
Dublin, Trinity College, MS 58,
f. 213.

Fig. 70. Initial *P* of *Philosophi*
with entangled nude female
figure and birds. Priscian,
Institutiones grammaticae,
Ireland, mid-ninth century.
St. Gall, Stiftsbibliothek, Cod.
904, p. 3.

Opposite: Fig. 71. Canon Table.
Barberini Gospels, Mercia (?),
second half eighth century.
Vatican, Biblioteca Apostolica,
MS Barberini lat. 570, f. 1.

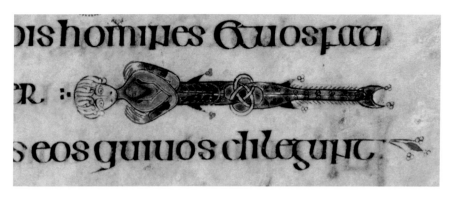

Priscian, a pagan Roman author. The letter *P* is the initial letter of *Philosophi*
("Philosophers," wrote Priscian, "define the sound of a word as follows").
The monk who wrote this text—he probably designed the initial as well—
drew a nude female figure and gigantic birds entangled in the letter *P*.

This preoccupation was not confined to the ornament of books with a
profane content. On the column of a Canon Table of a Gospel Book produced
in the south of England (Fig. 71), a gigantic male head and beasts are entangled
with each other; in the middle is a nude figure that clutches his beard with one
hand, while the other hand plays with his genitals, which are flanked by the
biting heads of two birds intertwined with his feet. This is perhaps the first
appearance of such imagery in Western art. It is in the art of
ascetic, monastic communities that we come upon the freest
projections of sadistic and masochistic fantasy and uninhib-
ited autoerotic imagery. I cannot relate it directly to the liter-
ature of the same time and place. But in the last lecture, I shall
refer to penitentials and other monastic writings that may
throw some light on this side of Insular art.

The field of script also was open to a different imagery,
more friendly and realistic, though sometimes violent, of
animals, hunters, horses, figures in secular dress, and even
contemporary monks; that is, the real world as it appeared in
isolated single figures that attracted monastic readers as well
as scribes and artists. This imagery belongs to the reader's
immediate physical environment rather than to a historic
imaginary mythical world transmitted in the sacred text. It
does not illustrate a written scripture text; it does not glorify
the word by its fanciful forms or symbolize an implicit sense
of the text. With this profane imagery, the monk who shaped
the field as scribe and artist took possession of the corners
and margins for himself. He perhaps dwelt in this imagery
for relief from the strain of producing that interminable

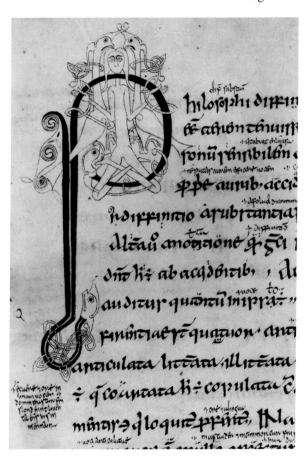

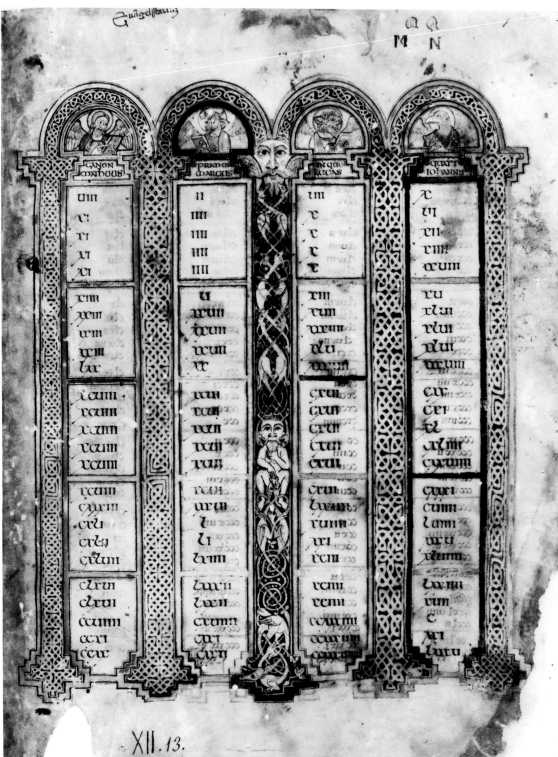

Fig. 72. Dog catching rabbit, line filler. Book of Kells, Iona (?), ca. 800. Dublin, Trinity College, MS 58, f. 48.

Fig. 73. Cock and hens, line filler. Book of Kells, Iona (?), ca. 800. Dublin, Trinity College, MS 58, f. 67.

stream of letters. I doubt, for example, that the small hunting scene with a dog catching a rabbit (Fig. 72), or the cock and two hens on another page (Fig. 73) carry any deep religious meaning, though hens and chickens were associated with ecclesiastic symbolism in the early Christian period. A more likely religious allusion, however, can be found in the cat and mice playing with the holy wafer, the Eucharist, at the lower margin of the great *Chi-Rho* page of the Book of Kells (Fig. 32), a subject to which I will return.

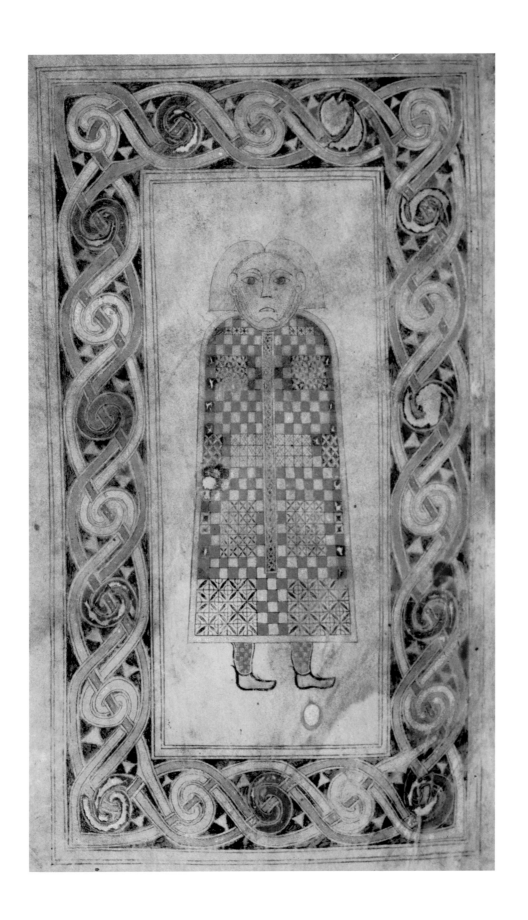

IV. MODELS AND THEIR TRANSFORMATION: SINGLE FIGURES AND MOTIFS

In this lecture and the next I will deal with the models, foreign and native, of Insular art and their transformation by indigenous artists. No attempt will be made to cover the field as a whole or to trace individual ornamental motifs and types back to their pre-Christian sources. Another aspect of ornament, however, will be discussed, one that has been less studied—what is called its grammar or syntax. Many authors refer to the "grammar of ornament," yet say little or nothing about the principles of grouping; they are concerned more with vocabulary, the inventory of smaller repeated units, the spirals, interlace, and animal motifs. Many more investigations have been devoted to the genealogy of single motifs than to the mode of composition, the systematic ordering of those elements in forming larger wholes, and their adjustment to fields of varying shape.

This lecture focuses on three works. Not only are they among the most interesting examples of Insular art, but they also permit us to see how the models—the more or less established standard types that existed toward the beginning of this art between the fifth and sixth centuries—were transformed by Insular artists in the course of work. My concern with the historical aspect is largely directed toward bringing out more sharply those features that are most individual or original in Insular art. We cannot, of course, know for certain what is original; we are not acquainted with the whole body of work produced in that period. What we call the initial state of this style is something we can only conjecture; we reconstruct it from a few remains of more

Opposite: Fig. 74. Image of the Man, Symbol of St. Matthew. Book of Durrow, Northumbria or Iona, second half of seventh century. Dublin, Trinity College, MS 57, f. 21v.

Fig. 75. Christ and subordinate figures incised on part of the east face of the stone cross at Carndonagh, County Donegal, tenth century.

recent stages. If we attempt to do this by examining the state of the art available through excavation and surviving works, we become aware of the more or less accidental character of their preservation, the rather scanty samples of the art. From old documents we know that great libraries, probably containing manuscripts with miniatures and ornament, existed in the sixth, seventh, and eighth centuries and were destroyed during the invasions as well as during the course of later catastrophes in history and through the effects of physical deterioration in time. Much that we say about this art, from the point of view of the historical process, is largely a piecing together and guessing on the basis of fragments. Since that is all we have, we must try as far as we can to discern within these remains what the starting point might have been, partly by comparison with no less fragmentary remains from other cultures and other regions during that time. Indeed a large part of the problematic side of this art is the question about its regional spread and history in the ethnic sense—which particular Insular groups produced these works—Irish, Picts, Bretons, Scots, or Anglo-Saxons. This question often remains unresolvable because we have so little information about any group, only unconnected facts of which we must speak with caution, admitting always the incompleteness of our knowledge and the provisional character of our hypotheses.

In this lecture I will compare the three works with related examples from a large region that spans practically the whole sphere of Christian civilization during the earlier centuries of the Middle Ages as well as the early Christian period. I shall first consider the similarities of form and then the question of relationships that depend on meaning and expression.

The first work (Fig. 74) is the surprising human symbol of the evangelist from the Book of Durrow, which I analyzed in the first lecture and alluded to again in the second and third. The figure confronts us as a strange work. We have nothing quite like it in earlier representations in the Mediterranean world, from which a large part of this art has come. This is an art that represents or symbolizes Christian content introduced into the north after several centuries of growth in the south. How did the northern artist come to this unusual conception of the symbol of Matthew? One can point to certain works that resemble it broadly, such as the large, central figure on a later stone cross in Carndonagh, County Donegal (Fig. 75), a work attributed to the seventh century.[18] Here the figures are incised in extremely low relief with a similar compactness of the body, feet turned in profile in the same direction, and both arms raised as a symmetrical pair in a posture of prayer. Comparing them, however, we note that the striking features of the Durrow man—the complete envelopment of the body by the robe and its carpetlike decoration—

are not to be found in the stone relief. This does not mean that a sculptor cannot achieve such qualities; there are sculptures of the early Middle Ages in which an effort was made to produce the effect of a richly tapestried robe.

Moreover the combination of the frontal posture with the repeated profile feet is a convention known already in late Hellenistic and Roman Egypt (Figs. 76, 77). There the frontal position of the head, already common in Roman and even Greek art, is associated with a characteristic profiling of the two feet in the same direction, an abrupt break with the sustained frontal aspect of the rest of the body and its symmetrical orant gesture. The character of the draperies, incised folds, and suggestions of modeling underneath make it clear that we are looking at a hybrid art in which the classical and Egyptian have been fused. Though we do not doubt that such types were transmitted to the West, we also wonder whether a naive Western artist with a vague idea of classical models could not have arrived at a similar solution independently, since frontal and profile forms and the repeated profile feet were so frequent in the preclassical art of northern Europe. That is only a guess, yet worth taking into account.

On the other hand, the costume of the Durrow man with its rich ornament, together with that rigidity and compactness of the body, reminds us of a beautiful gold male figurine in the Dumbarton Oaks Collection (Fig. 78), found in the neighborhood of Le Mans not far from Brittany, which was resettled by a Celtic people in the fourth or fifth century, well before the beginning of the Middle Ages. Ascribed to that period and associated with a pagan Celtic divinity, it may have been a votive offering to the god represented by the figure itself. The tight-fitting robe has been stamped with a tool, a punch that produced the cross units repeated on the robe with almost equal density. An axis is intimated in the continuity of at least one smooth vertical from head to hem in contrast to the horizontals below; but in other parts, adapting to the convexity of the body, there is a less regular alignment. The resemblance of the two works suggests there could have been a connection, however indirect, between the two figures, one coming from a Celtic region in France during the fourth or fifth century, the other from Northumbria or Scotland during the second half of the seventh century. Although the Roman conquerors of Britain tended to replace with Roman forms the native Celtic art that was so strong and fertile in the pre-Roman period, the latter survived in places, and as the imported Roman culture weakened with the decline of the foreign power and withdrawal of its armies, these residual elements of the older native art reemerged and artists of the sixth and seventh centuries revived certain themes that seemed to have gone underground or were preserved in the backwaters.

Fig. 76. Kollouthion and his daughter praying. Coptic grave stele from Kom Abu Billu, Egypt, between 268 and 340. Recklinghausen, Ikonen-Museum.

Fig. 77. Apa Schenute (d. 466). Limestone grave stele from Sohag, Egypt, after 466. Berlin, Staatliche Museen-Preussischer Kulturbesitz, Skulpturensammlung und Museum für Byzantinische Kunst.

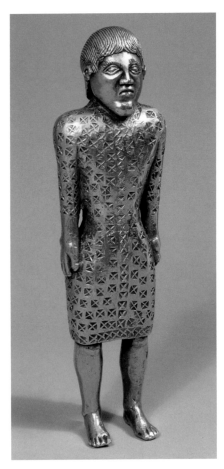

Fig. 78. Gold statuette of a man. Solid cast figure with *x* design stamped on tunic, probably originated in the region of Le Mans, where it was found, late fourth to early fifth century. Washington, D.C., Dumbarton Oaks Collection, Byzantine and Early Medieval Antiquities.

Yet if we compare these two figures more closely, we see that there is a complexity in the Christian work that is lacking in the gold statuette. The abrupt turn of the Durrow man's feet is not just a naive archaic device; as I pointed out earlier, it is a subtle factor in the complex organization of the page as a whole, with its bias toward anomalous systems or large paradoxical oppositions of frame and field, superimposed symmetries, asymmetries, and repeat structures that coincide at certain points. Further, the decoration of the figure itself follows an entirely different principle in the Durrow page. It is not a simple overall pattern, a repeated stamping of the same form as on the gold figure; the surface of the robe is partitioned and paneled by checkered subfields, larger and smaller, ornamented at each level with another type of repeated unit. If the subfields are paired symmetrically, they are, like their small units, repeats of each other.

These features are what lead us to give weight to another parallel, a figure (Fig. 79) on a small enameled plaque that was attached to one of the bronze hanging bowls of a type found in tombs in England and Ireland. These plaques show a remarkable combination of decorative motifs from older Celtic art with others that had come to England during the sixth and seventh centuries through contact with Germanic and Mediterranean arts. This example is in the museum in Bergen, and like other Insular bowls excavated in Norway was brought from England perhaps as the spoils of a Viking expedition. It has been dated around 700 but may be from the second half of the eighth century. The rendering of the mouth, the strong brow and bulge of the almond eyes, recall distinctly the head of the Durrow man. Compared to these eyes, the eyes of the gold figurine (and correspondingly the brow and lips) betray their connection with classical art.

Most striking is the treatment of the torso as a checkerboard, like the vestment plaqued onto the figure in the miniature. Of the nine square panels of ornament, the four in the corners are decorated identically with a tiny checker pattern, eight rows by eight. In contrast to this simple order, each of the four cardinal squares is filled by a bright yellow asymmetrical pattern consisting of a pair of large *L*s fitted together inversely. The arrangement of the *L*s in the left square, which we shall call AB, is repeated on the right, not reversed, not BA, as might be expected. The upper square, though not a strict repeat, also reads AB, but at the bottom we find BA, a reflection, the inverse of the other three squares. That is the principle of the unexpected reversal within a system in which a unit like the AB square is repeated frequently enough to set a pattern for the whole, which is then violated as in the BA reversal of the fourth square. On the other hand, the upper and lower squares on the torso are mirror images and therefore are related symmetrically with

respect to the horizontal axis. Thus, while the left and right squares remain constant, those at the top and bottom are reversed. Also, in this elusive system, the *L*s of the lower square pass into those of the horizontal row by a rotation of 90 degrees.

This ingenious design—bright, pronounced, and yet puzzling—is set between the strictly symmetrical head and legs of the figure. It is an order in which reflection, translation and rotation, symmetry, and two types of asymmetry are all the more anomalous and unsettling to the eye because the ornamental motifs are placed in a checkerboard field in which each square retains its shape and ornament through all the transformations.

Beyond these variations in the structure of the ornament, another appears in the scale of the decorative motifs. The tiny checkerboards in the four corners contrast emphatically with the much larger *L* shapes, and there is an intermediate scale in the filling of the central square. These features, of both structure and scale, have the authentic character of Insular conventions and are associated here with color on metal. The bronze figure bears a striking resemblance to the Durrow man from the point of view of formal structure, color, execution, and even the lack of arms. The feet, of course, are different.

On the other hand, there is in the same book a handsome carpet page (Fig. 27) in which a field of interlace is transformed by a superimposed color pattern with a different rhythm and mode of spacing that functions as a second decorative instrument; and then the whole is accompanied by a set of eight oblong panels, each with its own varied set of smaller angular units. The ornament of the upper left horizontal panel contrasts with that of the upper right, while below, that on the left repeats the upper left, and that on the right repeats the upper right. The upper horizontal panels are therefore symmetrical with the lower with respect to the horizontal axis, but differ from one another along the vertical. There is thus a reversal of the pairing when we shift from the horizontal to the vertical axis. Conversely, in the four lateral panels, the horizontal pair, which have identical ornament, are symmetrical with regard to the vertical axis, while the vertically paired plaques with dissimilar fillings differ along the horizontal. Elements of this system remind us of the symmetrical grouping of the small *X*-bearing units on the robe of the Durrow man, which form isolated panels of varying sizes that contrast in color with the red and yellow squares on the rest of the robe. These panels are distributed symmetrically on the vertical and horizontal axes from top to bottom. Thus the Durrow artist, in transforming the models for his figure of the man, applied a principle already evident in his highly original ornament. Comparison with older works has not disclosed a similar design and freedom of invention elsewhere.

Fig. 79. Bronze and enamel figure of a man. Mount from a bronze hanging bowl found in a Viking grave in Myklebostad, Norway. Ireland, seventh or eighth century. Bergen, Historisk Museum, University of Bergen.

Fig. 80. SS. Mark and Luke. Gospel Book, Armenia, 966. Baltimore, Walters Art Museum, MS 537, f. 114v.

Apart from the differences of structure, we do not feel altogether at ease with these comparisons between the gold statuette and the enameled figure because of the lacking relevance of meaning. What do these figures represent? One is a pagan idol, another is a still uninterpreted figure attached to a hanging bowl—perhaps someday we shall know more about it. But if we look elsewhere, some thousand miles to the east, we shall find a similar conception in an Armenian Gospel Book (Fig. 80), dated 966 and now preserved in the Walters Art Museum, Baltimore, but probably copied from a much older manuscript. The evangelists are represented under arches, each dressed compactly in a long enveloping robe with a silhouette that encloses the arms and book. The robes are divided into checkered, zigzag, and triangular patterns, and the feet are twisted in profile, in contrast to the frontal head and body. Was there perhaps a connection between this work and the Book of Durrow through common but earlier Syrian or Greek miniatures? Could an earlier source of the Armenian manuscript have provided an even closer model for the Durrow? It is hard to say, but still one must leave such a possibility open, while admitting that the translation of the Armenian ornament into the Insular would have required a number of syntactical adjustments before the artist could effect the particular phrasing and pattern of his intricate page. Even that is not a close enough approach, for, unlike the Armenian figures, the Durrow man is no evangelist. He is one of the four zoa of the visions of Ezekiel (1:5–14) and John (Rev. 4:6–8), creatures interpreted by the church fathers as symbols of the evangelists. We must turn to other works to see whether a closer approximation can be found elsewhere.

The conception of the symbol in Durrow as a richly robed figure is rare in Christian art. That the Gospel of Matthew speaks of the human nature and ancestry of Christ is not enough to account for this exceptional feature,

especially since Christ himself is not represented in such a robe. What is the sense of picturing man as a type, a generality, in so specific and elaborate a costume? A possible approach to an answer lies in a painting in a Sacramentary of the last years of the eighth century from the monastery of the Holy Cross at Meaux, near Paris. The four symbols of the evangelists (Figs. 81, 82) are shown there in different forms adapted to the shapes of initial letters of the texts that characterize the authors of the Gospels. Where the text beginning with *Johannes* (Fig. 82) speaks of John as having the likeness of an eagle because of his high flights, the symbol of John is represented as a standing human figure with an eagle's head and long wings folded along the body. (Note traces of ornament on John's underrobe. The winglike folds that adhere to his body may be a robe.) The calf of Luke (Fig. 82) and the lion of Mark (Fig. 81), adapted to the initials *L* for *Lucas* and *M* for *Marcus,* are

Fig. 81. Symbols of SS. Matthew and Mark. Gellone Sacramentary, Meaux (?), late eighth century. Paris, Bibliothèque nationale de France, MS lat. 12048, f. 42.

Fig. 82. Symbols of SS. Luke and John. Gellone Sacramentary, Meaux (?), late eighth century. Paris, Bibliothèque nationale de France, MS lat. 12048, f. 42v.

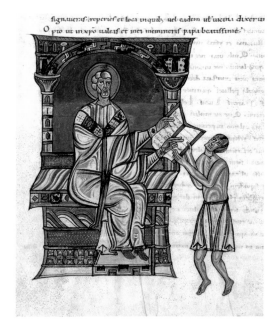

Fig. 83. St. Matthew. Matilda Gospels, San Benedetto di Polirone, Italy, end of eleventh century. New York, The Pierpont Morgan Library, MS M.492, f. 14v.

Fig. 84. St. Matthew. MacDurnan Gospels, Ireland (Armagh?), ninth century. London, Lambeth Palace Library, MS 1370, f. 4v.

smaller, partial figures with just the head and forelimbs forming part of the initial. Only Matthew (Fig. 81) is a fully human figure in accord with the adjoining text, but he constitutes the vertical of the initial *F* of *Filii*, which is completed by a bit of interlace.

What is interesting for our problem is that, besides wearing a richly decorated robe like the Durrow man, the Matthew symbol is given the crozier of a bishop, a surprising detail, since at this time there is no known text that refers to Matthew as having been a bishop. In the Gospels of Matilda of Tuscany, a manuscript from the end of the eleventh century, now in the Morgan Library, he is in fact depicted in the robes of a bishop (Fig. 83). By that time there existed a tradition that Matthew had been a bishop, but I have found no evidence of this belief during the seventh century. There is, however, a depiction in an Irish manuscript of the ninth century, the MacDurnan Gospels, in which Matthew appears with a crozier (Fig. 84). If it is true that he was regarded as a bishop at that time, his symbol could also acquire the

attributes of a bishop, namely the distinctive vestments and even a crozier. On the other hand, the symbol of Matthew is depicted in a rich costume in an Armenian painting of the twelfth or thirteenth century, a time when Armenian art had already assimilated much from Byzantium and, I suspect, also from Western art. When, for example, an Armenian artist represented Christ on the cross with three instead of four nails, we can be sure he had seen Gothic work. But there is other evidence of that kind. In an Armenian Gospel manuscript of 1230 in the Mekhitarian monastery of San Lazzaro, Venice (Fig. 85), the symbol of Matthew is a half figure of an angel holding a globe and scepter and clothed in an imperial purple robe, with broad, jeweled decoration. The conception of the symbolic man as an angel follows from the description of the four zoa in the Apocalypse as winged creatures. But the man in this Armenian work is an extraordinary angel; he has the panoply of a court figure, like the angels Gabriel and Michael who accompany the Majesty of God in heaven. This example would seem to attest to a pictorial tradition in which the symbol of Matthew wears a rich robe and other marks of his primacy. It is, however, a rather late work, and it would be difficult to connect it, even indirectly, with Irish or Anglo-Saxon art of the seventh century. Yet it might well go back to the sixth century, when archangels were first pictured with scepters in imperial costume and associated with God as ruler of heaven, represented with the attributes of a Byzantine monarch.

Earlier evidence, closer in time and place to the Book of Durrow, appears in a manuscript of the Apocalypse in the Morgan Library, copied about 940–45 from a work of the end of the eighth century (Fig. 86). The commentary of Beatus that accompanies the text is based, like the illustrations, on much older models. The symbols placed above Christ and the evangelists are of an archaic type; they do not carry books and have no wings. Only the symbol of Matthew has a halo and holds a scepter. By the end of the eighth century, the pictorial tradition of the symbol of Matthew as an august figure with a courtly robe and scepter had existed in the West, particularly in Spain, a region with which Ireland and England had many connections in the seventh century and perhaps earlier. The presence in Ireland and England of books by an important Spanish author, Isidore of Seville, during that

Fig. 85. Symbol of St. Matthew. Opening of the Gospel of St. Matthew, Armenian Gospels from Theodosiopolis (Erzerum), 1230. Venice, Mekhitarian Library of the Monastery of San Lazzaro, MS 325, f. 1.

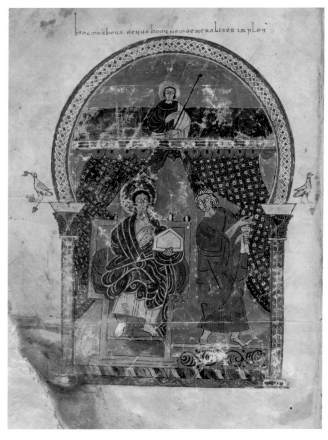

Fig. 86. Christ with St. Matthew and his symbol, the Man, in the arch above, painted by Maius. Beatus of Liébana, *Commentary on the Apocalypse*, Tábara, Spain, ca. 940–45. New York, The Pierpont Morgan Library, MS M.644, f. IV.

Fig. 87. Lion. Detail of a fragment of silk and gold textile, Baghdad (?), tenth century. New York, Cooper-Hewitt, National Design Museum.

period is well attested. So it is possible that in this peculiar, seemingly native, conception of the symbol of Matthew in the Book of Durrow there is preserved, in however vestigial or reduced a form, an old tradition of his distinctive attributes as an angelic figure.

We now turn to our second work, another page in the Book of Durrow, and raise similar historical questions about another symbol of an evangelist—the lion that is ordinarily identified with Mark (Fig. 1). I have already said enough about this work to make it familiar in detail. I call attention again to that curious arabesque or calligraphic form: the yellow band that marks the edges of the thighs, haunch, and belly and is not explainable simply by reference to the underlying anatomical structure. It belongs to the history of ornament more than to nature and reminds us of a corresponding treatment of the same parts of animals in ancient art. The next example (Fig. 87) is not an ancient work but a medieval one from a collection nearer home. It is a small silk and gold fragment at the Cooper-Hewitt, National Design Museum, one of the most important collections of old textile art in America. On this tenth-century fabric, attributed to Baghdad, the haunches and thighs of the animal have been marked by a band of different color with a vaguely foliate character as well as a spiral tendency. The legs have been decomposed into segments with a strong horizontal accent through the repetition of the same elements. Also the tail raised over the body makes us think of the lion in Durrow. I do not mean to say that the artist of the Book of Durrow copied an Eastern textile; I show this work rather as an example of a persistent tradition of design, of representation, which can be traced far back to the ancient Near East and appears in works of the Achaemenid period in Persian metalwork. In an armlet inlaid with enamel and precious stones from the Oxus Treasure in the British Museum (Fig. 88), for example, there are haunches, joints, and edges marked by channels, hollowed out and filled with colored matter, such as jewels or enamel. The artist created a secondary vegetable pattern on the animal body or shaped an independent cellular band along the contour of a figure.

That practice of Middle Eastern art, especially Persian, became known to the West during the fifth and fourth centuries B.C. The old Celtic tribes, during the period in which they occupied large parts of central Europe and traveled eastward, came into contact with the Scythians and Sarmatians, peoples who had absorbed much of Iranian art. The Celts crossed to Asia Minor and even invaded Egypt. That eastward and westward expansion of the Celts left its traces in the names Gaul, Galatia, Galicia, and Galatsi in France, Spain, Asia Minor, and Romania. Magnificent metal objects of bronze, gold, and silver, on which the occasional animal forms display this taste for marking the joints—the haunches and thighs of figures—and for tracing thick contour lines in spiral-formed cells, were produced during that period of migration. That mode of articulation, with a strong light-dark accent and an arabesque that enlivens the figure, may be connected with a primitive interest in the joints and other parts of the body. An English philologist, Onians, in a remarkable book, has studied the words for the different limbs and muscles and other organs in various languages and shown their connection with ancient spiritualistic ideas, an imaginative physiology based on expressive analogies of the movements of parts, their supposed vital functions, and their role in feeling.[19] In the images of animals we notice the frequent spirals and their accentuation by thick, strong contour lines with abrupt turns from the concave to the convex and from a pointed to a rounded form. Consider the spirals marking the joints of the beasts that form the handle and crown the lid of the flagon that was excavated in Lorraine in Basse-Yutz and attributed to the early fourth century B.C. (Fig. 89). Could it have survived for a thousand years to become a transmitter of the style? Or was the style transmitted by intermediaries? We have only a few sparse remains, no really decisive evidence. Yet when we turn to the newly revived, reemerging native British-Celtic styles, particularly in the south and east of England during the fifth, sixth, and beginning of the seventh centuries, at the moment of Christianization and just before it, we discover many images of animals with such accentuations of the larger joints of the body, especially the haunch and thigh, often with a spiral band and a marking of the contour by a double line.

An Insular example is the hanging bowl found in Lullingstone, southern England, now in the British Museum (Fig. 90). Compared to the older flagon and the ancient Near Eastern works, the British work appears rather clumsy in the use of those forms. It is assimilated to an ornament of repeated bars and stripes so that the distinctive curved lines and weighting of the particular parts are not as expressive as in the earlier works we have seen. They lack altogether the intensity and decorative finesse of the lion in the Book of Durrow. We must look elsewhere for native parallels or imagine that there

Fig. 88. Armlet inlaid with enamel and precious stones. Persia, Achaemenid period (533–330 B.C.). London, British Museum, Oxus Treasure.

Fig. 89. Celtic bronze wine flagon with duck on spout and animals on lid and handle. From Basse-Yutz, Lorraine, France, ca. 400 B.C. London, British Museum.

existed in the British Isles stronger works that have escaped our attention or are still underground.

On the eastern coast of Scotland, however, beyond Northumbria, there were discovered a series of stone slabs that were reused in fortifications of the harbor at Burghead, with incised images of animals of a most powerful and sure line (Fig. 91). It is hard to imagine how one came to draw on stone in that way. The artist was not a sculptor in the familiar sense of one who shapes bosses and hollows and brings out the fullness of volume of a figure, whether in the round or in relief. He traced the figure of a bull, deer, dog, and other creatures in decided rhythmic lines on the surface of the stone with just that patterning along the lower limbs and the haunches that calls to mind the lion and calf in the Book of Durrow. The artist of the Burghead stones clearly belonged to the same school of design as the Durrow master and must have known works of similar character to those used as models by the painter of the Book of Durrow. These stones, however, are of unknown date and origin; they are archaeological mysteries. They have been attributed to the Pictish people, who have long been an enigma to students of ethnology and history and are now believed to have spoken a Celtic language. Whether they were of the same group that came from the Continent with other Celtic tribes or an older native people who were conquered and adopted their conqueror's language is uncertain. Still these works are generally placed in the seventh century, though quite vaguely—some scholars say toward 700, others, the middle of the seventh century, and others, even later than 700, so that the precise relationship to the Book of Durrow is not certain.

But whatever their date, they help us to locate the Book of Durrow geographically. The decoration of the manuscript has its closest mates in works from southeastern Scotland. In Ireland the rendering of such forms along the body is much more simplified and employs a more pronounced spiral; it does not build up a continuous arabesque on the surface of the body, competing with the silhouette or contour of the figure. This feature is among the strongest evidence for placing the Book of Durrow as well as the Book of Echternach in a Scottish-Northumbrian milieu. It would not surprise me if

Fig. 90. Bronze hanging bowl with appliquéd stags, spiral escutcheons, and interlace plaques. From Lullingstone, Kent, seventh century. London, British Museum.

Fig. 91. Bull. Pictish incised slab from Burghead, Moray, probably first half of seventh century. London, British Museum.

there were other manuscripts like the Book of Durrow and that the artist who incised the figures in stone knew the manuscripts, rather than vice versa. But as long as we are uncertain about the relationship in time, the assumed priority of the painter remains a speculation.

Our third work, the most fascinating of all, is the image of the man in the Echternach Gospels (Fig. 35). Here the historical problem is more difficult. Not only do we wonder at the meaning of the figure, who unlike the other symbols of the evangelists in this manuscript is enthroned and holds a book in an ostensive gesture; the form itself is enigmatic. In this unique conception the body looks dismembered, so to speak, decomposed into a series of separate disjointed parts on three levels. All belong to a family of rounded, elongated forms and are characterized, among other things, by a pattern of kernel and shell. Each member has an inside as well as outside. Distinctive, too, is the beauty of color, with rose and purple enclosing yellow in the bottom zone and the reversal of this arrangement in the middle zone where yellow frames rose and purple kernels and then the recombination in the upper part. It is this transformation of the natural form that we wish to understand, not by finding another work with just this transformation, which would make our page less surprising, but rather something different that might have been its starting point and might give us a measure of the artist's energy of invention in adapting a suggestive model.

Let us consider as a first step a later work that bafflingly resembles our figure but, I believe, has nothing to do with it. It is a roundel, a tapestry inwoven with silk and gold in the Cleveland Museum, from the late eleventh century (Fig. 92). A Fatimid piece, probably made in Egypt, it pictures a king sitting crouched in the Muslim fashion and holding two objects in his hands. His legs have been treated as a bull's-eye pattern, pointed and slightly almond shaped, with a visible core and even a tiny seed; around each is a shell. Above is a lozenge, quite like the form in the Echternach drawing, though more rigid in effect than the latter's finely concave one with its enclosed ornament; above are symmetrical elements, transformed segments of the shapes below. The lozenge is repeated above, and the striped units of the arms and shoulders may be seen as counterparts of the forms of the legs.

I cannot present in detail here the reasons for my belief that these two works are unrelated and the resemblance is what ethnologists call a convergence. Through older Muslim works representing the same type of figure in a more naturalistic way, one can trace the steps by which, in a process of reduction, of reorganization into a more compact ornament, and of searching for pronounced color contrasts, there emerged the form in that roundel. I do not mean that I have explained it psychologically; I have simply put

Fig. 92. Enthroned king holding two objects. Silk, gold, and linen textile fragment, Egypt, late eleventh century. Cleveland Museum of Art. John L. Severance Fund, 1950.541

Fig. 93. Visigothic bronze belt buckle, reproduced vertically. Spain, (Province of Burgos?), seventh century. Vich, Museo Episcopal.

together a series of similar works from the same tradition or school of art, in which the pattern of the Cleveland figure appears as a likely outcome of certain artistic operations on a particular type of figure common in that school, independent of the tradition and series in which the Echternach figure arose. There is between the two works a great difference of time as well as space; but that is not decisive, since we know how often works from the beginning of our era were preserved and copied in the Middle Ages and one could therefore suppose that the Muslim and the Insular work had a common ancestor in early Christian art of the Near East.

We should not be surprised at the resemblance between these two works. There are illuminating parallels in language. While those who enjoy the game of etymology have in the past assumed that resemblance is a sure key to the ancestry of a word, linguists have shown that in different languages two words that sound alike may be independent of each other. A true etymology must be in accord with the rules governing sound combinations in the language and the historical processes of their change, a requirement often overlooked in etymological speculations. To give some examples: *feu* in French and *Feuer* in German are unrelated; they have different origins; one is not descended from the other nor both from a common ancestor. *Gros,* the word for "big" in French and *gross* in German are unrelated genetically. In Persian the word *bad* means "bad"; it has nothing to do with the English *bad.* They have different lines of origin. We must accept in principle that similarities, even striking enough to appear as identities, may occur without a genetic connection between the two forms that resemble each other.

In the case of the two images, however, we are more tempted to look for a connection because the resemblance is not a matter of a single word, whether of one or two syllables; it is a quite complex form. We are also struck by the fact that the Muslim figure is set in a medallion from which rays issue to a larger medallion, with a clamping, enclosing effect that resembles broadly the fixation of the figure in the rectangular field of the Echternach miniature.

Otto Karl Werckmeister called attention to a Visigothic-Spanish bronze belt buckle (Fig. 93) in which the successive parts seem to match those of the man in the Echternach Gospels.[20] It is a most surprising resemblance and one must congratulate Werckmeister on his acuteness in discovering in an ignored buckle a pattern of elements that recalls so strikingly the visual aspect of the human figure. I believe, however, that this resemblance will appear less significant if we view the object as a buckle. A buckle is not vertical as in Werckmeister's illustration. When we turn it horizontally (Fig. 94) as it appeared on an actual belt, the resemblance to the Insular work is less

Fig. 94. Buckle in Fig. 93
reproduced as it would
appear attached to a belt.

decided and even seems accidental, although a similarity remains. By inverting the buckle, he changed its original character, in order to bring out the resemblance. Of course one can say that an artist, in making such a buckle, saw it from different points of view, turned it about, and enjoyed the pattern in its various aspects. Still this seventh-century work is interesting for our problem in calling attention to the fact that with themes other than the human figure there are types of design in which an articulated whole is subdivided in a quasi-organic manner according to the functions of the parts, each part acquiring a different ornament that is integrated with the rest through symmetries, repetitions, analogies, and transformations of a common element. Are there not perhaps works still closer to the form of the Echternach man among other objects—brooches, buckles, and fibulae—in which the design of a rigid whole includes a partitioning of a surface and development of a theme in a manner that might have suggested to an artist that strange pattern of the man? Of course, there remains the question why an artist should take as a model for the human form something so far from the human, though not altogether remote since buckles and brooches are, one may say, human harness, and pertain to the body.

In Spain, where that buckle was found, there also appear in the so-called Mozarabic art of the tenth century occasional figures with analogies to details of the Echternach man. It is an art of great splendor of color, with a beautiful assembly of small cell-like units as spots of color in the figures. The Bible of 960, preserved in the church of San Isidoro of León and copied from a work that probably precedes the year 800, contains a miniature showing the high priest Aaron in the tabernacle (Fig. 95). The drapery on his thigh has been treated like a plant form, a palmette, with a slightly turned end, similar to those on Eastern fabrics. The part at the waist and middle of the body has a reversed curvature, and another such curve appears between the shoulders and arms. There, too, the artist functionally decomposed the continuous form of the body or garment into closed units; each is a curved form, but

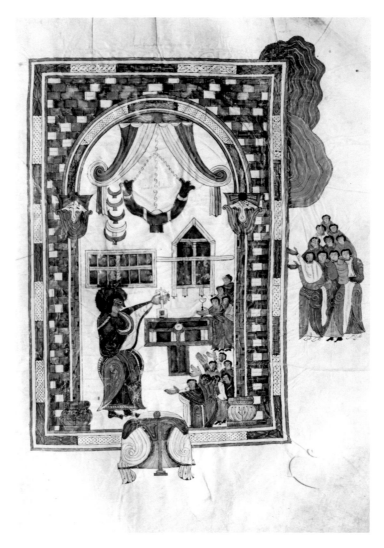

Fig. 95. Aaron Sacrificing in the Tabernacle. Bible of 960, Valeranica, finished in 960. León, San Isidoro, Cod. 2, f. 50.

Fig. 96. Christ in a mandorla supported by angels. Ivory plaque, Continental or Insular, late eighth or early ninth century. Munich, Bavarian National Museum.

with reversals and shifts from concave to convex and from vertical to diagonal, accompanied by changes in color as well. There is also the suggestion of a kernel motif in the outlining of the decorative form of the figure. A prevailing system of vegetative ornament, particularly of textiles, has supplied the pattern for the construction of a clothed body.

An ivory carving of the late eighth or early ninth century in Munich (Fig. 96), however, offers a better analogy to the Echternach figure than the works I have just cited. The division of the seated Christ's costume into distinct, symmetrically paired parts, most of all, the lozenge in the center of the body, gives us an idea of a possible late classical work that might have served as the artist's point of departure in his radical decomposition of the human form into that pattern of ornamental shapes.

If we look for a model closer to the region of the Insular artist, we shall discover in northern England during the late Roman period representations of figures with a religious subject in which the classical Mediterranean vest-

ment of the body has been recast in a pattern approaching that of the Echternach man, a pattern perhaps influenced by a native style of ornament in metal or fabrics. An example is a relief from Bewcastle in the museum at Carlisle in northwestern England, not far from the Scottish border, that represents an earth or mother goddess of the Roman-Celtic cults of the region (Fig. 97). I call your attention to the big sleeves forming symmetrical podlike units; to the hollowing out of the drapery across the lap and knees in concavities, bordered by convexities; to the striking lozenge in the center of the body framed by the arms and legs; and to the wavy hemline at the feet. The figure holds fruit as an emblem of her role as an earth goddess. A rather surprising sculpture in the Roman-Celtic context, the relief was presumably executed by a Roman Briton. Though it owes so much to Roman art, it has a distinctive style; the sculptor transformed the foreign model in terms of the sensibility and ornamental practice of an older native art.

Could the artist of the Echternach figure have seen this work or works like it? It is impossible to say. We know, however, that in the seventh century a Northumbrian king visited Carlisle, a town southwest of Bewcastle where the sculpture was found. According to a report, he admired the Roman remains, the beautiful streets, buildings, and objects of art.[21] As late as the seventh century, Carlisle was one of the great sights of Anglo-Saxon England.

I have said that the similarities to the ornament of buckles lead us to look further at such small objects in the Roman-British sphere. I have remarked, too, that, although Roman culture displaced the Celtic, native artists maintained certain themes of the older art and in several places, under special conditions, during the fourth and fifth centuries, even revived those indigenous forms with more vigor and helped to initiate the movement of art that preceded the Insular style. On a small bronze plaque, inlaid with enamel, which was found in the Thames near London (Figs. 98, 99), the artist combined classical and Celtic features. The ornament of the middle field is flanked by spiral fluted columns and bases; note in particular the pediment and above it the confronted griffins with a vase. These are classical motifs familiar in Roman provincial art. But the spirals and double curves filling the middle field and the upper zone, though ultimately derived from Greek art, are not characteristic Roman forms; we know these motifs, however, in Celtic art in Britain before the Roman occupation, for example, in the enameled plaque from Polden Hills in the British Museum (Fig. 100). On the Thames plaque, the voluted forms are not only superposed, they are nested in and seem to grow out of one another. Also suggestive of the Echternach man are the concave lozenges immediately above and below the four-petaled "flower" at the center of the pelta design as well as the fine spiral ends of the

Fig. 97. Mother goddess. Romano-British stone relief found at Bewcastle (formerly ascribed to Netherby), Cumberland, late second or third century. Carlisle, Tullie House Museum.

Fig. 98. Small bronze enameled plaque shaped like an altar with pelta designs, confronted griffins (top), and lions (bottom). Romano-British plaque found in the Thames River near London, fourth century. London, British Museum.

Fig. 99. Drawing of the pelta design on the Thames plaque in Fig. 98. From T. D. Kendrick, *Anglo-Saxon Art to A.D. 900*, London, 1938, p. 56, fig. 10.

Fig. 100. Bronze enamel horse brooch with pelta decoration. Found with harness mounts, Polden Hills, Somerset, mid-first century. London, British Museum.

pelta forms. The composition of the ornament on the plaque is not the same as that of the Echternach figure, but the kinship of elements in the two works is evident.

It is also worth noting that during the pre-Christian period, in the Celtic regions of the Continent, especially the Rhineland, which had a large Celtic population, stone monuments were erected in which the human head was associated with geometrical forms that were applied arbitrarily above and around it and even on the face. These works lead us to suppose that in later Celtic tradition an artist would be ready to translate the forms of the body and costume into motifs of ornament suggestive of foliage and vegetation. Among those works are the famous pillar from Pfalzfeld in the Rhineland and a fragmentary stone head from the same region (Figs. 101, 102). The head on the pillar, like the freestanding stone head, has palmette segments carved on the forehead, eyes like berries, and a nose like a supporting stalk. Both heads are also crowned by what looks like enveloping hair, which takes the form of symmetrically paired convex almond shapes, a pattern reminiscent of the segments that form the body of the Echternach figure. The almond shapes containing concave kernels on the stone head are especially close. The head on the pillar is further surrounded by paired and reversed *S* forms.

Finally, turning to Anglo-Saxon metalwork and jewelry, there are the beautiful gold and garnet bosses from a scabbard excavated in 1939 at Sutton Hoo (Fig. 103), a stupendous find in East Anglia of a treasure buried with a boat as a memorial to a chieftain in the seventh century. For our problem I point not only to the central motif of the concave lozenge and its filling but especially to the color. A similar taste in color appears in the Echternach pages, different from that of the other great Insular manuscripts, including the Books of Kells, Lindisfarne, and Durrow. It is characterized by the choice of gold and yellow, rose and purple. These are the colors of the finest jewelry in the Sutton Hoo treasure. I am inclined to ask whether one of the aesthetic factors in forming the Echternach artist's style was his experience and training in the native metal crafts; his color is

Fig. 101. Celtic grave pillar with head of a god (?) and pelta decoration. One of four faces of a carved, red sandstone pillar from Pfalzfeld, Germany, late fifth or early fourth century B.C. Bonn, Rheinisches Landesmuseum.

Fig. 102. Fragment of a Celtic stone head of a god (?). Germany, late fifth or early fourth century B.C. Karlsruhe, Badisches Museum.

not that of Mediterranean figurative art but points to models in gold and jewelry.

I have spoken of a strong disposition in the native pre-Christian arts as well as in the art of the barbarian invaders to decompose the human figure and reassemble its parts in a decorative succession of related forms of a family type, with variation from zone to zone, axis to axis. An instructive instance of that radical play with the human body from the period just before the Echternach man is a small buckle found in Switzerland, now in the museum of Zurich (Fig. 104). The figure between the lions, unlike the usual schematic reductions of the older recognizable Daniel on buckles of this type, has been complicated by a knot-work pattern. It resembles the knotting of the sleeves and hands of the Echternach man (Fig. 35) but inverted, and, like the segments of the Echternach figure, emphasizes the relationship between the core and outer layer. Moreover in the figure—and this is a more or less poetic analogy for which we have no means of judging its relevance and weight for interpretation—the figure of Daniel, who is threatened by the terrible creatures and counts on the Lord's intervention as in the prayers of the early Christian period, is clamped by the beasts. He is caught between them and held firmly, yet he looks secure in the stable axes and the compactness of his simple form. There is an interesting passage from the rectangle with the eight dots crowning the figure through the oval of the head to the single dots of the eyes and the serrated teeth, an imaginative recasting of those parts. From that egg shape and cube over his head, we pass to a twisting of the whole body. It is as if the anguish of Daniel, his terror before

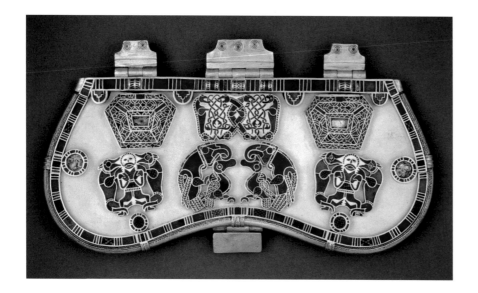

Fig. 105. Purse lid. Gold border inlaid with garnets and cloisonné plaques filled with garnets and millefiori glass. Sutton Hoo, Mound 1 ship burial, seventh century. London, British Museum, Sutton Hoo Treasure.

the beasts, the effort to contain himself, and the tension of such feelings have been expressed through the bit of ornament that makes up the body but resembles no familiar bodily organ. It is a felt visceral form, so to speak, and not the anatomical or external body. The animals, too, are pictured through a process of segmentation and recomposition typical of animals' bodies in Germanic ornament as distinguished from narrative representation. This process has been admirably investigated by Scandinavian scholars, particularly Bernhard Salin, in a book on old Germanic animal ornament.[22] Similar renderings of beast and bird heads appear in works from Sutton Hoo, which make it clear that there was a transmission of styles across the North Sea and the English Channel. An example is a purse lid excavated in Sutton Hoo, a work in gold inlaid with cloisonné plaques filled with garnets and millefiori glass (Fig. 105). The little human figure between paired animals is still nearer to the anatomical body as a whole; but if you turn to the beasts and their heads, especially those of the birds grasping the smaller birds in the middle, you will note a relationship in the convention for dividing the head into small parts, rearranging them, and building a sequence of forms with constantly shifting axes and varying frequencies of the small elements.

So far I have discussed the formal similarities without commenting on the meaning of the figure, the bearing of this conception of the form on the idea of the *Imago hominis* (Fig. 35). I shall conclude with a reference to several works that relate to it. The figure with an open book held ostensively, as in a ritual, is known in Hellenistic art and especially in the mystery religions. In the cult of Isis, for example, the priest holds a book in front of him as he reads and displays it so that the initiates may see the mysterious letters. The second-century author Apuleius, in his novel *The Golden Ass,* speaks of the

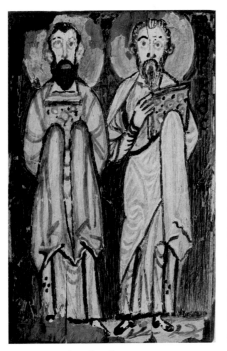

Fig. 106. SS. Luke and Mark. Painted wooden cover of the Codex Washingtonianus (Greek Gospels, late fourth to early fifth century), Egypt, seventh century. Washington, D.C., Smithsonian Institution, Freer Gallery of Art. Gift of Charles Lang Freer, F1906.298

ceremony of the cult of Isis and the strange, unfamiliar letters in the book read by the priest that look like images of figures or animals (a reference to hieroglyphs).[23]

In Christian art this ceremonious posture and display of the sacred book is addressed to the viewer, as in a solemn ritualized reading. That practice underlies the conception of the evangelist Luke on a book cover in the Freer collection in Washington, now in the Smithsonian Institution; it is a Coptic Egyptian work of about the seventh century (Fig. 106). Mark is an evangelist, however, while the Insular figure is the symbol of the evangelist who is rarely, if ever, represented holding a book in that manner. Since the symbol might have been inspired by an image of the evangelist, we may look among images of the symbols of the evangelists for a corresponding type. There is, moreover, a significant difference in the gesture: the evangelist on the book cover holds the sacred book in veiled hands, and the drapery hangs in symmetrical folds, like pillars. A somewhat different sense of the ceremonious is expressed here, an active ritual posture; it is more impersonal in that respect than the *Imago hominis*.

There are other examples of the symbol of the evangelist who holds a book in that way. Here we turn again to Armenian art. In a gospel book, dated 1193, in the library of the Mekhitarian monastery of San Lazzaro in Venice, the four symbols appear in two successive frames of the canon tables between the capitals of the outer columns and the great arches above (fols. 5v, 6). In the first frame, the little figure of Matthew's symbol on top of the left column on fol. 5v (Fig. 107) holds his book up with both hands although they are not veiled. Also, unlike the Echternach man, he is shown with wings. Though the Armenian figure is not a complete body, it still provides sufficient evidence that there existed in the Near East the type of evangelist symbol holding the book ostensively in a rigid posture, enclosed by architecture above and below, a type that might go back to a work of the sixth or seventh century or perhaps even earlier. From that source in the East the Insular artist could have borrowed a model and recast it to accord with his style and sensibility in this remarkable interchange of vegetative and geometrical forms.

We do not have to depend on the distant Armenian miniature for an explanation, however. There is a Western work of the ninth century in which a figure is represented holding a book in just that way, and in other details it is even closer to the Echternach man than anything discussed until now (Figs. 108, 109). The figure appears on the tomb of the patron saint in the Romanesque church of Bourg-Saint-Andéol in the Ardèche in southeastern France. Originally a Roman sarcophagus, the uncarved rear side of the tomb was reused during the ninth century for sculpturing the figures of SS.

Benignus and Polycarp flanking a central inscription honoring St. Andéol. These carvings might be taken for Romanesque works, and if it were not for the ninth-century script of the text, the type of interlace in the panel above the inscription, and the Merovingian frieze of confronted animals below (not shown in the photograph), it would be difficult to decide whether the figures were of the Carolingian period or later. It is known that in the ninth century, the body of St. Andéol was moved to this church and his relics were placed in a sarcophagus. We have at least a historical document connecting the reliefs with that early date. What is important for us is the conception of

Fig. 108. Back of a marble sarcophagus with figures of SS. Benignus and Polycarp flanking an inscription honoring St. Andéol. Reused Roman sarcophagus, Provence, late eighth or early ninth century. Bourg-Saint-Andéol, Church of St. Vincent.

Fig. 109. St. Benignus. Detail of sarcophagus from Bourg-Saint-Andéol, Church of St. Vincent.

the costume in the sculpture of St. Benignus (Fig. 109). The figure does not wear a classical robe but a kind of dalmatic or paenula open at the neck and with big sleeves that hang from the arms. The hands are very small, among the tiniest we know in early medieval art. The way of holding the book accentuates it and gives prominence to the pattern of the sleeves, which is repeated in the folds above leading to the shoulders and the head, just as the open collar is like the pattern of the book. That sleeve pattern enables us to understand the conception of the middle zone in the *Imago hominis* (Fig. 35), otherwise so puzzling. The painter, one may suppose, had before him a model in which the hand holding the book was set in a large-sleeved robe; the hanging sleeve, exposing its inside as well as outside, suggested that intermediate form, which afterwards, in later versions in the Books of Chad and Dimma, was either radically redesigned (Chad; Fig. 110) or omitted altogether (Dimma; Fig. 111). The Echternach man is closer to the presumed early model of the sixth or seventh century, in which the figure holds a book but wears a robe with long, hanging sleeves. Instead of treating the sleeves in a naturalistic way, in order to give greater strength to his gesture of displaying the book, the artist isolated them and made them an independent motif. He thereby created a bridge to the curved forms of the legs and in so doing rediscovered the form conceived in the relief from Bewcastle long before (Fig. 97).

I should perhaps say a few words about the expressive sense of the Echternach man. I fear I have talked about the figure in too anatomical a way,

Fig. 110. St. Luke. Book of St. Chad, Northumbria (?), eighth century. Lichfield, Cathedral Treasury, s.n., p. 218.

treating the design as if it were almost a mechanical result. What is the bearing of this form on the expression of the whole, on the quality of the figure, which is labeled by the artist as the "Image of man"? Clearly the rigidity of the posture and conversion of the body into this vaguely plant ornament and the resemblances to an older decorative style are aspects of a whole with a most intense expression, concentrated particularly in the eyes. These are not simply impassive, schematic, neutral features that take their place with the

Fig. 111. St. Mark. Book of
Dimma (Gospel Book), Ire-
land, second half of eighth cen-
tury. Dublin, Trinity College,
MS 59, p. 30.

rest of the drawn forms as ornaments; the eyes are brought close together,
indeed so close that it is a strain for us to fix our glance on the face. We tend
to introject in ourselves the posture and tensions as well as the opposed
swelling of the parts. Such treatment of the eyes is unique in Insular repre-
sentation. The artist wished to realize a particular expression of spirituality, a
marked effect of inwardness and concentrated reflection of the devout atten-
tiveness of an inspired religious figure. The features, as I said, are not simply
a schematic reduction of a realistic rendering of a head or the eyes.

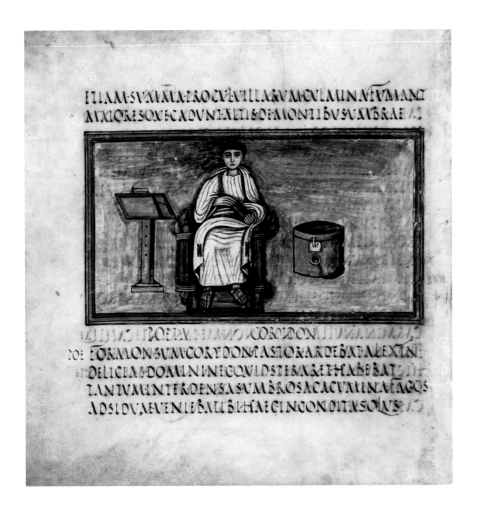

Fig. 112. Portrait of Virgil. Codex Romanus (the Roman Virgil), Rome (?), later fifth century. Vatican, Biblioteca Apostolica, MS lat. 3867, f. 3v.

In a comparable late classical portrait of Virgil (from the Vatican's Codex Romanus), in which the subject also seems compressed by the frame (Fig. 112), the face has a relaxed tranquil character; the features are drawn and distributed in a normal, stable manner, with some delicacy; the head has a lovely oval shape, and we observe, too, a rhythmical continuity of the drapery folds around the middle of the body in contrast to the symmetry of the head and feet. This figure has nothing of the Echternach man's tenseness or suggestion of inwardness. The difference is all the more significant, since we do not think of Insular art as expressive through mimetic physiognomic detail or gesture but rather through the play of lines in a quasi-musical sense through enclosing frames. That musical quality of the figure suggests to me that behind this work, as a ground of the expression, there was a deep empathy on the part of the artist, an experience of the ascetic stance of Insular monasticism, with its great missionary zeal, its love of the wilderness, solitary travel, and existence, and its fearfully strict discipline. We read of horrifying mortification of the individual in the rigorous rules of monasteries, accompanied by savage penitential punishment, even self-mutilation, which it is

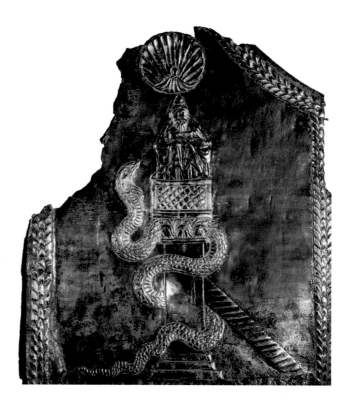

Fig. 113. St. Simeon Stylites on his column besieged by a serpent. Chased silver votive plaque with traces of gilding, Syria, sixth century. Paris, Louvre.

hard to believe existed in a Christian community. That rigor of religious life was not confined to the Insular sphere; it also appeared in the late Roman world and in the monasticism of the Continent. But it was most intense in the British Isles, where the early penitentials prescribed severe penalties, even torture, for slight infractions. Besides, there was the self-imposed, solitary, ascetic way of life that called for extreme constraints, a contraction of the self to a single axis of religious existence in opposition to the material world—the physical, the bodily, the practical as such.

In this context the image of the man in the Echternach Gospels appears as a forerunner of those attenuated column figures on the Romanesque portals that are sometimes clamped between a capital and a base and become immobile, inorganic verticalized forms. We can judge their character by comparison with the caryatid statues of the Greek temples. In the latter one leg is always flexed, and the convexity of the body is brought out in its fullness; the contrast of the stable and the mobile as potential states of the body is realized through contrasted qualities of the modeling and the play of lines in different parts. In the case of the Echternach man, the rigidity is not just of the style of modeling but a self-sought ideal quality of the represented human being.

One can understand it better through another image of an ascetic, made in Syria from a different artistic point of view, a century or more earlier

(Fig. 113). It is a silver plaque, now in the Louvre, depicting Simeon Stylites, the saint who lived in solitude on a high column for a decade or more. His food was hoisted up to him, and a covering protected him from the rain and sun. But accounts of stylite saints tell us of some who would not accept even that degree of protection. Gregory of Tours, in his *History of the Franks,* tells of such a man, a Lombard living in eastern France who endured incredible self-torment in order to mortify himself and persuade others to give up idolatry and lead a true Christian life.[24]

The Louvre figure of St. Simeon is set on a tall column and, like the Echternach man, displays a book. An immense serpent coils around the base of the column, as if interlaced with it, a reminder perhaps of the serpent in the standard images of Paradise that rises to address Eve. It reaches up to Simeon, tempting and threatening him but not availing against the saint. Simeon is set between the shell, which one may regard here, as in classical art, as a female symbol, and the great vertical column he surmounts. It is a living reality of ascetic life, an evocation of an evil surmounted by his solitude, a rigorous expression of a lived ascetic outlook, which in the Echternach man is projected through more refined, imaginative, and arbitrary artistic inventions, without allusion to a particular person or event.

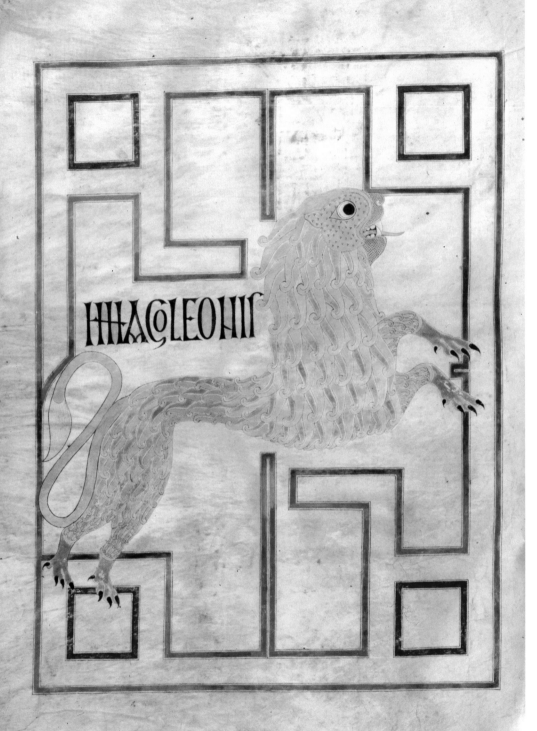

V. MODELS AND THEIR TRANSFORMATION: COMPOSITION AND FIELD AND FRAME

In the last lecture I showed a series of works from outside the Insular sphere for comparison with single figures as well as motifs of ornament as a way of approaching the process of assimilating and transforming foreign models. Where we observed a close relation to these models in the type of theme and in singularities of form, we also noticed a decided, sometimes radical, change in the aspect of the work as a whole, a change not only in the drawing of the units but also in their relation to the setting of the frame.

Now I shall speak of the corresponding process less with respect to single figures or motifs than with respect to the composition, that is, modes of grouping and contact of parts with each other. The approach may be translated into linguistic terms by saying that previously we studied the history, or etymology, and shapes of simple elements where the difference between the prior and later form is often startling, although we know of intermediate forms that support our idea that one motif is descended from the other. But now we are comparing syntactical forms—the principles of grouping, their phrasing and assembly into a large ordered whole. It is a relationship that is not easy to grasp. In spite of all that has been said by psychologists about the tendency of perception to grasp the visual field in terms of wholes, we do have an inveterate habit of isolating small elements and are often attracted by

Opposite: Fig. 114. Image of the Lion, symbol of St. Mark. Echternach Gospels, Northumbria or Echternach, late seventh or early eighth century. Paris, Bibliothèque nationale de France, MS lat. 9389, f. 75v.

Fig. 115. Three augusti enthroned: Constantine II, flanked by his brothers Constantius II (left) and Constans (right). Reverse of a silver medallion of Constans, minted at Siscia, 338. Paris, Bibliothèque nationale de France, Cabinet des Médailles.

singular parts, the familiar, the immediately recognizable, the exceptional single features. Perception of a part is often the cue to recognizing a whole individual object. Our memory of complex structural relationships is vague and this is also true of learning a language. We begin by isolating single units rather than chains or complex relationships of which the context escapes us or at least their boundaries are not clear.

I shall begin with a type of ornamental structure in the Lindisfarne cross page (Fig. 20), which I have already described in the first and second lectures and compared with classical modes of grouping human figures. One of the characteristics of the ornament in the Lindisfarne and Durrow carpet pages, and others, is that while the page presents a symmetrical form as a whole, analysis of the composition often discloses surprising breaks with the usual symmetry. These are not simply breaks of a detail at one point, not variations in a craftsman's touch but the more deliberate and often drastic shifts from a system of symmetry to a system of regular repeats as well as reversals or inversions of the system of repeats where we expect the same repeat to continue. That mode of composition is not characteristic of the primitive arts we know. It may be found emerging already in the art of the so-called barbarian, or migration, period. But the minute inventive play with such relationships first becomes evident in Insular art on a grand scale in the Book of Durrow, the Lindisfarne Gospels, and their successors.

The cross from the Lindisfarne Gospels is a large regular configuration, of which the symmetry is broken in its ornamental details by a repeated accent of the dominant color in one direction. In the upper field, the shields reserved between the cross and the frame are not readily isolable; their frame is a continuation of the line that defines the cross, and the symmetry is of diagonal forms. On the other hand, within that reflection of the pattern along a diagonal axis are seams with a pronounced vertical axis. But in the lower reserved fields at the sides of the cross, the repetition of the stronger color favors one diagonal direction in the symmetrical X-shaped unit. That contrast between the upper and lower parts can be found earlier in late classical art, on the reverse of a fourth-century silver medallion of Constans that shows the Emperor Constantine II enthroned between two other augusti, his younger brothers, Constantius II and Constans (Fig. 115). The figures form a group of three with Constantine as a dominant center. The reversed profile heads of the flanking augusti confirm that dominance, and the lower parts of the three figures—the legs, feet, and belts—maintain the symmetrical form. Instead of corresponding to the larger symmetry, however, the hands and arms of the two side figures are repeats: both right hands are flexed and both left hands are bent downward. The left hand of the central figure also points

downward so this detail is repeated a third time, though with a difference in the exact placing or size. Further, the mantle falls in the same way over the shoulders of all three figures. There is still reference to an axis, but the grouping is a series, A1, A2, A3, instead of an A paired with the reverse of A on the other side. Also in the fall of drapery lines below, on the symmetrical legs, the same diagonal reappears three times and gives an air of rigidity, of ornamental regularity, to the design. But one must admit that it is much more interesting than would be the case had the artist reversed the direction of the drapery lines in the right figure in contrast to the left or adapted the ceremonial gestures to the symmetry of the main forms.

Fig. 116. Triumphal Cross adored by archangels Gabriel and Michael. Embossed silver paten, Constantinople, late sixth century (?). St. Petersburg, State Hermitage Museum.

Another example, the silver paten of the sixth century in the Hermitage Museum (Fig. 116), is of higher quality, with a surer command of classical form, and freer from the banal reductive repetition of lines in drapery. The symmetry of the central cross commands the symmetry of the angels, whose heads are turned to each other; their feet are balanced in a corresponding way and rest above the four rivers of Paradise, which form symmetrical pairs. But the ceremonial gestures and scepters introduce a pure repeat seen again in the diagonal drapery lines and flying folds in the lower parts of the costume.

A more complex instance of the visual logic underlying such breaches of symmetry had appeared already in classical art. It was not a matter of skill in carving or drawing but rather a formalism of design, a more intellectual principle, a commitment to contrast. It also had an expressive sense; the counterplay of symmetry and asymmetry gives life, freedom, and an air of movement to a whole that has been ordered with respect to a larger dominant axis or center that ordinarily implies a more or less static form.

In a sarcophagus of the third century in Rome (Fig. 117), which has been called the tomb of the philosopher Plotinus—the identity of the deceased is not important here—the seated central figure has an asymmetrical posture accented by the slope of the large curved scroll that defines him as a man of the book. In the paired women and men standing on either side of the central figure, the heads are turned so that the outermost figures look away from the center, the next inner pair face the center, and closest to the center is an ingenious balance of a head on the left and on the right a hanging knot of folds in the mass of a draped curtain—elements of unequal strength in the play of light and dark. Given the obvious, legible game of alternation and reflection of symmetrical pairs of heads facing left and right, but as pairs always symmetrical with respect to the axis of the central figure, we understand better what happens in the drapery lines of their robes. Those of the two figures at the left form a symmetrical diverging pair as the long folds of

the mantle on the man fan out to the left and those on the woman flow to the
right. The drapery folds on the pair at the right, however, converge. The pairs
are not symmetrical with each other; they have undergone a more interest-
ing transformation, combining a translation and rotation resulting in an
inversion where we would expect simply a repeat, in accord with the sym-
metry of the forms above. Yet we can also describe it as a system of repeats
in which the rising drapery of the outer left figure is duplicated, not reversed,
in the outermost pair at the right. The folds of the next figure at the left move
downward to the right, and on the other side, those of its counterpart move
upward to the left. From these repeats in pairs, each symmetrical as a pair, is
formed a larger set, symmetrical in the position of the figures but asymmet-
rical in the detailed shapes. This larger set contrasts with the system of sym-
metry in the upper part of the work, with which it corresponds strictly in the
number of paired elements.

It is clear from this late classical sculpture that such conceptions of
design are not "barbaric" or the outcome of a loss of skill in representation
or of a drive toward ornamental forms; they occur in late antique figurative
art in ingeniously complex compositions.

Precisely that mode of ordering also appeared in the ornament of the
sarcophagi of southern France over the following centuries, such as one in
Narbonne from the second half of the sixth century (Fig. 118). In the upper
register, every panel has a plant ornament that is internally symmetrical with
a central vertical axis of its own and with diverging growths that reflect each
other. That register is also symmetrical as a whole. In the lower horizontal
field, a quite different system appears. The middle panel is symmetrical in

Fig. 118. Two registers of plant ornament from a marble sarcophagus. Gaul, sixth century. Narbonne, Musée Lapidaire.

its ornament, but the lateral ones are asymmetrical. The plant stalks in the panels on the left are diagonal and diverge, moving from lower right to upper left in the outer panel and from lower left to upper right in the inner one. The inner is thus a reflection of the outer. The diagonal stalks of the two right panels, on the other hand, converge, with the inner rising from lower left to upper right and the outer from lower right to upper left. At the same time the outermost left panel is repeated, not reflected, in the outermost right one since they both move in the same direction. Similarly, the inner left panel is repeated in the corresponding field on the right. Note, too, with respect to the horizontal axis of the two registers, that in the upper one the paired ornaments of the paired panels on each side are repeats, whereas below, in the opposed divergence and convergence of the two pairs, each is symmetrical. The inner is thus a reflection of the outer.

It is this type of relationship that we find in Insular design, though without the detailed motifs of the classical work. We learn here how a general principle of composition can survive and be applied to new elements without depending on the reproduction of the subject matter or motifs of the works from which it came.

There is in Irish art a remarkable instance of the method of composing with contrasts of repeats and reflections, symmetry and asymmetry, in a manner that is paradoxical, even capricious and piquant. In the miniature of the Virgin and Infant Jesus in the Book of Kells (Fig. 119), for instance, the angels are paired at the sides, above and below, in nearly strict symmetry, turned to one another; they gesture and hold their scepters in a corresponding way, not as a repeat but in mirror image. If you look closely at the Virgin's feet, however, you will discover that she has two right feet and two right toes; similarly, the Infant has two left feet, a repeat instead of a symmetrical pair.

Is this because the artist was careless with the treatment of anatomy? Had he been negligent and failed to notice what he was doing? I do not believe so. Observe that the angels all have a right and left foot. One may surmise

that the habit of variation in systems of pairing and symmetry, where there is also a dominant with its own counterplay of the symmetrical and asymmetrical, will also affect the rendering of very small human parts. Otherwise it would be difficult to explain this lapse; perhaps an assiduous, ingenious student of iconography will discover a text that inspired an artist of that time to give the Virgin two right feet and the Infant Christ two left ones.

I leave this aspect of structure and turn to another that I have mentioned in previous lectures: the relations of figure and frame. These are not of a fixed kind; they are a field of exploration, of invention. I have outlined in the second and third lectures a series of such types of contact, exchange, interaction, and secret correspondence with unlike systems in the frame and in the filling of the frame and the field.

Let us now consider some possible models or starting points of these forms in previous art. I do not mean that the forms I have described earlier were simply copied from works that I will discuss, but rather that the underlying principle has been adapted from another art and become for the Insular artists a source of independent invention.

I have already described the framing devices of the *Imago hominis* from the Echternach Gospels (Fig. 35) and will not repeat those descriptions here. In other examples of figures that appear to be clamped by the frame, they are not held in quite the same way, for the Echternach design is unique in its conception of the frame intruding into the space of the figure, securing it closely in its space, immobilizing it, or accentuating an immobility already given in its posture and details of the drawings, especially of a core element and of an axis broken and varied in every segment.

In a manuscript attributed to the fourth or fifth century, a text of Virgil's *Eclogues, Georgics,* and *Aeneid* in the Vatican Library, called the Second Vatican Virgil, a portrait (Fig. 112) shows the poet's head touching the upper frame with his chair placed firmly on the lower border. The subject is in a broad field with considerable voids; his axis, contrary to usual practice, is opposed to the horizontal of the field, though the abruptness of the contrast is tempered by the lectern and chest of scrolls placed beside him. There is also in the continuity, rhythm, and repetition of drawn lines enough similarity to later medieval and especially Insular works to have prompted N. P. Kondakov, the great Russian scholar and pioneer in the study of Byzantine manuscripts, to comment that the Virgil miniature looked as though it could have been painted in the eighth or ninth century by an Irish illuminator working from an antique fresco.[25] However, he assigned the work, which he considered an infantile and barbarous imitation of a classical work, to the Roman decadence of the sixth or seventh century. The fact that he could have

thought of Irish art in looking at that page suggests a resemblance and affinity of features in the two works marked enough to have made the idea seem plausible to him. That the manuscript is a product of late classical art is evident enough from the style of the beautiful script, though the painting itself still strikes some observers as provincial and even artless, a judgment that betrays a failure of perception in ignoring the work's positive qualities. In spite of these judgments, we are attracted today by this novel ordering of the whole as well as by the striking qualities of the drawing.

It is not that the Echternach figure was copied from the Virgil, but rather that behind the former was a concept of composition new in the late classical world, one that tied the figure to the frame more closely and introduced abrupt contrasts of the axis of the figure with the major axis of the surroundings. That effect has been explained as part of a general process of flattening the composition, the frame as a window through which a scene shown in perspective is replaced by the frame as part of a surface pattern in which the figure participates through devices of color and spotting, and above all, of contact or continuity of lines. I have already discussed the portrait of Matthew (Fig. 14) in the Lindisfarne Gospels, which is copied from a miniature in the Codex Amiatinus or one very similar to it. We saw in that figure of Matthew a more radical solution than in the Virgil: the unifying of the substance of frame and figure through the continuity of their lines.

Another example of the figure connected to the frame is provided by the fifth-century stucco reliefs of prophets in the Orthodox Baptistry in Ravenna (Fig. 120). The figures are unclassical in the construction of the body, having lost the idealized, athletic build and balanced articulation that in classical art express in a single posture both stability and potential movement. The labile and the stable were given together then in a contrast of the relaxed leg with a more rigid bearing leg; the upper body was adapted to the movement of the lower by a corresponding asymmetry that is a model of Renaissance contrapposto. Given that later tendency toward the rigid and self-enclosed, as well as the ornamentalizing of complex features of drapery and the reduced modeling of the body, this placing of the figure so compactly within its field and this contact of head and feet with the frame would appear to be not just a positive artistic idea but a regression—a primitivizing, owing to a loss of the ability to represent depth and movement and thus to locate the figure in its surroundings through the suggestion of space in front of, above, and behind the entire body. This is another interpretation that has been offered of the phenomenon that I am describing. There is indeed a primitive aspect in that snug fitting of figures into a narrow space and in the multiplying of its contacts with the frame, which we see in so many

Fig. 120. Stucco figures of prophets flanking windows. Ravenna, Orthodox Baptistry, fifth century.

Fig. 121. Lion hunt. Marble sarcophagus, Gaul, seventh century. Toulouse, Musée des Augustins.

Insular works. As an extreme example I refer again to the charming drawing in the St. Johns College Gospel, Cambridge (Fig. 58), in which David, struggling with the lion, touches the frame at several points, and other figures are connected with the frame by small dotted lines, as if the contact were necessary and had to be affirmed, even by an arbitrarily added line.

A sarcophagus, from Gaul and now in Toulouse, has a hunting scene, corresponding to the theme of David fighting with the lion, that presents a similar solution (Fig. 121). The hunter's mantle flies backward, like a wing, and touches the upper frame; the spear with which the man attacks the lion extends horizontally across the entire field; and the lion's tail turns and touches the frame, as does the back of his leg. Above is another hunter in a tree with a bow and arrow; he, too, is set in the corner so as to fill that space, though not as part of a dense, overall pattern. Interesting empty spaces are reserved between the figures in relation to one another and the frame. This work shows that what we have found in Insular art is more general; even if many works are characterized by a reduction of the modeling and articulation of bodies, it is handled with sensitiveness to the effect of lines upon each other and to the play of relief and void in carvings. Also, during the seventh and eighth centuries, before they became Christians, the barbarians in central and eastern

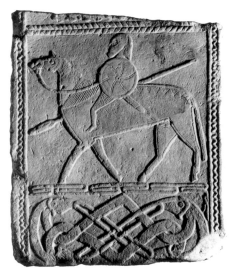

Fig. 122. Relief of a horseman and animal interlace. Fragment of a sandstone funerary stele from Hornhausen, seventh century. Halle, Landesmuseum für Vorgeschichte.

Germany, in a corresponding process, decorated their tombstones with figures of warriors. An example is the *Reiter,* or horseman, from Hornhausen (Fig. 122). The rich frame and horizontal band indicating the ground plane supporting the horse and rider are evidence of learning from a more naturalistic, observant style. Such assimilations have taken place at different periods in the history of the northern peoples, as far back as the Iron Age, when they met the Etruscans and northern Italic peoples as well as the Greeks, but in those older works we rarely find such a close bond of the figure with the frame. It is mainly at the end of antiquity or beginning of the Middle Ages that barbaric works, whether Christian or pagan, present such a conception of contact. In the *Reiter* it is associated with an original imposition of the forms of northern Germanic ornament in the drawing of the figure. Note on the horse the extremely fine doubling of the outline as a material strip or band; it is not just the edge of the contoured relief mass of the horse and rider but more like a hem or thick thread. The artist drew the thread around the animal in order to define its form. A beautiful pattern of lines issues from the shield as the center of the whole, including the head, spear, scabbard, legs, and reins. The frame itself is an ornament that reminds us of braiding and other techniques with a material that can be twisted and interlaced. The ground is a compressed, flattened meander; below it are demonic, intersecting, mutually biting creatures with great zigzag forms that make repeated contact with the frame in passing from one point of the field to another.

Like these others, the Insular form is a native transformation of a method of design already evident in the Mediterranean during the fourth to sixth centuries. It is often of an intensely expressive, original character. In answer to the question whether such a compression of a figure by its frame and contacts that immobilize the figure in the field is necessarily owing to a persisting primitive habit and lack of skill in representation, one can point to a mosaic of grand style with noble forms in the church of Hagia Sophia, Constantinople (Fig. 123). It belongs to the end of the ninth or beginning of the tenth century and shows an emperor kneeling at the feet of Christ, who is flanked by busts of the Virgin and the angel Gabriel. The figure of Christ is drawn in the fullest detail, with a strong interest in his attributes and the expression of an ideal supreme human presence. Here, too, the artist accepted the conflict between the central form with its implied symmetry realized in the two medallions and the surprising void at the lower right—we expect it to be filled by an element corresponding to the kneeling emperor at the lower left. In an Insular or other northern work, one would be inclined to explain such asymmetry in a closed centralized composition by the naiveté or inexpertness of an artist distant from classical tradition.

Fig. 123. Christ (Holy Wisdom) enthroned, flanked by busts of the Virgin and Archangel Gabriel in rondels, with the emperor Leo VI prostrate at his feet. Mosaic over narthex entrance, Hagia Sophia, Constantinople, between 886 and 912.

While that process is common to both southern and northern arts, in the north the frame, as I have mentioned earlier, often appears ductile, or flexible, as if made of a slender substance that moves around the whole like the hem of a curtain or the outline of the Germanic tombstone figure. It exhibits so many features common to the figure it encloses that it seems to be not just a frame but an object, like the curtain rod, the trumpet of the angel, or the edging of Matthew's book and the hem of his robe in the Lindisfarne Gospels (Fig. 14). It is this unification of frame and figure through their continuity and their interlacing and diffusion throughout the work that is the parti pris of Insular artists.

I have described only one type of figure-frame contact, however, in the comparison with the art of the south. Actually the relations of figure to frame in Insular art include others of a more surprising kind. In the Book of Dimma, an eighth-century work, Mark (Fig. 111) recalls the Echternach man and Luke in the Book of Chad (Fig. 110). Besides bringing the tonsured head of Mark into direct contact with the frame so that the upper outline of the crown of the head does not exist—it is only felt in the segment of the frame—the artist depicted the feet passing behind and through the frame. The effect seems to us irrational and unmotivated. It is a pure caprice, a fantasy of the artist; yet if we turn to other works of the school, we discover that it is a more or less common feature.

In manuscripts of St. Gall, a monastery which, like Echternach, was also founded by Irish missionaries, there are paintings of the evangelists (Fig. 124) in which the feet break through the frame, just as the evangelist's symbol

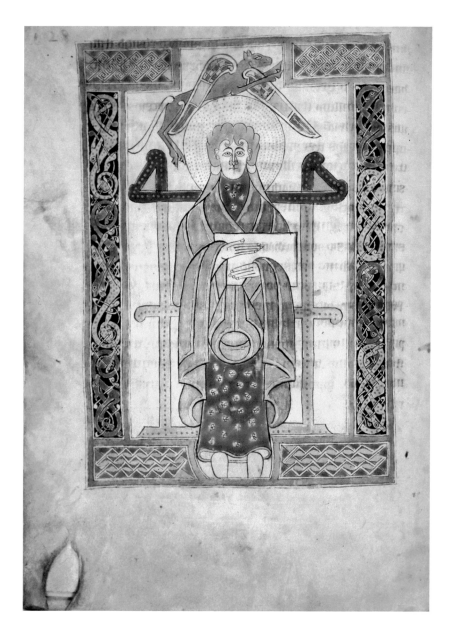

Fig. 124. St. Luke. St. Gall Gospels, Ireland, eighth century. St. Gall, Stiftsbibliothek, Cod. 51, p. 128.

above breaks through it, forcing the frame to detour around the figure. It is a device that is applied with climactic force in Romanesque art, in the great tympanum sculpture of Vézelay (Fig. 44). But one can also point to a classical precedent. In a fourth-century catacomb painting (Fig. 125) on the Via Latina, Rome, a figure is set in a frame that it crosses with its feet. This frame is in turn enclosed by another of increasing thickness, so that the frames together look less like a window through which you view a scene than like a bare room with a distant doorway out of which the figure advances. The result is an effect of space in three dimensions, produced with minimal and purely geometric, though sketchy, means that are nonetheless integrated and cohere with elements of picturesque representation in light and shade as well as with a sketchy execution of the figure. Without such prototypes it is improbable, I believe, that northern artists would have conceived their own forms, but they treated them in a new way that no longer maintained the original suggestion of depth in the overlapping of a figure and an object behind it that partially frames it.

Still another type, with an opposite effect, appears in the evangelist portraits of the Gospel Book of Mulling, Trinity College, Dublin. In the portrait of John (Fig. 126), for example, it is not the feet that break through the frame but the halo and head. Even this device, which is common in medieval art, may be seen in many Roman sculptures, where it is a space-forming device, and in Greek art of the fifth century B.C.

In a catacomb on the Via Latina, Rome, in a depiction of the miracle of the multiplication of the loaves (Fig. 127), the figure of Christ stands in deep space before a concave niche that brings out his convexity by contrast and

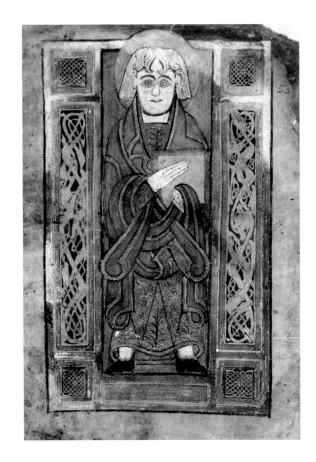

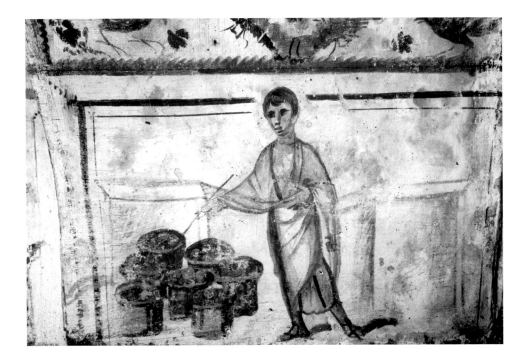

Fig. 125. "Egyptian" soldier. Wall painting, Via Latina Catacomb, Rome, fourth century.

Fig. 126. St. John. Book of Mulling, Ireland (Tech-Moling?), second half of eighth century. Dublin, Trinity College, MS 60, f. 81v.

Fig. 127. Christ Multiplying the Loaves. Wall painting, Via Latina Catacomb, Rome, fourth century.

Fig. 128. Prancing lion. Reverse of a Celtic bronze coin with the name of King Rigantikos inscribed in Greek letters, second or third century B.C. Found in southern France. From Adrien Blachet, *Traité des monnaies gauloises*, Paris, 1905, 275, Fig. 135.

Fig. 129. Rampant lion at the end of the Gospel of St. Mark. Book of Kells, Iona (?), ca. 800. Dublin, Trinity College, MS 58, f. 187v.

adds to the significant centering of the whole, through both the symmetry and curves that relate to the extended hand that performs the miracle. The doubled frame makes way for Christ's halo; the inner frame yields on one side to the cornice of the niched, architectural form at the sides as well. Forms like those were transmitted, I suppose, from the Mediterranean northward to Gaul and England and were admired by the later northern artists, who translated them in a way that reduced or lost the spatializing effect of the figure behind or across the frame.

A more complex type of relationship is that of the lion to the stepped frame in the Echternach Gospels (Fig. 114). The frame creates a labyrinth around the figure and by its corridors and symmetry determines a large diagonal axis opposed to the diagonal of the figure. The lion, I have remarked earlier, is formed of horizontal and vertical parts. The conception seems so unlike anything we know in classical art, it is so different in principle from the familiar relationships of figure to frame, that we would be disinclined to look for a classical precedent.

Before considering ancient parallels to this pattern, I would like to comment briefly on the type of the figure. There is in the repertoire of Celtic art of the pre-Christian period, as far back as the third and second centuries B.C., among the Celts in southern France, a body of coinage copied from Greek coins of Marseilles and its region, with the image of a lion that in posture and drawing (Fig. 128) has an obvious resemblance to the Echternach figure. Was such a coin available to an artist in Scotland or Northumbria (some would say in Ireland) nearly a thousand years later? We would suppose that it was so by a rare accident, if we did not know that this type of Celtic coinage was widespread, that many treasure hoards included coins, and that there existed other classical coins with lions of that type. It is not impossible, however, that the later artist owed his acquaintance with that type of lion to a late antique work other than a coin, even to an early Christian object. The rampant lion type was sufficiently common in more than one context.

Must one also suppose that the artist of the Book of Kells who drew the symbol of Mark at the end of his Gospel as a rampant doglike lion (Fig. 129) knew the Echternach Book or a related codex? But if we admit that relationship, we acknowledge that late classical forms were available in the Insular sphere, for a telltale feature of the Kells lion—the painting of the farther legs in a darker color than the rest—confirms it. What does such a light and shade effect, though drastically schematized, mean in an Insular figure? The calligraphic linear style does not call for light and shadow. There is little interest here in depth relationships as expressed through value contrasts of the near and the far; yet it is precisely this detail that permits us to say that classical

models were known in that Insular art. (This also occurs with the hound with the rabbit found on fol. 48 of the Book of Kells; Fig. 72.) A comparable lion on a pavement mosaic from Antioch (Fig. 130) is of a type that undoubtedly existed throughout the Mediterranean world. Few motifs traveled so far as pavement designs; individual artisans either had copybooks, or, working in teams, they learned from each other as they moved from place to place, just as the legions passed from one province to another in the Roman Empire. In the Antioch mosaic, the lion's farther legs are of a dark color and the nearer ones, light. It is such a type that underlay, I believe, the conception in the Book of Kells, different as the styles may be.

The continuity is not altogether unexpected; and there are other examples of the process. A distant parallel appears in the synagogue of Beth Alpha in Israel in a mosaic of the sacrifice of Isaac (Fig. 131), a work of the sixth century. The ass at the left is pictured in strong outline, quite flat but with one pair of legs in light color, the other in dark—all so simplified and reduced that it would be extremely difficult to reconstruct its model in an older style. Yet the mosaicists were undoubtedly acquainted with an art of more painterly character in which the four limbs of a beast were rendered with an alternation of light and shadow and a distinction of color values in the near and far.

To return to the forms of figure and frame, I show another wall painting from a catacomb of the mid-fourth century on the Via Latina, Rome, depicting Daniel between the lions (Fig. 132). Not only is the lion at the left rampant in a manner that recalls the Echternach lion, his tail is turned

Fig. 130. Mosaic of the beribboned lion. Floor mosaic found next to the House of the Buffet Supper, Antioch, second quarter of fifth century. Antioch, Museum of Mosaics.

Fig. 131. Sacrifice of Isaac. Floor mosaic by Marianus and Hanina, Beth Alpha Synagogue, Galilee, sixth century. Israel, Beth Alpha Synagogue National Park, Kibbutz Hefzibah.

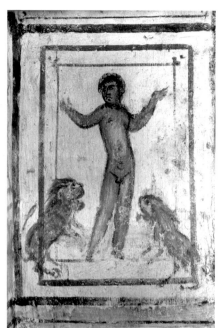

Fig. 132. Daniel in the Lions'
Den. Wall painting, Via Latina
Catacomb, Rome, fourth
century.

upward in a corresponding way, though it lacks the elegance or precision of
the Insular drawing. But like the latter, this figure is inserted within three
framing lines; it touches one, crosses another, overlapping it, and is crossed
by and overlaps a third. We have already seen how, through such relation-
ships of a figure to a multiplied frame, painters of the fourth and fifth cen-
turies evoked depth of space. In the Echternach page there is a residue or
distant reflection of that method, but it was changed from a spatializing
device to a typical Insular network of lines. It is not altogether lacking in spa-
tial suggestion, however, for overlapping as such produces an appearance of
front and behind.

The catacomb painting, an older work, does not present the stepped,
labyrinthlike lines of the frame in the miniature, but even for these one can
find a classical precedent, though not as suggestive and strong as those in the
Echternach lion. Around 1900, in the underground basilica of a secret, sup-
posedly neo-Pythagorean sect active at the beginning of the first century in
Rome, near the Porta Maggiore, there was discovered a remarkably well-
preserved set of refined stucco reliefs on the ceiling with episodes from Greek
mythology and history, in which members of the sect found a spiritual and
moral sense (Fig. 133). One of the reliefs, showing Helen and Ulysses in con-
versation, is set in a framework of stepped forms, perhaps a schema of lines
suggesting an interior space, though they are not clearly architectural. Forms
that in part represent architecture and from which hang elements as from a
ceiling or door, have been drawn as stepped lines, which, entering between
and around the figures, assume the character of a more purely abstract
design. The continuous line, a rectilinear counterpart to the curved figures,
also has a role in defining their space. It is crossed by one, encloses the other,
and forms a stepped frame in the space between them. It accords with the
rectilinear in the postures and drapes of the figures and their supports.
Whether such forms existed in house decoration in Gaul and Roman Britain
I cannot say; I have found no examples. But I show this one in a speculative
effort to suggest the broad ground of the complexity of Insular figure-frame
patterns in a tradition other than old Celtic and Germanic art, which lacks
these structures. We have seen that they existed already in Roman art. But we
do not find in classical works the Insular radical transformation in an orna-
mental sense, with the search for continuity and symmetry on a diagonal
axis. If we turn, however, to the pavements in Roman Britain several cen-
turies before the Insular school, which are found in pagan Roman villas and
public buildings as well as in churches of the fourth century—the oldest in
England—we often come upon a design with repeated and varied units
among which circulate meanders that intersect and are connected along

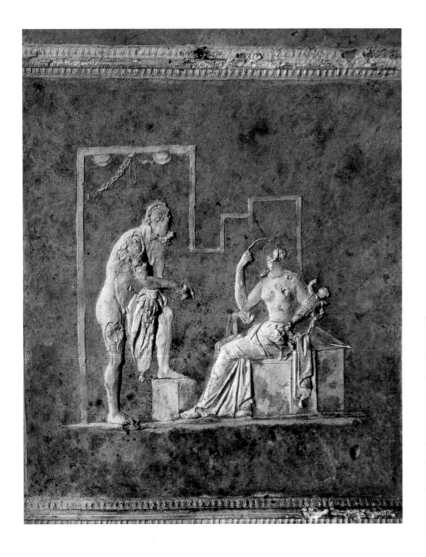

Fig. 133. Ulysses and Helen. Stucco relief in the underground basilica near the Porta Maggiore. Rome, mid-first century.

Fig. 134. Drawing of lost Romano-British mosaic pavement from a villa at Combe St. Nicholas, Somerset, fourth century. From T. D. Kendrick, *Anglo-Saxon Art to A.D. 900*, London, 1938, pl. XVII, 2.

diagonal axes (Fig. 134). This intervening form, a stepped pattern in a context of other regular elements, might have provided a model. Such forms certainly persist as ornament in Insular art. The idea of shaping and ornamenting the frame in response to the forms in the enclosed field, an idea that we have noted, particularly in the Durrow and Echternach manuscripts, may be found in Roman art. The frame responds to qualities of the figures and their opposed elements. Their conflicting axes and patterns are reconciled and unified by hidden continuities.

I shall deal finally with a particularly interesting aspect of the frame-figure relation that I brought up in the first three lectures: the response of the frame to qualities of the figure and the unification of opposed forms and conflicting axes and patterns of figure and frame by hidden continuities and correspondences, as in the beautiful lion page of the Book of Durrow (Fig. 1). The upper and lower bands, in

their color and diagonals, correspond closely enough to the animal to make us see them together. In the vertical panels a pattern of another color is shaped like the uncolored parts of the figure, and at the point of approach to the horizontal axis of the figure, the interlace of the border becomes loosened, lax, and less regularly tangled. It is colored with sharper contrast in a pattern that resembles even more closely the features of the animal.

That correspondence of figure and frame is related to a practice that emerged in late classical art. It may seem to us quite natural for artists to seek such correspondences between figure and frame. On the other hand, one can say that it is not a natural or obvious relation, since the frame, whether newly added or given in advance, is a standard, regular form that can be used for very different pictures. It is not constructed uniquely for the image that fills it. In the mosaic from Antioch, which I have shown before (Fig. 130), the artist decorated the border of the lion with a scrollwork—it is called a "running dog" or sometimes a "Vitruvian scroll"—that in its shape has a curious analogy to the pattern of the animal. The head is like a little scroll, and the leftward movement of the advancing form of the animal reappears in the series of light scrolls running across a dark ground in the upper portion of the border and in the dark scrolls on a light ground in the lower portion. But we can also see a relationship to the forms of the tail and the distant hind leg. Such a rapport between the small unit, a nuclear element in a border, and a large expanded, organic element in the field appears in many classical works, especially those from the late period. I would like to bring it out more clearly by showing other examples from the Near East—I am sure they were not restricted to that region—in which we can observe a process of selective assimilation of the ornament of a border and the large structure and even of qualities of small structure in the enclosed pictorial field.

In a miniature from a Syriac manuscript of the late sixth or seventh century, now in the Bibliothèque nationale de France, Paris (Fig. 135), the ornament of the border is a repeated blossoming *V*-shaped plant. From the base of the *V* rises a conelike calyx with three small pistils or other floral form. That divergent *V* form is repeated on the horizontal bands with a larger angle than in the vertical bands. We understand that form in terms of the action, the drama of the scene. It is of Moses and Aaron appearing before Pharaoh. There is a clash of wills, and its expression is intensified by the postures of the figures and, above all, by the spears. Pharaoh's immense scepter is tilted upward to the right, and two spears point to the left, with the head of a soldier between scepter and spear. At the extreme left is Aaron bearing a slender rod. Note also the raised arm of Moses at the left and the spear that aligns with a stripe on his sleeve. That recurrent *V* shape enclosing a head or

other rounded form reappears repeatedly in the border. So pervasive is this element that the artist rendered each of the shadows cast under Pharaoh's feet as a pair of divergent lines. With a strange arbitrariness he drew the two separate shadows converging toward each other rather than parallel and continuous with the source of light. This is an unmistakable instance of ornament functioning as an expressive marginal accompaniment, rhythmical and fairly regular, on the borders of a scene in which elements of that ornament appear also as a larger structure in the scene's dramatic composition.

In Insular works, the complex ornament of a border loosens and changes in places to accord with a figure. Such an adjustment of a repeated border motif to dominant axes of figure composition may be illustrated by another Syriac work, the Rabbula Gospels of the year 586—specifically the page of the Crucifixion with Resurrection-related episodes below (Fig. 136)—written in the Mesopotamian part of Syria, and now in the Laurentian Library, Florence. While in the Moses and Aaron scene (Fig. 135), the floral unit retains its vertical stance on all four sides of the frame, in the corresponding border of the Rabbula Gospels, the iridescent stepped motif moves upward on the left and right and inward at the top and bottom until they meet on the axis of the cross and tomb of Christ. Through this variation of axis and direction, they reinforce the remarkably integrated composition of the page, of which the various upper figures of the Crucifixion and the lower scenes of the two women at the tomb, the three soldiers at the tomb, and Christ appearing to the two women have been disposed symmetrically with respect to the axis of Christ on the cross. In that upper scene the postures and glances of all the figures are directed toward Jesus, while in the band below the scenes of the Resurrection and Christ meeting with the women diverge asymmetrically from the sepulchre with its telltale open doors and flashes of light. In the upper space the three soldiers at the foot of the cross are a symmetrical group fitted by glances and contours to their central position, in contrast to the falling soldiers in the lower scene. The ornament of the two horizontal borders deviates from the unbroken uniform

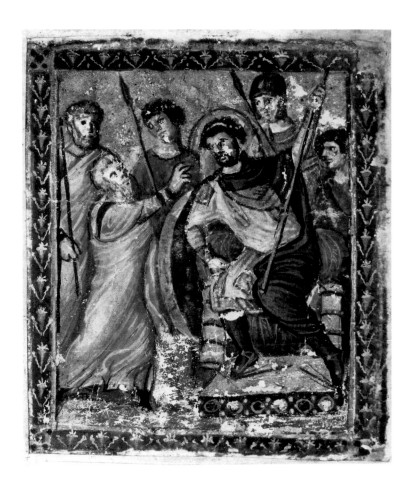

Fig. 135. Moses and Aaron before Pharaoh, frontispiece to Exodus. Syriac Bible, northern Mesopotamia, sixth or seventh century. Paris, Bibliothèque nationale de France, MS syr. 341, f. 8.

order of the vertical ones in their opposed axes and reversed directions that accord with the focal position of Jesus on the cross. It is a part of the expressive composition, and its iridescent colors are a kind of palette or original substance from which the colors of the image have been selected. But most important is the symmetrical disposition of the units that march from the sides toward the central axis, just like the figures standing below the three crosses, all of whom turn to look at Christ, and the balanced arrangement of the two mountains, sun, and moon that flank the central cross.

I turn to some remarks on the relation of the carpet pages to pavement mosaics. Several observers, particularly Thomas Kendrick, whose book I mentioned in the last lecture, have noted that in Roman British pavements— and I must say at this point that they are for the most part of a type found throughout the Roman Empire—appear many motifs that recur in Insular carpet pages. But beside the single units of ornament, they share the idea of an organized space, a large rectangular field, heavily framed and subdivided so that the parts, too, have strongly marked frames. It is this concept that unites the pavements and carpet pages. The classical ideal of planning, of organization, with a strongly accented structure of framing, enclosing, partitioning, and axial groupings, was taken over from the Romans by Insular artists as a model for their own compositions. Perhaps only in a civilization like the Roman, where pavement mosaics decorated buildings that were themselves great planned complexes of highly organized spaces, with units of different size and varied axes, could the mosaic pavements acquire to an increasing degree that multiple framing and organization with motifs of varying size being juxtaposed. There are also pavements with a looser, more freely strewn composition, though of fairly uniform density throughout a field. The density is the same in quadrants, in eighths and even smaller parts. Unity and harmony are achieved without requiring boundaries. We do not distinguish clearly subgroups of elements or see their relation to one another. In some panels the effect is of a random grouping as in the pavement of a Roman dining room (Fig. 137), representing the debris of a meal—scattered bones, shells, and peelings, sometimes with a mouse nibbling in a corner.

We now return to the more regularly organized type, while recognizing that the strewn kind is also ordered, though on other principles. Let us consider an example of a Roman pavement in a Christian building of the fourth century in Frampton (Fig. 138). The ornament is set in many bands and frames, the units densely filling the field are regular crosses, polygons, and *T* shapes, all with bilateral symmetry. There is, in contrast, a winding continuous motif in the simple two-strand interlace, which, in coiling, makes its way around all the stable bounded elements. If isolated, these

Opposite: Fig. 136. Crucifixion. Rabbula Gospels, northern Mesopotamia, Monastery of St. John at Beth Sagba, 586. Florence, Biblioteca Medicea Laurenziana, MS. Plut. I, 56, f. 13.

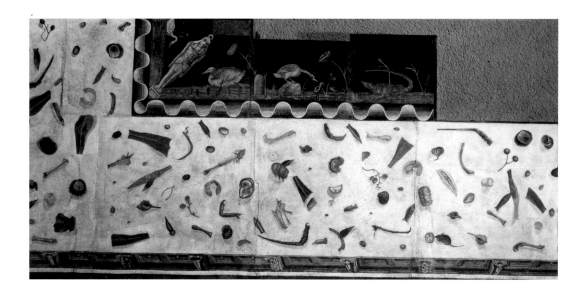

would present groupings of a higher, also symmetrical, order. Seeing the cross pattern with the *T* forms and solid panels in the Lindisfarne page (Fig. 139), one is reminded of features of this pavement; yet the ornament in the manuscript is of another and more developed kind. It depends on motifs that were introduced from the new Germanic styles of the sixth and seventh centuries as well as from late Celtic art and the arts of the Mediterranean regions that are of a much later period than the forms in the Frampton mosaic. Moreover the finials—the projecting handlelike elements of the corners of the frame—introduce a competing factor; the diagonal alignment of their small colored units, which contrasts with the vertical and horizontal axes of the frame and field, accords with the diagonal zigzag lozenge fillings of the four oblong panels. Such a use of finials is not at all in the spirit of the design of classical pavements. They recall rather the small metal objects of the Germanic peoples. The taste for knobs and handles and other terminal units in the metal arts of the primitive tribes of northern Europe also was transmitted to the classical peoples, who never developed these elements with the intense expressiveness to which we respond in so many works of the seventh and eighth centuries. But it is enough to note here the concept of a large organized field with subdivided rectangular fields marked by accented frames and with a grouping of the smaller elements into regular units of a larger order, embracing four, five, or six smaller units in an equally regular configuration.

In an eighth-century Gospel Book in St. Gall (Fig. 140), the figure of Mark is flanked by rectangular panels in which lozenge forms are inserted, each with its own kind of ornament. This motif of a large lozenge framed by

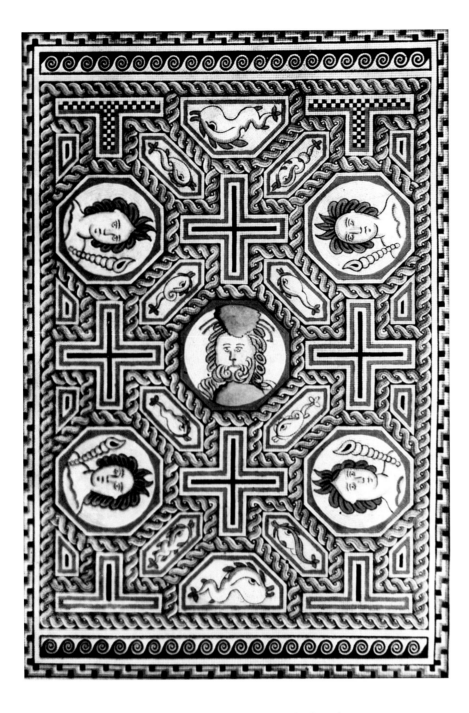

Fig. 138. Romano-British floor mosaic with the busts of a god (central medallion) and the four winds (outer medallions). From room D of a villa or place of worship in Frampton, Dorset, fourth century. Dorset County Museum.

a rectangle appears, for example, in the border of a fourth-century pavement from a villa in Brantingham (Fig. 141). The two forms are also found as component elements of the central field, as in the floor mosaic from Brislington (Fig. 142), which features squares and lozenges as a repeated theme in the central portion of the pavement. The two motifs, however, alternate here instead of aligning with one another as they usually do in the midsections of pavements.

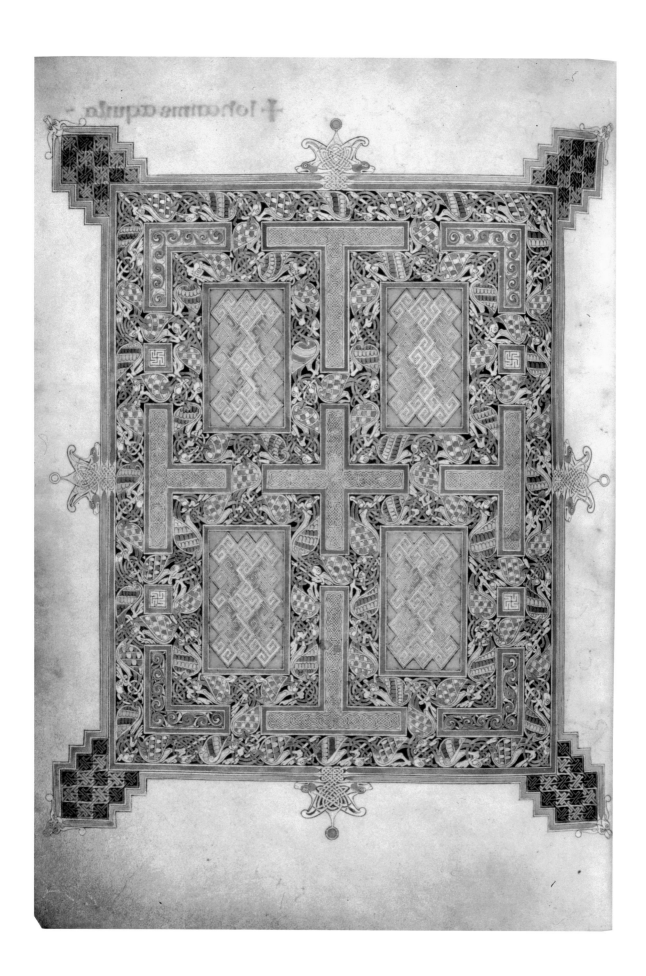

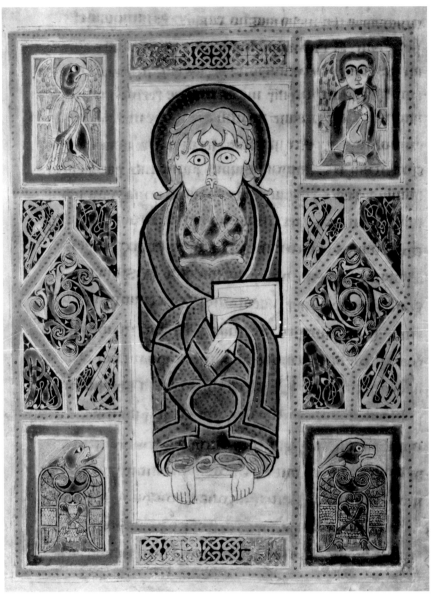

Opposite: Fig. 139. Carpet page. Lindisfarne Gospels, Lindisfarne, late eighth or first quarter of ninth century. London, British Library, MS Cotton Nero D.IV, f. 210v.

Fig. 140. St. Mark. St. Gall Gospels, Ireland, eighth century. St. Gall, Stiftsbibliothek, Cod. 51, p. 78.

Fig. 141. Romano-British mosaic pavement with goddesses and nymphs framed by a border of rectangles enclosing lozenges. From a villa at Brantingham, Yorkshire, fourth century. Hull, Archaeology Museum.

Fig. 142. Romano-British floor
mosaic with overall pattern of
squares and diamonds filled
with floral or interlace motifs.
From corridor house, Brisling-
ton, Somerset, late second or
early third century. Bristol,
Kings Weston Site Museum.

In conclusion, I would like to compare mosaic pavement forms with a
great page of the Lindisfarne Gospels (Fig. 25), where the lozenge as a diag-
onal theme, which fills the body of the cross and flanking panels, is varied in
scale, color, axis, and order, in counterpoint to the rectangular forms of the
great central cross and paneling around it. The taste for such contrast may be
illustrated by a pavement in Silchester (Fig. 143), in a church of the fourth
century, one of the oldest Christian remains in the British Isles. Here, in a
much simpler design, the artist arranged what at first resembles a checker-
board but is really more complex. He contrasted the central field of small
black and white squares with the much larger red and gray diamonds in the

border. He also divided the central field into four segments whose corners are defined by a checkered *L* shape. The *L*s are white in the lower right and upper left sections, and black in the other two. This creates an elusive *X* symmetry that produces a disarray of the whole; it is difficult to isolate any feature as unequivocally a part of one rather than another quadrant. There is in fact another latent grouping in which a black *L* appears symmetrical to a white above it or, conversely, a white *L* is symmetrical to a black beside it in the next quadrant rather than in its own field. At any rate we see on a simpler level the designer's delight in the use of field and frame as elements of formal competition and interaction, always of an elusive complexity. But the elements and their scale are of another order than those of the Lindisfarne Gospels, which depend on other types of artistry as well, namely, that of the pen and of refined metalwork—the skills of the scribe and the goldsmith. One cannot ignore the art of the centuries intervening between the two works I have compared.

Fig. 143. Romano-British floor mosaic of checkers bordered by diamonds. Pavement in front of apse of small church, Silchester, Hampshire, fourth century. Reading (England), Reading Museum and Art Gallery.

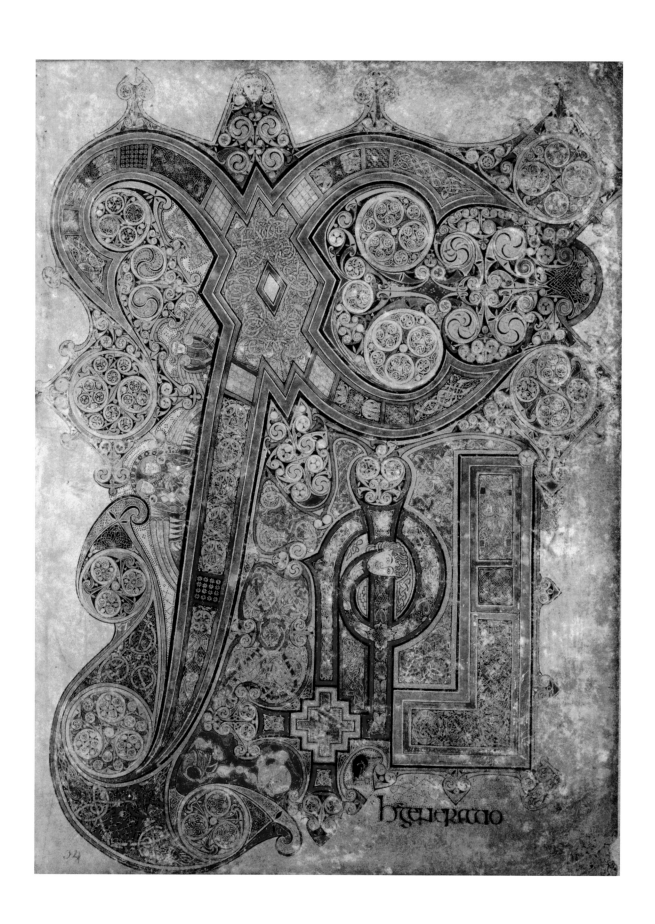

VI. THE RELIGIOUS
AND SECULAR GROUNDS
OF INSULAR ART

In this final lecture I treat a problem of Insular art that has been neglected in most writings on the subject, namely, how to explain it. It admits no easy solution and contains many difficulties even for a partial solution. We do not expect, of course, a complete explanation, but a statement of preconditions and circumstances would enable us to understand better how this art came about in England, Ireland, and Scotland rather than elsewhere, and why during the seventh and eighth centuries, not a hundred years earlier or later. It is well known that this art came to an end in Anglo-Saxon England after 800, when the Vikings and Danes invaded the country, destroying, plundering, pillaging, and weakening the continuation of the old type of institutional, communal life that had stimulated and supported this art. It made it increasingly difficult to undertake costly enterprises of painting, metalwork, and the copying and decoration of manuscripts. There was a rapid decline in quality as well as in the range and level of the projects and the resources and ambition of the artists, who could no longer emulate the great works of the late sixth, seventh, and eighth centuries.

Explanations of the character and flowering of Insular culture have tended to focus on an idea that is intelligible—that they are the effect of an innate, inherited disposition of the people who are called Celtic. One thus assumes there are specific traits in the psychology of the Irish and other Celtic peoples that account for the character of this art. We are not satisfied by this explanation. Apart from the vagueness of the concept of an ethnic psychology,

Opposite: Fig. 144. *Chi-Rho* page (Matthew 1:18). Book of Kells, Iona (?), ca. 800. Dublin, Trinity College, MS 58, f. 34.

the notion of a race or people must take into account the intermingling of peoples in the British Isles; language does not coincide with ancestral continuity, culture, or history. Besides, the same ethnic groups whose artists created those masterful works in the seventh and eighth centuries produced very little on that level of quality over the next centuries, and in Ireland, for several centuries after. Such an ethnic approach fails to explain another remarkable fact: the extraordinary intensity of growth in that art during a period of about one hundred fifty years. Between 650 and 800 this art changed almost decade by decade; at least we assume this from the variety of the works produced and from the amazing development of its forms between the earlier and later stages.

In a previous lecture dealing with the great initial pages, I discussed two *Chi-Rho* pages marking the beginning of Matthew 1:18—one in the Book of Durrow, from the second half of the seventh century (Fig. 33), the other in the Book of Kells (Fig. 144)—in order to show the extraordinary florescence of the original innovating idea. The earlier initial has many of the elements from which the later forms evolved, but you could not predict from knowledge of the first and from what we know about the supposedly innate Celtic temperament or mind—if one can speak of such a thing—that there would emerge in about a hundred years the kind of form you see in the Book of Kells. Because of that intense and rapid growth of the art and the great variation and interchange of styles between one region and another, we find it hard to decide whether a work was produced in Northumbria, Scotland, Ireland, the north or south of England, Wales, or the central region of Mercia. Their stylistic features or character are not made more intelligible by reference to a racial or ethnic spirit or a particular aptitude of a people. It is often said that a people is gifted for line as is another for color or pattern. But if we attempt to apply such notions consistently to the art of a long period of history or of a large region, we soon recognize that while they may appear to illuminate certain continuities and unexpected revivals of style, they are hardly clear enough to serve as guides to historical explanation. We understand, of course, that the reference to an ethnic character in the now discredited biological sense of a racial psychology, aptitude, or world view had a strong appeal in this particular context because for many centuries the people of Ireland, Scotland, and Wales, in trying to maintain their culture and self-respect under foreign domination, were led to cultivate their old traditions and arts in a defensive, self-affirming spirit. The notion of an inherent racial genius served a purpose then in maintaining the culture and resisting a foreign ruler. This is evident in the maintenance of a native tongue or dialect in defiance of a foreign conqueror's language.

As an alternative to this ethnic or racial approach, an explanation based on social and economic life has been proposed. A Belgian scholar, François Masai, a specialist in the study of medieval Latin manuscripts, argued that the essential character of this art is better understood through the fact that the makers belonged to a precommercial, preurban type of civilization.[26] Such societies of farmers and hunters tend to produce, he thought, an art that is abstract and irrational, while peoples who engage in trade and live in cities are likely to be more rational and naturalistic. They have a greater need to observe and organize. I do not believe that one need take this view more seriously, though it is in some respects an advance on a purely ethnic-psychological explanation. But the main objections arise from the fact that the argument does not fit all agricultural precommercial societies, nor does it fit urban commercial ones. Muslim art, for example, also tended toward a high development of ornament and interlace. Its use of the figure was not essentially naturalistic, at least for many centuries; yet Muslim civilization was founded on communication and trade and centered in big cities like Baghdad, Cairo, and Cordova. Moreover, if we turn to primitive peoples, we see that some do produce a naturalistic art. Besides, the attribution of irrationality to Insular art is a prejudiced notion. These great pages of ornament exhibit a subtle and finely developed sense of order, a close coherence of forms, a great ingenuity in creating a consistent complex pattern out of a few motifs, a pattern open to many variations. It is an immensely fertile art associated with the written word.

So from these points of view, one must reject these explanations. But one can raise more concrete questions about the significance of the social situation in the British Isles for art in the period when this art emerged and for its changes during the hundred or more years in which it developed. It is not easy to do so, however; our information is sparse and much of it depends on documents from a later period, which record events from the viewpoint of later observers and historians rather than contemporaries. Besides, there is the difficulty of localizing and dating that I mentioned before. We are not sure which works were made in Ireland, which were by Irish monks in the neighboring lands, or which were by Anglo-Saxons or Scots. Nor do we know in which parts of these countries, or at what moment these works were executed. We are forced to deal with an exceedingly complex set of changing circumstances, a varied culture or set of neighboring cultures that could be understood better perhaps in some respects as a single whole, though that is doubtful.

We must admit that difficulty from the start as an obstacle in reaching an explanation of the unique characteristic of single features of this art. Nevertheless, we can try to approach this art as a whole and study that

complex of cultures as a unity in the sense that they have common qualities and communicate with each other. Much that appears in one is likely to be absorbed by the others and modified in some respect without remaining unique for long. This openness and interchange is noticeable not only in works of visual art but also in literary remains, theological writings, texts, handwriting, costume, and bodily decoration. In many common features, and especially in religious life, we observe that these are not closed regions with discrete outlooks. Whatever their old native traditions, they are in sustained contact with each other during a period of intense interchange and movement, even migration. It is a time when new political entities, communities, and kingdoms are formed and peoples are regrouped; it is also a highly active period for religious life, with conversions, missions, new foundations, and great individual vocations. In this rich complex whole, we must attend to single significant features and aspects and be satisfied if we can find connections among certain parts and particular circumstances, even if we cannot explain the large whole.

One of the first conditions we take into account is the diversity of ethnic groups—each having its own language and tradition—in the British Isles during the seventh and eighth centuries. Some, like the Irish, the Britons, the Welsh, and the Picts, had been there for centuries, and others, like the Angles, the Jutes, and the Saxons, had settled there more recently as invaders from the Germanic world, though some were regarded as military allies. Later came the Vikings; there were also traders from Gaul and Belgium. These peoples had highly skilled arts of their own just before this new art appeared in England and Ireland. Such skills are particularly evident in the better preserved work in metal; wood quickly disappears, and textile fabrics waste away. Metal objects in bronze, gold, and silver have a special preponderance in the art of the Insular sphere. I use *Insular* to cover the Irish, the Scots, the Britons, and the Welsh together with the Germanic invaders in their settlements and new kingdoms. (*Celtic-Germanic* would be more appropriate.)

The study of Insular metalwork provides a vision of the meaning and importance of art in that world. These objects are superbly made weapons, armor, and fittings of costume and trappings. They belonged to an individual, rather than to a cult institution, though there are cult objects among them. They are for the most part the personal equipment of a tribal aristocracy that engaged in war, hunting, cattle raiding, and personal combat and valued courage, military prowess, and loyalty as important manly virtues. The objects were not only for personal use and display, asserting the owner's dignity as noble, prince, king, or warrior, they were also exemplary gifts as expressions of homage and fidelity. They were also a means of exhibiting

power and largesse, as in the phenomenon of primitive society that social anthropologists call potlatch, a competition with others of one's own tribe or clan in the display of wealth through extravagant contribution and even destruction or burial of precious objects. In the northern sphere, works of the smith in gold and silver were made with an amazing cunning and finesse. This metal art can be traced far back in pre-Christian times to the Iron Age; its development can be followed in that long period of folk wanderings, when power in Europe increasingly fell into the hands of Germanic tribes. In their graves are found beautifully designed, skillfully executed metal artifacts, together with treasures from the Greek and Roman world. The orally transmitted heathen literature of these peoples was not written down until the ninth to eleventh centuries. In *Beowulf,* the *Eddas,* and *Waltharius* are descriptions of the marvelous equipment of a prince or soldier, the great treasures of gold, and the eagerness and struggles for their possession as well as the generosity of princes in donating these precious objects.

In 1939 such a treasure was uncovered in a buried ship at Sutton Hoo in eastern England. I have discussed several of the pieces already (Figs. 103, 105). The burial, which has been dated about the year 650, and the objects found in it have been identified as the work of Germanic craftsmen; but there were also pieces obtained by trade, plunder, or tribute from the Mediterranean and the Near East. The existence of that great treasure in a burial place without a body—it is a cenotaph in the form of a boat—shows that the account of such a burial in *Beowulf* [27] was not just fantasy but referred to an actual practice.

Christian art in the seventh century proceeded then from a culture in which the beauty of small metal objects for personal use and the skilled craft of the metalworker, especially in precious substances, including gems, enamel, and inlay, are highly valued. The love of such objects, particularly of the beauty of costume and its decoration, in color and texture, is encountered often as a theme in the poetry and tales of the Irish and Anglo-Saxons. It is a permanent and essential attitude in those cultures.

I shall consider a few examples of Celtic metalwork from Iron Age Britain and proceed from there to works of the sixth and seventh centuries. First are the great shields, one found in the Thames River at Battersea (Fig. 145), the other in the Witham River near Lincoln (Fig. 146). The shields were made by Celtic craftsmen in Britain sometime during the fourth through the second centuries B.C. In both works the magnificent wavy, linear ornament in low relief in contrast to the large circular bosses, the quality of movement, and the scale of elements are reminiscent of features of the later art. During the sixth and seventh centuries, the Germanic conquerors, mainly in the

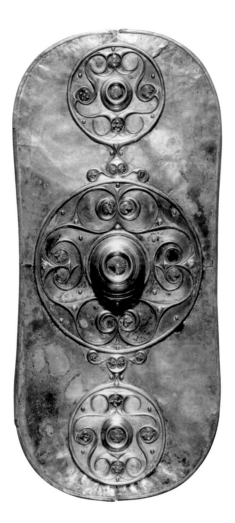

eastern part of England, but also far inland, brought their crafts of gold, silver, bronze, and jewelry, especially inlay work, which had been less developed by the natives, although Britons practiced an art of enameling much appreciated by the Romans and Greeks. The early-seventh-century gold cloisonné brooch from Kingston Down (Fig. 147) is a splendid example of the Germanic inlay technique, which required precision and skill in execution. The gold-banded cells are inlaid with flat chips of blue glass, white shell, and garnets, shaped to fit exactly. The canny choice and distribution of the various large and small units and the warm and cool colors played against the gold frames create an intriguing and complex design. One can readily see how that art could provide a standard in decoration of the type that I have described in the pages of the manuscripts.

During the sixth and seventh centuries, buckles, fibulae, and brooches of various kinds began to exhibit new themes of ornament that were then adopted by the manuscript painters who gave them a different effect in response to the special context of the book. The interlace ornament seen on the Taplow buckle (Fig. 148), the division of the field into panels with heavy

borders, the play of the bosses of varying size and relief are new features in the art. The sixth-century Barrington fibula (Fig. 149), with its rectangular head, curved bow, expanding sides, and long foot, already displays, in its complexity and division of the whole field and in the application of different kinds of ornament to each framed or partly framed panel, a conception of highly articulated ornament that provided a training ground or at least standards for manuscript design. Among the objects found in the Sutton Hoo burial is a beautiful pair of gold shoulder clasps inlaid with garnets and millefiori glass (Fig. 150). The rectangular panels, filled with cloisonné checkerboards of garnet and glass, are bordered by garnet-inlaid chains of interlaced, biting animals. Plates of garnet and millefiori glass were also used to create the bold design of interlocked boars on the rounded end of the clasps.

Early objects of this kind enable us to understand the high technical level of the work done later for the church and the Christianized laity. One

Fig. 150. Gold shoulder clasps inlaid with garnets and mille-fiori glass. Sutton Hoo, Mound 1 ship burial, seventh century. London, British Museum, Sutton Hoo Treasure.

Fig. 151. Detail of the so-called Tara brooch. Gilded bronze annular brooch with panels of gold filigree and amber and glass studs, Ireland, eighth century. Found at Bettystown, County Meath. Dublin, National Museum of Ireland.

did not simply transpose the heathen metal ornament to the pages of manuscripts—that is hardly a sufficient account of the process. But no less important than the materials and techniques is the visual sensibility formed, through judgment and taste, in successive productions of works of art as well as in the commissioning of new works on a larger or richer scale. In Ireland we observe in the metalwork from the seventh century on an increasing assimilation of new forms that have come from the Germanic side, from England, and from the Continent. The famous eighth-century Tara brooch (Fig. 151), pseudopenannular in form, is of a type peculiar to the English and Scottish regions. The continuing growth of the older art is evident in the decoration of the brooch, in the division into panels, the relief of the frames, the contrast of colors, frame, and filling, the taste for triangular groupings, and the combination of interlace bands of different thickness, scale, and density. Most of the panels on the ring of the brooch and the triangular head of the pin are filled with a variety of gold interlace, some of which include animals' heads and other parts. The patterns of interlace go back to a Mediterranean source but acquired new rhythms and breaks from artists in Saxon England over the course of the seventh and eighth centuries.

The importance of the smith, or goldsmith, in that barbaric newly Christianized society certainly affected his self-consciousness as an artist, his feeling of liberty as an inventive mind, and the will to emulate and produce

an extraordinary work. It is evident in the social status of the smith as a craftsman. There are interesting legends about the smith, particularly the one who works in bronze, gold, and silver, the materials valued especially in armor and personal decoration as well as in treasure and gifts. The stories of Wayland, Eigil, Waltharius, and Siegfried—all those Germanic heroes who have counterparts in Celtic literature—treat the smith as a person of high merit and often of great social importance. The legends are clear on this point and contradict the common conception of the early medieval artist as an anonymous, selfless craftsman, referred to, after the Greek term, as a banausic personality who works with his hands rather than his mind and is without intellectual or imaginative powers. That view of the metalworker doesn't hold up to the character of his craft, which is so original and varied and often so fanciful that we think of him as an artist in the modern sense, one who strives to surpass previous work, in a style of his own, and to realize himself through ingenuity, complexity, and fantasy in the work. He is not doing a job strictly to order, one that has been prescribed in advance, nor following set rules of a craft but works with his own invented forms.

The smith's prestige in the Insular world is clear from the fact that in the sixth, seventh, and eighth centuries, we read of bishops who are goldsmiths as well as of priests who fabricate precious objects. The colophon of the Lindisfarne Gospels, of a later date than the manuscript but reliable in recording old information about it, attributes the writing of the manuscript to a bishop of Lindisfarne named Eadfrith and credits the beautiful gold and jeweled binding to the succeeding Bishop Aethelwold and to a hermit or anchorite monk named Billfrith.

Manual work then, in the fashioning of gold book covers and jeweled objects and in the craft of the scribe, was regarded as compatible with the dignity of a priest and even a bishop. The bishops ordained by St. Patrick are described in the old hagiographic books as gifted makers of croziers, reliquary crosses, and gold objects. In the seventh century, one of the greatest saints of northern France, St. Eloi, or Eligius in Latin, was an artist in gold and enamel who eventually became an abbot and finally a bishop. He was an ambassador of the Merovingian king and enjoyed the highest esteem throughout his lifetime. His tomb was the site of miracles, and his reputation as a goldsmith-saint was cherished by later artists in the precious metals.

Another sign of the goldsmith's prestige in the heathen and then in the Christian world, where the old tribal laws of the Germanic conquerors were preserved and still applied during the eighth and ninth centuries, is the fact that in the coded punishment of crimes against a person, injury to a goldsmith entailed a much higher wergeld, or penalty. If a carpenter was hurt he

would be paid, let us say $50; an ironsmith, $100; but a goldsmith, $500. These old distinctions were written into the laws of the Germanic peoples and are juridical evidence of the estimation of the gold and silver worker as an artist.

A great document of the resulting self-consciousness and pride of the goldsmith is the grand high altar of the church of Sant' Ambrogio in Milan, which dates from about 830 (Fig. 152). On the back of the altar, where the priest stands, are two medallions: on the one at the left is represented St. Ambrose, the patron of the church, crowning the Archbishop Angilbertus, who commissioned the altar; on the right medallion is the same Ambrose placing a crown on the head of a lay figure, identified by an inscription as *Vuolvinius magister phaber,* that is, the "master smith." *Phaber* is spelled with a *ph,* not an *f,* a pretension to learning, like spelling *smith* with a *y* instead of an *i.* (Note that *ph* as a Greek letter is retained in Latin translation for terms relating to philosophy, science, and the arts.) It is an unusual, isolated image in medieval art. We do not know of a classical work of the same type, though there is a story about Phidias putting his own portrait on the shield of Athena in his famous statue of the goddess and being punished for his irreverent boldness. It was not customary in the Middle Ages for an artist to declare himself by a representation of his crowning by the patron saint beside the image of an archbishop, especially in the more honorific place at the right. This equality of the goldsmith and archbishop is an example to remember when you come upon a modern statement about the anonymity and artisan status of the medieval artist.

A ninth-century Anglo-Saxon text confirms this high regard for the goldsmith. King Alfred, in translating into Anglo-Saxon the Latin *Consolation of Philosophy* by Boethius,[28] came upon the line "Where now lie the bones of the faithful Fabricius, the good Cato, and Brutus?" Fabricius was a Roman consul of the Republican period noted for his civic virtues and qualities. Alfred rendered this Latin passage: "Where now lie the bones of Wayland?" Wayland was the great legendary master of the smith's craft in German and Anglo-Saxon tradition. Alfred apparently identified *faber* in Fabricius with *faber* in the contemporary sense of goldsmith. By linking Wayland with the greatest names in the Roman tradition of civic virtue, Brutus and Cato, he affirmed the high role and dignity of the outstanding smith in his own culture and community.

With the prestige and self-conscious individuality of the smith as an artist in the Insular sphere, there was a corresponding valuation of the scribe and illuminator. They may be the same person, but we are not able to discern whether that is the case for particular manuscripts. In the barbarian north, the scribe was a new kind of craftsman, though not altogether new, who

Fig. 152. Archbishop Angilbertus II (r. 824–59) offering altar to St. Ambrose, who crowns him (left); St Ambrose crowning Vuolvinius, maker of the altar (right). Silver gilt relief rondels from the lower central portion of the back of the Golden Altar in Sant' Ambrogio, Milan, second quarter of ninth century.

acquired more importance with Christianity. The new religion, brought from the Mediterranean, was founded largely on the teachings of a book, the Bible, and particularly the Gospels. The copying of the sacred book was a religious task, accepted by monks, priests, and anchorites as a serious act of devotion, a source of spiritual merit. It was also a process through which one entered into closer contact with the inspiring message of the text itself. The writing of books in this newly literate society inherited the aura of a sacred work, a spiritual prestige that few books had possessed in the pagan world. The introduction of writing was particularly significant in Ireland, where the culture, having had little contact with the Greek and Roman worlds, remained without the institutions and customs of classical literary culture.

But when Christianity was introduced in Ireland in the fifth century, and in the course of renewed contact with Mediterranean Christianity in the sixth and seventh, the Irish church adopted the Latin language of the Roman church, as did the Anglo-Saxons, Franks, and Germanic conquerors in Italy and Spain. The new language was regarded as a sacred tongue, distinct from Irish, to be learned specially. Clergy and monks constituted a class of scholarly devotees of the Latin language, who also prized the pagan Latin authors. One had to learn from classical writings on grammar, rhetoric, and orthography—all that pertained to the word—in order to decipher and interpret the sacred texts and church fathers as well as to compose new literary works.

These northern converts became, as I said, devotees of the written word, with a passion unsurpassed in any culture we know. There is an incredible literature of the Irish monks, fragmentary, it is true, but clear in its physiognomy, a literature often concerned with word play, script, and the peculiarities of language. The writers are curious about Hebrew and Greek as well as Latin. Their knowledge of Hebrew and Greek was fragmentary and often incorrect; it is an obsessive interest that appears in the invention of pseudo-Hebrew and Greek words to match Latin terms. In commenting on a Latin phrase, they dig out from various sources the Hebrew and Greek equivalents. I mention these details to indicate the quality of their passion for the written word.

There had been, it seems, a preparation of this interest prior to Christianity in both the Anglo-Saxon and Irish spheres. What writing existed then in so-called oghamic and runic scripts was identified with the priesthood, mystery, and magic. The word *rune* comes from an old Germanic word pertaining to magical incantation and play; oghams have retained to the present day an aura of the occult because of the difficulty of their decipherment but also because of their association with the Druid priest and their restricted use.

The role and merit of the scribe were acknowledged socially in laws that gave the scribe a higher station than that of ordinary people, sometimes equal to a nobleman's or bishop's. The scribe's prestige is evident from the frequent reference to the act of copying and to the mastery and beauty of script, in accounts of lives of saints, bishops, and even rulers. The extraordinary respect for the written word in that literature has a parallel perhaps only in the tradition of Judaism, with its sacred Torah scroll and the importance given to every word, stroke, and mark as the bearer of hidden meanings that can be divined through a hermetic process of combination and decipherment. The legends about books and scribes; the riddles, poems, and questions about the nature of the letter, the alphabet, and the written word; and the fantasies concerning the pen, the parchment, and the scribe's work all form a rich complex of ideas and attitudes that enable us to see how the arts of the book, the act of writing and particularly the copying of the sacred book—even of the pagan classical works that are part of the education for reading and interpreting sacred writings—were a ground for the extraordinary flowering of the medieval illuminated manuscript. We see this process in contrast to the situation in the pagan world and even in the first centuries of Greek Christianity, when pagan attitudes and practice still prevailed in the decoration of books.

The new value of the written word and book can be observed in the manuscripts themselves. I shall begin by pointing to a frontispiece page in the Codex Amiatinus (Fig. 16). It undoubtedly copies a model in a sixth-century

Bible from the scriptorium of Cassiodorus, a former high official of the ruler Theodoric. Cassiodorus was a scholar and organizer of learning who established an institute for advanced biblical studies, together with classical studies, as preparation for knowledge of the Bible. The picture of a scribe in this codex, executed in England at the beginning of the eighth century as a copy of a Bible of Cassiodorus and brought from Rome to East Anglia by the abbot Ceolfrith of Wearmouth and Jarrow, represents not Moses as the author of the Pentateuch nor Cassiodorus himself, as has been supposed, but Ezra, as is indicated in the inscription at the top. Ezra is the figure who, after the deterioration of the manuscripts of the Old Testament, with the loss of many texts, reorganized and restored them and created a canon of the Bible. He is described in Nehemiah 8:1–2 in the Vulgate as *scriba* and *sacerdos*—scribe and priest—a model, therefore, of the priest-scribe, the priest-writer. He is not just a composer of new books, though he was an author, but one who writes with his own hand. We have in this miniature an exceptional image that is a document of the interest in the text of the Bible and its study at Squillace, southern Italy, in the monastery of Cassiodorus.

Another detail that reflects the importance of the scribe is the particular way of representing the evangelist as a writer at work. In old Greek Gospel manuscripts, he writes with the book in his lap. On a little table before him are the scroll or codex he is copying along with his ink, pens, and instruments for erasing, correcting, and polishing. The oldest known image of an evangelist who writes on a desk is the miniature of Mark in the Lindisfarne Gospels (Fig. 153). The table as the scribe's support does not appear in Byzantine art until much later, and is rarely, if ever, found in Muslim representations of scribes. Even in the nineteenth century, the Muslim scribe writes with the book in his lap. In the Lindisfarne page not only is the contemporary fixture introduced, unlike the traditional image of the scribe, but the evangelist is shown writing on an isolated parchment leaf with a ruled line inside, like a frame, as if he is preparing an ornamented or pictorial page that is to be inserted separately.

Also noteworthy is that in Insular books the miniatures do not provide a narrative illustration of the text as in manuscripts of the Old and New Testament in the East and later in the medieval West. While there are a few examples of narrative illustration in Insular manuscripts, the pictures of the evangelists or their symbols are more typical. Writers in Ireland and England often compose or quote verses about the symbols and identify them with the evangelists. John, for example, *is* an eagle; he is not merely symbolized by an eagle, but he *is the* eagle. It is a primitive and widespread mode of thinking, particularly strong in the Celtic and Germanic spheres. Heroes are named after

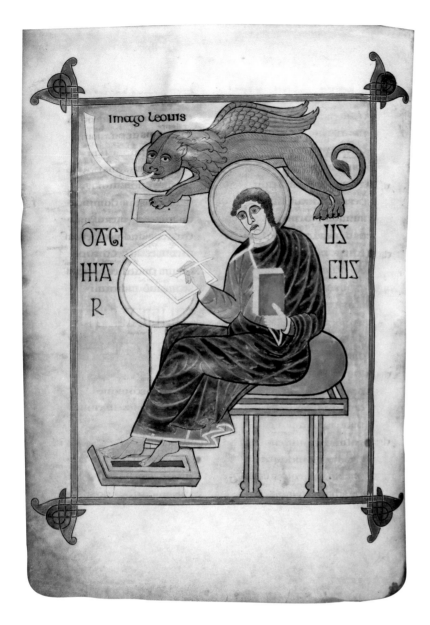

Fig. 153. St. Mark. Lindisfarne Gospels, Lindisfarne, late seventh or first quarter of eighth century. London, British Library, MS Cotton Nero D. IV, f. 93v.

an animal characterized by a quality appropriate to them. The image of the evangelist and his symbol is a projection of the scribe's self-consciousness. The authors of the books were often conceived as scribes, and all that pertained to the act of writing was of interest to the scribe-artist.

I would like to give another example of the scribe's self-consciousness as the maker of a book. In Maeseyck, Belgium, is a fragment of a manuscript produced in England during the eighth century in which the evangelist is depicted sitting on an unusual type of chair (Fig. 154). It is not the traditional model that we have seen in the Codex Amiatinus and other manuscripts, based on late classical and Near Eastern chairs. Instead he is depicted on a complex structure of which the seat is supported by a series of little arches under a horizontal rung with a triangle carrying a vertical member. It looks mysterious at first, unlike any furniture we know. A similar form appears on the tower of the eleventh-century church at Earls Barton, England (Fig. 155), south of the Humber. Pilasters are applied to the walls, not as structural members, but as a surface ornament; a series of small arches appears between the pilasters on the second story, and small triangles span the spaces between the pilasters on the story above. It is as if the artist enthroned the scribe on a church tower and endowed him with the elevation and majesty of the tower. It has been debated whether this strange form reproduced native wood construction or was borrowed from stone pilasters in the churches of the Rhineland that copy Mediterranean models. I believe that wood construction is the likely source; the evangelist's seat in our miniature suggests that there were actual thrones with a pattern of that kind. But what interests us here is the assimilation of the scribe's seat to a monumental form.

Fig. 154. Evangelist (unidentifiable). Maeseyck Gospels, fragment, probably Echternach, early eighth century. Maeseyck, Church of St. Catherine, Treasury, s.n., f. 1.

Fig. 155. Tower with pilaster strips. Church of All Saints, Earls Barton, Northamptonshire, eleventh century.

All this agrees with the high esteem for the scribe-illuminator as an individual who enjoyed the status of a learned man as well as of an artist and inherited something of the native Irish admiration for the man of mind or imagination, whether poet, scholar, or lawyer. In Ireland, prior to Christianity, in the courts of small local rulers, the poet and a type of scholar-poet called a *filid* and the *brehon,* who knew the laws by heart and could apply them in litigation, were recognized as men of high dignity in the social order. Something of that prestige was enjoyed by the first monks, abbots, and bishops, many of whom belonged to the aristocracy—in ruling a monastery they headed a religious community closely associated with kings and nobility. The succession of abbots was often within a single family, in the clan of the original abbot who was a nobleman.

How do the specific Christian content of the book and the circumstances of the scribe-artist-

intellectual, often a monk or priest with the intense religious vocation char-
acteristic of the fervent Christianity of the islands at that time, affect the qual-
ities of writing and the growth of ornament and illustration?

Let us compare the scribe's work with books of an earlier period. In
copying a pagan text, even of an author like Virgil, who was regarded as almost
a Christian for having predicted the coming of Christ and whose verses were
often quoted in a religious context, the scribe of the fourth or fifth century,
whether pagan or Christian, no matter how gifted, was impersonal in tran-
scribing the text. He was a pagan slave or hired artisan who worked in a shop
with others and wrote from oral dictation, producing a standard article. His
writing was only incidentally, if at all, affected by the content of what he tran-
scribed. In the oldest classical manuscripts, there is little sign of emotional
response to or recognition of the more important passages, the extreme situ-
ation, or the sacred allusions and names in the text. That doesn't mean it is
dull or mechanical work. On the contrary, we marvel at the beauty of the
rhythmical flow of strokes, thick and thin, in this seemingly routine script.
Standardization does not have the same effects in all cultures and under all cir-
cumstances. A standard form may be a noble artistic achievement. A page
from a fifth-century manuscript of Virgil's *Aeneid* (Fig. 156) exemplifies this
type of classical writing. The text is inscribed in a stream of marks of crys-
talline regularity and compactness with only the barest acknowledgment of
breaks between words and sentences or of varying stresses of meaning. The
great early Greek manuscripts of the Bible, such as the Alexandrinus or Sinaiti-
cus codices, were written in a similar manner, though in a different script (Fig.
157). Only at the end of each of the books in these Bibles do we come across a
few words enclosed in a simple decorative penwork border executed by the
scribe in the same ink as that used for the text. These decorative tailpieces
incorporate the principal title of the book, which appears at the end, rather
than the beginning, of each book in these manuscripts. In addition the first let-
ter at the top of the page or at the beginning of each paragraph, as in the Codex
Alexandrinus, is often isolated and enlarged.

A new conception of writing appears in Insular art. The page is appro-
priated by the scribe-artist as a field for individual fantasy, expression, and
elaboration. Certain words and phrases seem to incite him to do more than
write out the letters in a standard way. It is inconceivable to us that two pages
of the same text in two different Insular manuscripts or two successive pages
in the same book should look alike. The scribe and artist together, and some-
times the single scribe-artist, were inspired to design an initial at the begin-
ning of important sections of the text. The artist was not content to trace the
letter; he enlarged and embellished it, transforming it into a new whole that

is often unrecognizable. On fol. 19v of the Book of Kells (Fig. 158) the first five letters of *Zachariae* are enlarged. The word introduces the *capitula* or table of contents of the Book of Luke, which precedes the main body of the Gospel. At certain points the scribe-artist introduced little animals in the text; next to the dog is a small mark, shaped like a telephone; it was used by scribes to indicate that the next word belongs after the last letters in the line below. You see the letters *pas* at the end of the lower line and then, returning to that mark, read *toribus*, the end of the word *pastoribus*. Instead of writing continuously the scribe left blank spaces to which he would revert later. His procedure entailed analysis. We may discover in it an order, a principle of style, but even without such analysis we recognize the continuing response of the scribe-artist to certain words in the text according to their special weight and function as initial or terminal units or as elements of greater interest by virtue of their meaning.

I shall make this clearer through another example in a manuscript produced in France in the eighth century, the

exponitur uidendi desiderio collocato &

quaerentibus fructus laboris & do magiste.

rii doctrina seruetur

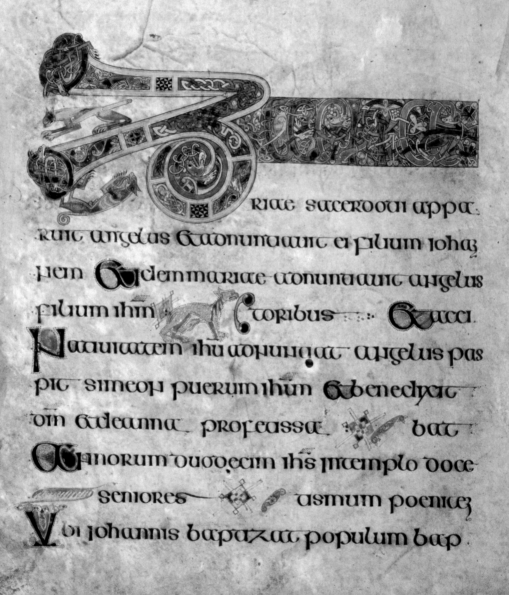

riae sacerdoti appa.

ruit angelus & adnuntiauit ei filium ioha.

nem & idem mariae adnuntiauit angelus

filium ihm toribus & acci.

Natiuitatem ihu adnuntiat angelus pas

pit simeon puerum ihm & benedicit

dm & anna prophetissa bat

& annorum duodecim ihs intemplo doce

seniores astrum poenitez

Ubi johannis baptizat populum bap

Gallican Missal (Fig. 159). It is written in several varieties of script. Just as there are different modes in poetry and music appropriate to different contents, so in script there is one style for the rubric of the prayers for a particular occasion, another for the title of a mass or sacrament, and a third for the text that is read aloud in a religious service (the deacon's function).[29] On the page from the Gallican Missal, at the point where a new passage, a prayer, begins with the words *Rege nos domine,* the R of *Rege* starts in the line above the word it introduces and descends two lines below it. Note also that the prayer for the beginning of Christmas Eve on the lower part of the page is marked by an immense *D* that belongs with the *[e]i* of *Dei* in the third line from the bottom. It intrudes into the text of the previous prayer; drawn in advance, it forces the latter to detour around it. Certain words are varied by distinctive contractions. While most are spelled out fully, *Domine* is written *Dñe* (Fig. 159, lines 3, 17) and *Iesu Christi* is *Ihū xp̄e* (Fig. 159, last line). These are sacred words, more significant than the others. To express this greater weight of meaning, the scribe often distinguished them in the uniform stream of letters by enlargement and richness or other accent.

In Hebrew manuscripts with vowel points, the name of God is written without the points. Where the text says *Adonai,* one pronounces *Jehovah;* where the text says *Jehovah,* one reads *Adonai.* One acknowledges thereby the sacredness of those words. In a related process in Christendom, by the seventh and eighth centuries, script underwent a transformation. Through variations of form, the scribe responded to sacred meanings and the hierarchy of word values in the text. Ornament was developed then as a device to mark, as with a visual fanfare, the entry into a text, or a particular section for oral reading in the church service, or to give a special resonance to a word that inaugurates an important text. I will not further discuss ingression, which I dealt with in the second lecture with regard to the *Liber generationis* page from the Lindisfarne Gospels (Fig. 23). Abbreviations and contracted forms in the writing replace the full sacred names. Eventually there was an increasing separation of words, a further breaking of the old stream of letters.

I leave this aspect to consider a concluding problem that has been much discussed: the roles of Ireland and England in the formation of this art and in the attribution of works to one or the other of these regions. It is not easy

to treat the problem in a fully detached spirit if one is either Irish or English. But I believe that even for a scholar who is not of those peoples, there are unconscious tendencies and sympathies, and implications beyond art that may affect one's understanding. I have wondered whether the attitude of certain Continental writers in support of the originality or priority of Ireland has to do with a national or personal bias. One will perhaps discover an Anglophilic trend in conclusions that are more favorable to an English thesis. I don't think I can go into sufficient detail here to warrant a definite statement. But I would like to indicate the state of opinion today. When I say "state of opinion" I mean it only in the broad sense that most scholars, and especially younger ones, incline in a certain direction.

It has been supposed by M. Masai, who adopted the drastic position I quoted earlier, that the Irish contributed nothing new to this art; Irish monks coming to England as scribes learned this art from native Anglo-Saxon artists and brought it to Ireland, where its decline appears in the inferior works of the ninth and tenth centuries.[30] There is also the view that nothing important was accomplished until about 700, when the Book of Durrow was produced, supposedly in Northumbria. This was followed by the Echternach Gospels, the Lindisfarne codex, and the Book of Kells, all of which for reasons too complex to present here have been assigned to Northumbria. In opposition to this view, some students believe that the Books of Durrow and Kells show so many connections with Scotland as well as Northumbria and contain so many features that appear in stone carvings in Scotland afterward that one can readily conclude that these manuscripts originated in Iona, an island off the western coast of Scotland, a famed monastic center from which Irish missionaries and pilgrims went forth throughout western Europe. Their role is an important chapter in the history of this art as well as of the church. Monks from Iona settled in the monastery of Lindisfarne in the 630s and left during the 660s, after having contributed to the local Anglo-Saxons, besides the tradition of writing, their ascetic way of life and probably certain models of art.

Nils Åberg and Carl Nordenfalk have shown that prior to the Book of Durrow there existed already in a series of Irish works, dating from the end of the sixth century to the middle of the seventh, elements of ornament, script, and decoration that may be regarded as examples of the prehistory of the Book of Durrow and the Echternach Gospels.[31] But none of those works has the scope, intensity, or grandeur of the manuscript art we are studying. They are evidence, however, that in an Irish milieu—in Ireland and Iona—book arts were practiced with form elements that served as a native starting point of the later Insular school. The Book of Kells is perhaps the most significant for this problem. As a great national monument, it has a prominent

place in the historical and cultural self-awareness of the Irish today. You cannot read James Joyce's *Finnegan's Wake* without thinking often of the Book of Kells; and modern Irish literature abounds in poetic details that remind one of features of the old manuscript. The fact that the Book of Kells was preserved in the monastery of Kells, as was the other book in Durrow, inclines us to believe that they were written there or by migrant Irish monks in England or Scotland. The question of the place of origin of a particular work is not the same, of course, as the question of the origin of the style of art. What in these manuscripts is specifically Irish? Are there distinctive Irish features? And further, what relative weight and role have the Irish forms, made available and developed further in England, especially in Northumbria and Scotland in the seventh and eighth centuries, in works by Irish artists, like the Tara brooch (Fig. 151)? To deal with these questions would require more space than is allowed here.

A few examples will illustrate the complexity of the interchange and the interlacing traditions and models within the Irish and Anglo-Saxon world. I have already discussed the remarkable painting in the Book of Kells of the Virgin and Child flanked by four angels who carry big scepters (Fig. 119). This page, a unique image in the manuscripts of the Insular school, is also exceptional as a theme in Irish art. But the type of Virgin and Child, a type in a broad sense that I shall qualify presently, did appear in Scotland, and that fact perhaps strengthens the idea of a connection of the Book of Kells with Iona. It has also been observed that in Durham, Northumbria, on the wood coffin of St. Cuthbert, an influential native Anglo-Saxon saint who died in 698, is incised a figure of the Virgin holding the Child across her lap (Fig. 160), clearly like the image in the Book of Kells. This similarity has been studied by Ernst Kitzinger, who, after pointing to the dependence of the Book of Kells on a Northumbrian work, has concluded that the image in the Book of Kells does not copy this Northumbrian type but rather a variant that must have circulated in Scotland as well, though not in Ireland, where no trace has been found of either the common type or the variant.[32]

What is the difference between the two works, apart from the fact, hardly noticeable, that the Virgin has a right and left foot on the Durham coffin and two right feet in the Book of Kells? You will note, first, that on the coffin the Christ figure holds a little scroll, and though the place of his hand has been damaged, we can make out fingers that suggest a gesture of blessing. Since Christ has a cross nimbus, the conception is of a Virgin and Child in which theological attributes of Christ as the Word and the source of the Gospels, as a member of the Trinity, and as the author of Salvation, are clearly indicated. In the corresponding miniature in the Book of Kells (Fig. 119), Christ has no halo, does not

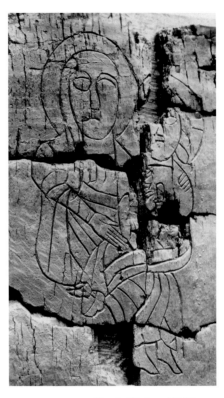

Fig. 160. Virgin and Child. Incised figures from the end of the oak coffin of St. Cuthbert, Lindisfarne, 698. Durham, Library of the Dean and Chapter of Durham Cathedral.

Fig. 161. Virgin nursing the Child. Niche fresco from the Monastery of Jeremiah, Saqqara, Egypt, seventh century. Cairo, Coptic Museum.

bless, and holds no book—a very different conception. But the Virgin there is dominant, monumentalized; three little crosses in her halo suggest a transfer of divine attributes to her, but I am not sure of that and shall propose another explanation later. She sits on a throne rich in metalwork, enamel, and inlay, whereas the Virgin in the Durham carving, who serves as a throne for the child, has not even a little stool for her own support. She is not glorified as in the Book of Kells. There we are in another sphere of religious imagination. Moreover, and this is more important, I think, not only does the Virgin in the Book of Kells embrace the Child, but the Child clasps the mother's hand and raises the other hand toward her. The intimacy and mutual love, so evident in this image, are lacking altogether in Durham.

What is the sense of that conception from Kells? Is it uniquely Irish or Scottish, or does it reproduce an older work, as has been supposed? Possible models for such an image can be found in Coptic Egypt. During the sixth and seventh centuries, particularly in monasteries, one represented the Virgin nursing the Infant Christ and the Infant grasping the mother's arm with both hands, such as in the example from Saqqara (Fig. 161). Still another appears in a Coptic miniature painting of 893 in the Morgan Library (Fig. 162). The enthroned Virgin nurses the Child, the Child holds the mother's hand, but here the Child has a small scroll and two angels accompany the image. It is clear then that in Coptic Egypt there existed the pictorial type of Virgin and Child as a theme of affection, with the mother nursing the Child. It enables us to understand a peculiarity of the miniature of Kells, namely, the Virgin's breasts drawn transparently through her robe. I believe that is a residue of the image of the so-called Virgo Lactans, the Virgin nursing the Child. The type is exceptional in icons and other representations of the Virgin and Child at this time. In Kells, however, there are four angels and not just two as in the Coptic work; the whole has an aspect of the monumental, unlike the other miniatures in the Book of Kells. We may ask then whether there did not exist in the churches of the British Isles wall and panel paintings with features like those of the Virgin and Child in the Book of Kells. None have survived, but old descriptions of churches in both Ireland and England, as early as the sixth century, mention wall decoration with panels and images of Christ and the Virgin and scenes from the Old and New Testament.

Fig. 162. Virgin nursing the Child between angels, painted by Isaac. *Eulogy of the Four Incorporeal Animals* (in Coptic) by John Chrysostom, Egypt (Ptepouhar, Fayum), 893. New York, The Pierpont Morgan Library, MS M.612, f. 1v.

One such text is the life of St. Brigit (d. 523) by Cogitosus, an Irish nobleman of the middle of the seventh or eighth century. He describes in Kildare the paintings, beautiful jewelry, metalwork and gold objects around the altar and on the tomb of St. Brigit, who was, in her lifetime, revered as "another Mary."[33] There is also the account of the decoration of the double monastery of Jarrow and Wearmouth, to which the abbot, returning from Rome in the latter part of the seventh century, brought pictures, which, we surmise, were panel paintings; we read of scenes of the Old Testament coupled with scenes of the New.[34]

A recently restored eighth-century icon of the Virgin and Child in the church of Santa Maria in Trastevere (Fig. 163) suggests a connection with Rome.

Fig. 163. Virgin and Child flanked by angels. Icon executed for Pope John VII, 705–7. Rome, Santa Maria in Trastevere.

The Virgin, a royal figure, is crowned and jeweled, but the Child is of a different type than in Kells, and there are only two flanking angels, both bearing knobbed scepters. For the four angels beside the enthroned Virgin, one must wait until late in the Middle Ages; they became common during the thirteenth and fourteenth centuries, as in the examples by Cimabue and Duccio. I do not doubt that there existed earlier panel and wall paintings of that type. In Santa Maria in Trastevere, where that icon is preserved, a great mosaic of the thirteenth century, with the Virgin nursing the Infant Christ, perhaps reproduces an ancient icon that had belonged to the time of the Book of Kells but has disappeared. We see that the question whether the Book of Kells is a Northumbrian or Scottish work is complicated by the fact that while its unique features seem isolated and original, they are similar in some respects to contemporary and later works in distant Egypt and Rome. From these we may infer that in England and Ireland, during the seventh and eighth centuries, there existed more than one stream of types from which artists could select. A broad resemblance of type does not permit us to draw a definite conclusion as to the immediate source of a particular image.

One question about the relation of Kells to England can be answered in a positive way through the evidence of single details. It was supposed long ago that the Book of Kells is exceptional among the works we have discussed in its use of foliate ornament beside the usual interlace and animal motifs. This foliate ornament has been explained as the outcome of contact of the artists of the Book of Kells, whether in Iona, Ireland, or Northumbria, with the Carolingian art of the Continent, particularly of the Rhineland, during the last years of the eighth century or at the beginning of the ninth. It is an art that revives many features of late classical pagan and early Christian classical styles, especially in the foliate ornament. While those characteristic scrolls and long leaves with berries are found in the Book of Kells, for example, in the upper right corner of the Temptation of Christ (Fig. 37), one can also point to an example of similar ornament in a work dated before 746 (perhaps as early as 735), a manuscript of Bede's *Ecclesiastical History of the English Nation* in the State Public Library in St. Petersburg, which E. A. Lowe once thought contained the autograph of Bede himself in the colophon.[35] In an initial *B* of this manuscript (Fig. 164), we see a plant with a rising diagonal stem and berries and long pointed leaves precisely as

in the Book of Kells. Another motif of Kells, the banding of a field and its filling with color as in inlay work, is found in several initials of the Bede manuscript, which was produced in Wearmouth/Jarrow, Northumbria, forty or more years before the Book of Kells. It is clear evidence that the model for these ornaments, so exceptional in the major works of the Insular school but found particularly in the Book of Kells, existed in Northumbria two generations before.

Other details in Kells show the extent of the Northumbrian penetration of the Irish milieu of Iona, where many Anglo-Saxon students and scholars, some from noble and royal families, came. In Iona, as in other centers, one can trace close connections with art from Northumbria and the south of England. The movement was not in one direction, as has been supposed, from the north to the south, or from the west of England and Scotland to the east, but in both directions. On the page with St. Matthew in the Book of Kells (Fig. 165), you will observe a peculiar element in the framing of the figure and the throne: the series of small tongue-shaped forms that run in a band across the top of the curved back of the seat. This form, which is hard to understand as part of a chair—it could be an ornament—appears in a miniature of St. Luke in an Italian manuscript of the sixth century, which belonged to the church in Canterbury and is now in the library of Corpus Christi College, Cambridge (Fig. 166). This manuscript was long believed to be one of the books brought by the St. Augustine who was sent by Pope Gregory as a missionary to southern England at the end of the sixth century. We do not know whether that tradition is reliable, but the manuscript was probably in the Canterbury Library throughout the Middle Ages and it might well have been brought from Rome by at least the end of the seventh century, if not earlier.

We find in it not only the detail on the back of the chair but also the peculiar arch, wider than the span between the inner supporting columns, a form that reappears in the curious enframements of the figure in the Book of Kells (Fig. 165). Just how one arrived at that solution I do not know. It was prepared or suggested in other Italian works. In the Orthodox Baptistry of Ravenna the stucco figures of prophets (Fig. 120) stand in a flat rendering of a three-dimensional space in which the two back columns have been pulled forward and the entablature they support seems to rise up to meet a surmounting form rather than recede back in space. Here then there is a columnar support with an outward movement of the entablature and the arch going over it.

A second telltale sign of an Italian ancestor in the architectural frames of the Kells artist is the peculiar form of the capitals on one of the Canon Table pages (Fig. 167). It is shaped like a bowl surmounted by an upward flaring vessel with the two bordered by a single continuous band, as if they were a single member. Each, however, has a separate filling, like two distinct

Fig. 164. Initial *B* of *Brittania* enclosing plant forms from a copy of Bede's *Ecclesiastical History of the English Nation*, Northumbria, Wearmouth/Jarrow, ca. 746. St. Petersburg, State Public Library, MS Q.v.I.18, f. 3v.

Following two pages:
Fig. 165. St. Matthew. Book of Kells, Iona (?), ca. 800. Dublin, Trinity College, MS 58, f. 28v.

Fig. 166. St. Luke surrounded by scenes from the life of Christ. Gospel Book of St. Augustine (?), Italy, sixth century. Cambridge, Corpus Christi College, MS 286, f. 129v.

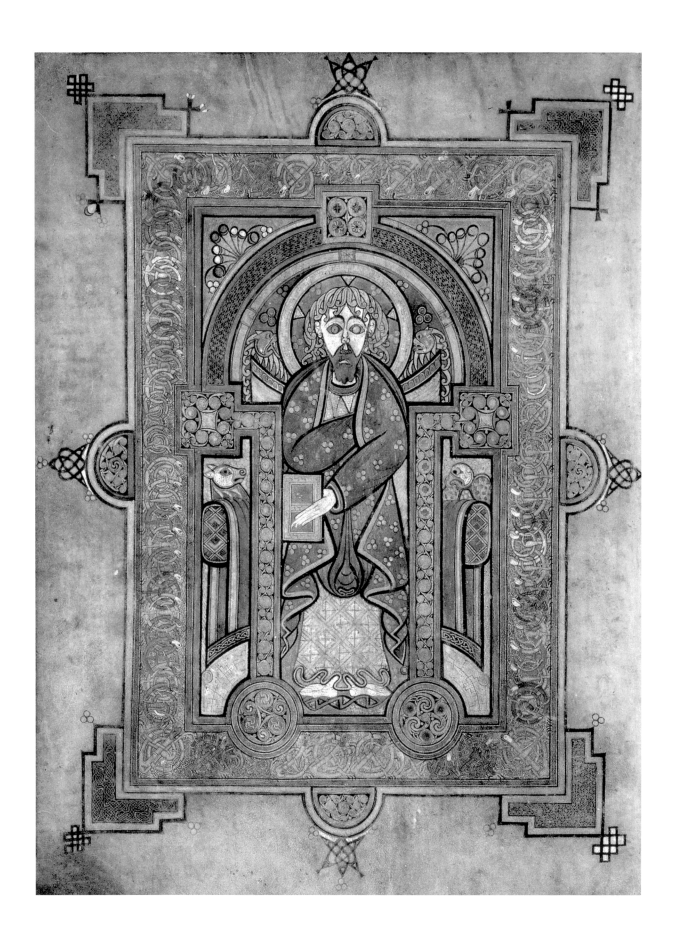

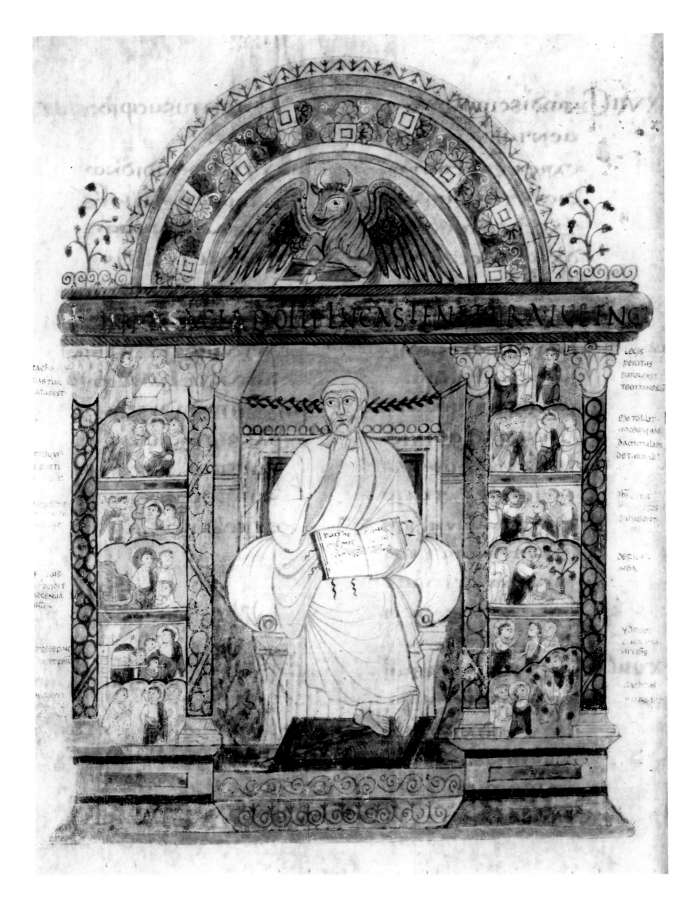

Fig. 167. Canon Table. Book of Kells, Iona (?), ca. 800. Dublin, Trinity College, MS 58, f. 2v.

receptacles. I shall not analyze here the extremely interesting and characteristic process of the artist in recomposing the elements of a real architecture that he has known through an older representation. What interests us here is the model or source. A student of early Christian buildings will recognize in that form the combination of a basket capital and a high, flaring pulvin on columns of the fifth and sixth centuries in Saloniki and Ravenna (Fig. 168).

Other characteristic features of the Book of Kells that reveal the assimilation of Italian forms are found in the portrait of John (Fig. 18), whose frontal pose and widespread feet bear a relationship to the figure of Christ in the Codex

Amiatinus (Fig. 169), executed by Anglo-Saxon artists after an Italian model of the sixth century. In the Book of Kells, however, the posture of John becomes even more rigid, more marked, and more closely tied to the frame, as I observed in a previous lecture. The conception of the Amiatinus Majesty, in which Christ, sitting on a huge cushion on a throne, is set within a mandorla of concentric circles, is found again in the Kells portrait of John (Fig. 18) in the circle enclosing the smaller circle around his head, which is more than a halo and, as a halo, is so extraordinary. These concentric circles are more intelligible if seen in relation to a picture of Christ like that in

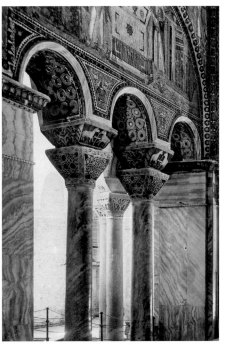

Fig. 168. Basket capitals with high, flaring pulvins. San Vitale, Ravenna, 546–48.

Fig. 169. Christ in Majesty with the four evangelists and their symbols. Codex Amiatinus (Bible), Wearmouth/Jarrow, before 716. Florence, Biblioteca Medicea Laurenziana, MS Amiatinus 1, f. 796v.

the Northumbrian Codex Amiatinus, where the recurrent circularity suggests an image of Heaven with angelic spheres and circles and with angels beside the Lord. John is the evangelist who was most closely identified with Christ; he was revered not only as the theologian-evangelist but also as the celestial evangelist whose mind was able to soar to the highest heavenly realms like the eagle, and his closeness to Christ at the Last Supper was particularly noted by Bede and Alcuin of York. The transfer of attributes from Christ to John is therefore less astonishing or unlikely. I would suggest, too, that in the Amiatinus page the form of the angel at the left with his heavy robes and the parallel lines of the folds may be rediscovered in the evangelists of the Book of Kells.

Another surprising work about which I hesitate to draw a definite conclusion but I show because of its great suggestiveness in this context is a prefatory page of the Codex Amiatinus (Fig. 170). The text is an excerpt from the account of the contents and divisions of the books of the Bible, written by Hilary, an important saint in Gaul, a region with which the Insular world was in close contact during this early period. Observe how the text is framed schematically by three circles above and how the crosses are joined to them by an arch. Note also the *Tabula Ansata* below as well as above. One is reminded of the three circles around John's halo in the Book of Kells (Fig. 18) as well as of the immense crosses inserted in his frame.

Fig. 170. Diagram showing the order of the books of the Old and New Testaments according to St. Hilary. Prefatory text, Codex Amiatinus (Bible), Wearmouth/Jarrow, before 716. Florence, Biblioteca Medicea Laurenziana, MS Amiatinus 1, f. VII.

I shall touch briefly on an aspect of this art that may be more specifically, even uniquely Irish, since it appears in its fullest development in the Book of Kells, namely, the elaboration of marginal and script ornament as a field of free figurative fantasy, not as illustration or symbolism, but as a spontaneous imagery of fanciful human and animal figures. Earlier I spoke of these animal and human forms as themes of violence against oneself as well as others as themes of sexuality, and finally, as themes of irony, parody, or playful allusions to religion and the text. It is a mode of pictorial fantasy that had a great fortune in the Middle Ages, especially after the eleventh century but most of all on the margins of manuscripts of the thirteenth and fourteenth centuries. That the margins of a religious text are a field for imagery unconstrained by

rules, that the artist is free to allude in these images to the text itself or to personal fantasies, is surprising in a culture driven by Christian devoutness. Medieval art generally has been understood as motivated by a religious idea or outlook that imposes a necessary order and unity on the whole. Here, on the contrary, we discover features that remind us of the arts of the modern period, arts concerned with individual perceptions and fantasy.

For example, on the page with the initial *Z* previously discussed (Fig. 158), a doglike creature with a spiral tail and exposed genitals seemingly pursues the cat above, shown with a rigid tail. The form of the cat's tail was suggested partly by the slope of the *Z* and the coiled end of the dog's tail by the spiral end of the letter. It is the letter itself that provided a model or formal analogue from which sprang the fantasy about animals, of living forces polarized, contrasted with each other as being right side up and upside down; one moving left, the other right; one with tail out, the other with tail coiled inward. Such duality is one of the basic themes or ideas in the creation not only of contrast but of wild fantasy in different arts throughout the world, in poetry and music as well as in visual forms. I have given an example earlier in the engaging lower left corner of the great *Chi-Rho* initial of the Book of Kells with the two cats behind two mice (Fig. 32) who hold between their jaws a wafer marked with the cross. On the backs of the cats are two mice who are watching. What is the sense of this image? Is it an abstruse religious thought, a translation of religious ideas into symbolic animal forms? I am inclined to doubt this, but I believe the conception might have had a religious context, though not a homiletic or theological one. More essential, rather, is the self-indulgent liberty of the artist who imposes his own fanciful thought on that context as the painstaking poetic master of the sacred page.

Let us turn to other works that correspond to it. On the margin of a manuscript of the fourteenth century in Brussels (Fig. 171), a dog holds a book and a hare swings a censer. The image transforms the persons of the church, the clergy of the Mass, into an animal world. Gothic liturgical manuscripts abound in such imagery and playful ideas. They are a boundless reservoir of humor, spirited play, and sustained vitality. Lillian Randall published a book with nearly a thousand reproductions of thirteenth- and fourteenth-century pictures of that type.[36] They are a great surprise in their revelation of the energy of uninhibited bodily movement, the flexibility of the human body, and the artist's freedom to parody the sacred on the margins of liturgical books. Marginal art is a distinct category that we can understand not only through its place but also through the role of the artist in the rest of the work. Another example is from the Ormesby Psalter, an English manuscript of the fourteenth century (Fig. 172). Here a man in armor is beheading a five-

Fig. 171. Dog holding book and
hare swinging censer, margina-
lia. Bible, Belgium, ca. 1330–40.
Brussels, Bibliothèque royale
de Belgique, MS 9157, f. 419v.

Fig. 172. Monks chanting in
initial *C* of *Cantate* beginning
Psalm 97 with a man fighting a
dragon and two hares assault-
ing a dog in the lower margin.
Ormesby Psalter, Diocese of
Norwich, early fourteenth
century. Oxford, Bodleian
Library, MS Douce 366, f. 128.

headed dragon, while below two hares belabor a dog, an inversion of the
world where dogs usually chase hares—it is a reversal, a world upside down,
so to speak, as in folklore imagery.

I believe that the cats and mice in the Book of Kells, especially the
mice, have to do with a similar theme, based on a story in the lives of Paul
and Anthony, saints very dear to the Insular churches. Paul was an Egyp-
tian hermit to whom a raven brought daily half a loaf of bread. One day he
was visited by St. Anthony. The raven then brought a whole loaf, and the
two hermits, having to decide who should break it, held it jointly and broke

it in two. Paul and Anthony are often mentioned in Ireland and England in devotional writing and commentaries about monasticism and the ascetic life. They were depicted in the eighth century on the Ruthwell Cross, as standing figures who hold the round loaf of bread between them (Fig. 173). Is it a reconciliation of the hermit and the church? The image reappears in Ireland on stone crosses of the ninth and tenth centuries, such as those in Monasterboice (Fig. 174), Castledermot, and Moone Abbey (Fig. 175). The last, badly weathered, can be better understood in the accompanying drawing (Fig. 176). I regard the two mice with the wafer, and the cats watching them, as a parody of the theme of Paul and Anthony. Perhaps you will disagree with this interpretation; I cannot find a simpler or better one.

The theme of the cat is related, however, to another fantasy of a monk, one who feels for the cat as Baudelaire felt for it, though not entirely with Baudelaire's sense of the cat as the embodiment of female personality, a creature subject to her own whims, characteristically domestic, yet independent, and dear to lovers and scholars.

I quote my translation of Baudelaire's "Les Chats."[37]

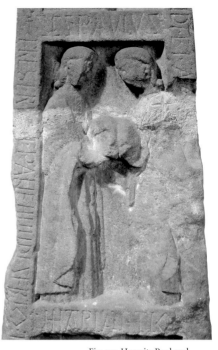

Fig. 173. Hermits Paul and Anthony breaking bread. Relief from north side of the Ruthwell Cross, Northumbria, second quarter of eighth century. Stands inside the church at Ruthwell, Scotland.

THE CATS

Mad lovers and scholars cool
Both delight in pussy cats,
Strong and soft, with whom one cannot fool;
They chill at once and hunt for rats.

Friendly to science and to joy,
They seek out silence and the horrid shades.
Erebus would have taken them for steeds
Could they have bowed to such employ.

In brooding thought their noble attitude
Is like the sphinxes' in deep solitude
Sinking to sleep in some endless dream.

Their fecund loins are full of magic rays,
And sparks of gold in a glowing stream
Set their vague mystic eyes ablaze.

The cat appears in Irish literature in several contexts, but there is a particular one I should like to cite, and, as a parallel to it, a drawing in a manuscript of ca. 838 written in Ireland, now in the library of the University in Leiden (Fig. 177). It is a Latin text of Priscian, a classical writer on grammar.

Fig. 174. Hermits Paul and Anthony holding staffs and breaking bread. Relief, top north side of the cross of Muiredach (south cross), Monasterboice, County Louth, tenth century (?).

Fig. 175. Hermits Paul and Anthony breaking bread with a plump raven hovering overhead. Relief (badly weathered) from the north face of the cross at Moone Abbey, County Kildare, ninth century.

Fig. 176. Drawing of Paul, Anthony, and the raven in Fig. 175. From Françoise Henry, *Irish Art During the Viking Invasions (800–1020 A.D.)*, Ithaca, 1967, 146, fig. 19b.

Fig. 177. Cat seated on initial *N* of *Nomen*. Priscian, *Institutiones grammaticae*, Ireland (Armagh?), ca. 838. Leyden, Universiteitsbibliotheek, MS BPL 67, f. 23v.

A cat is represented perched in profile on the top of the tall vertical leg of the *N*. This drawing of the cat in a context of scholarly reading, of learning the Latin language, will recall to readers of Irish poetry an enchanting little poem, written by an Irish monk in the eighth or early ninth century. It was translated by Gerard Murphy[38] as follows:

I and white Pangur practise each of us his special art: his mind is set on hunting, my mind on my special craft.

I love (it is better than all fame) to be quiet beside my book, diligently pursuing knowledge. White Pangur does not envy me: he loves his childish craft.

When the two of us (this tale never wearies us) are alone together in our house, we have something to which we may apply our skill, an endless sport.

It is usual, at times, for a mouse to stick in his net, as a result of warlike battlings. For my part, into my net falls some difficult rule of hard meaning.

He directs his bright perfect eye against an enclosing wall. Though my clear eye is very weak I direct it against keenness of knowledge.

He is joyful with swift movement when a mouse sticks in his sharp paw. I too am joyful when I understand a dearly loved difficult problem.

Though we be thus at any time, neither of us hinders the other: each of us likes his craft, severally rejoicing in them.

He it is who is master for himself of the work which he does every day. I can perform my own work directed at understanding clearly what is difficult.

The drawing of the cat, like the drawing of the cats and mice in the Book of Kells (Fig. 32), has an element of self-avowal. It conveys an attitude toward the animal world, which is not of admired and glorified force, nor of self-torment, but of whimsical appreciation of the cat by a monk, a scholar-scribe who is engaged in intricate decipherment of a difficult text.

NOTES

1. The lectures took place at The Pierpont Morgan Library in 1968, on March 4, 11, 18, 20, 25, and 27.

2. John Ruskin, *Sesame and Lilyes*, Lecture III, "The Mystery of Life and Its Art" in *The Works of John Ruskin*, E. T. Cook and Alexander Wedderburn, eds., New York, Longmans, Green, 1903–12, vol. 18, pp. 170–74.

3. J. O. Westwood, *Facsimiles of the Miniatures and Ornaments of Anglo-Saxon and Irish Manuscripts*, London, B. Quaritch, 1868.

4. In Durrow, John's symbol is not the customary eagle but, following a pre–St. Jerome order, the lion. Irenaeus of Lyon, for example, in the second century, had connected the lion with John.

5. That term has been used with reference to this page of the Durrow work in a study of the sculptures of the abbey church of Souillac published in the volume *Medieval Studies in Memory of Arthur Kingsley Porter*, Harvard University Press, Cambridge, Mass., 1939, p. 362, n. 4 (reprinted in *Romanesque Art. Selected Papers of Meyer Schapiro* I, New York, George Braziller, 1978, p. 104ff., n. 4). The concept goes back to Meyer Schapiro's observations of the sculptures of Moissac and Souillac in 1926–27.

6. Concerning the principle of the "active," participating frame, do not all frames (e.g., classical and Renaissance) participate in the effect of the whole? But compare seventeenth- to nineteenth-century frames, which are applied or *chosen* only after the *painting is finished,* while in Insular and many other medieval works, it is constructed and filled, in the same process of design as the picture itself. It is part of the latter.

7. G. B. de Rossi, *La Bibbia offerta da Ceolfrido, abbate al Sepolchro de S. Pietro: Al Sommo Pontifice Leone XIII, omaggio giubilare della Biblioteca Vaticana*, Rome, 1888.

8. Alfred North Whitehead, *Process and Reality: An Essay in Cosmology*, New York, The Humanities Press, 1957, pp. 34 (items vii, viii), 38, 66, 245, 356, 444.

9. The *Chi-Rho* initial introduces the text of Matthew 1:18, "Christi autem generatio," which begins the narrative of Christ's life. The *h* form at the bottom of the page is an abbreviation for *autem*.

10. The source of the Herschel citation has not been identified. For the advanced skills of prehistoric and later Scandinavian artisans as a foundation of later technological progress, see Thorstein Veblen, in *The Instinct of Workmanship and the State of the Industrial Arts*, New York, A. M. Kelley, 1964 (first appeared ca. 1914), pp. 103–37, esp. 127–28, 131–37.

11. Staatsbibliothek, Bamberg, MS. patr. 61, fol. 29v. See P. Courcelle, "Le Site du monastère de Cassiodore," in École française de Rome, *Mélanges d'archéologie et d'histoire,* vol. 55, 1938, p. 266ff., and E. A. Lowe, *Codices Latini Antiquiores*, Oxford, Clarendon Press, 1934–71, Part 8, pp. 3, 60.

12. Flavius Josephus, "The Jewish Antiquities," in *Josephus in Nine [i.e., Ten] Volumes*, with English translation by H. St. J. Thackeray et al., Cambridge, MA, Harvard University Press, 1976–81, vol. 4, pp. 23, 25.

13. John Milton, *Paradise Lost*, Book 5, ll. 623–24.

14. Gerard Baldwin Brown, *The Arts in Early England*, London, John Murray, 1921, vol. 5, fig. 27, p. 381.

15. John Romilly Allen, *Celtic Art in Pagan and Christian Times*, London, Methuen & Co., 1912, pp. 244–79.

16. Táin Bó Fraích, sections 9, 10; James Carney, *Studies in Irish Literature and History*, Dublin, Institute for Advanced Study, 1955, p. 4.

17. *The Works of John Ruskin*, E. T. Cook and Alexander Wedderburn, eds., New York, Longmans, Green, 1903–12, vol. 16, pp. 274–75.

18. The cross is now dated to the tenth century, but the formal comparison remains instructive. See Peter Harbison, *The High Irish Crosses of Ireland: An Iconographical and Photographic Survey* (Monographien, Römisch-Germanisches Zentralmuseum, Mainz, Forschungsinstitut für Vor- und Frühgeschichte, vol. 17), Bonn, 1992, p. 376.

19. Richard Broxton Onians, *The Origins of European Thought About the Body, the Mind, the Soul, the World, Time and Fate: New Interpretations of Greek, Roman, and Kindred Evidence, Also Some Basic Jewish and Christian Beliefs*, Cambridge, Cambridge University Press, 1951; reprint, Cambridge, 1988.

20. Otto Karl Werckmeister, *Irisch-northumbrische Buchmalerei des 8. Jahrhunderts und monastische Spiritualität*, Berlin, de Gruyter, 1967, pp. 40–42, pls. 4, 5b. Compare another Visigothic buckle in the Museum of Vich reproduced in its horizontal aspect in Helmut Schlunk, "Arte Visigodo," in *Ars Hispaniae*, Madrid, 1947, vol. 2, 310, fig. 327F.

21. The name of the king and the source from which this account was taken are unknown. But the recognition of and admiration for Roman remains in seventh-century Britain are corroborated by the well-known contemporary report of a visit to Carlisle by St. Cuthbert, Bishop of Lindisfarne (d. 687). According to his biographer, Cuthbert and his party were shown the city walls and fountain, which Waga, the reeve of the city who was conducting them, explained had been built "in a wonderful manner by the Romans." *Anonymous Life of St. Cuthbert*, Book 4, chapter 8, p. 123; Bertram Colgrave, *Two Lives of Saint Cuthbert: A Life by an Anonymous Monk of Lindisfarne and Bede's Prose Life*, Cambridge, Cambridge University Press, 1940, 122–23; reprint, Cambridge, 1985. In Bede's account of the visit, it is the citizens of the city who show Cuthbert the "marvelously constructed" Roman walls and fountain; ibid., chapter 27, 242–45.

22. Bernhard Salin, *Die altgermanische Thierornamentik*, Stockholm, Wahlström & Widstrand, 1904; reprint, Stockholm, 1935.

23. Apuleius, *The Golden Ass*, translated with an introduction by P. G. Walsh, New York, Oxford University Press, 1994, Book 11, chapter 22, pp. 233, 268ff.

24. Gregory of Tours, *The History of the Franks*, translated with an introduction by

Lewis Thorpe, Harmondsworth, Penguin Books, 1979, Book 8, chapter 15, pp. 445–47.

25. N. P. Kondakov, *Histoire de l'art byzantine considéré principalement dans les miniatures*, translated by M. Trawinski, Paris, Librairie de l'Art, 1886–91; reprint, New York, Burt Franklin, 1970, pp. 74–75.

26. François Masai, *Essai sur les origines de la miniature dite irlandaise*, Brussels, Éditions "Erasme," 1947, pp. 15–18, 21–26.

27. Howell D. Chickening, Jr., *Beowulf: A Dual-Language Edition*, Garden City, Anchor Press/Doubleday, 1977, pp. 50–51, ll. 26–52.

28. E. K. Rand and S. J. Tester, *The Theological Tractates/Boethius*, Cambridge, MA, Harvard University Press, 1973 (1978 printing), p. 222, l. 15; for King Alfred's translation, see Walter J. Sedgefield, *King Alfred's Old English Version of Boethius De consolatione philosophiae*, Oxford, The Clarendon Press, 1899; reprint, Darmstadt, Wissenschaftliche Buchgesellschaft, 1968, p. 46, ll. 16–20.

29. See the remarks on "modes" as "stylistic" in the article, "Style," reprinted in *Theory and Philosophy of Art: Style, Artist, and Society. Selected Papers of Meyer Schapiro* IV, New York, George Braziller, 1994, pp. 94–96.

30. On M. Masai, see the article, "The Place of Ireland in Hiberno-Saxon Art," reprinted in *Late Antique, Early Christian and Mediaeval Art. Selected Papers of Meyer Schapiro* III, New York, George Braziller, 1979, pp. 225–41.

31. Nils Åberg, *The Occident and the Orient in the Art of the Seventh Century, the British Isles*, Stockholm, Wahlström & Widstrand, 1943, p. 88ff.; Carl Nordenfalk, "Before the Book of Durrow," *Acta Archaeologia*, vol. 18, Copenhagen, 1947, pp. 141–74.

32. Ernst Kitzinger, "The Coffin Reliquary," in *The Relics of St. Cuthbert*, C. F. Battiscombe, ed., Oxford, Oxford University Press, 1956, pp. 223, 248–64.

33. Sean Connolly and Jean-Michel Picard, "Cogitosus: Life of St. Brigit" (English translation), in the *Journal of the Royal Society of Antiquaries of Ireland*, vol. 117, 1987, pp. 5–27. For the Latin text, see J.-P. Migne, *Patrologia Latina*, Paris, 1884–1864; reprint, Turnhout, Brepols, 1982, vol. 72, cols. 775–90.

34. Bede, *Lives of the Holy Abbots of the Monastery in Wearmouth and Jarrow* in *Baedae opera historica* (with an English translation by J. E. King), The Loeb Classical Library, Cambridge, MA, Harvard University Press, 1954, vol. 2, pp. 405–7.

35. E. A. Lowe, "An Autograph of the Venerable Bede?" *Revue Bénédictine*, vol. 68, 1958, pp. 200–202; see also P. Meyvaert, "The Bede 'Signature' in the Leningrad Colophon," *Revue Bénédictine*, vol. 71, 1961, pp. 274–86.

36. Lillian Randall, *Images in the Margins of Gothic Manuscripts*, Berkeley, University of California Press, 1966.

37. Translation by Meyer Schapiro, October 18, 1968, of Baudelaire's "Les Chats," after reading the linguistic analysis of Roman Jakobson and Claude Lévi-Strauss.

38. Gerard Murphy, *Early Irish Lyrics, Eighth to Twelfth Century*, Oxford, Clarendon Press, 1956, pp. 2–3.

INDEX OF
MANUSCRIPTS CITED

BY TYPE AND POPULAR NAME

Codex Egberti. *See* Trier, Stadtbibliothek, Cod. 24

Codex Romanus. *See* Vatican City, Biblioteca Apostolica, MS lat. 3867

Codex Washingtonianus. *See* Washington, D.C., Smithsonian Institution, Freer Gallery of Art

Dimma, Book of. *See* Dublin, Trinity College, MS 59

Durrow, Book of. *See* Dublin, Trinity College, MS 57

Echternach Gospels. *See* Paris, Bibliothèque nationale de France, MS lat. 9389

Egberti Codex. *See* Trier, Stadtbibliothek, MS Cod. 24

Gallican Missal. *See* Vatican City, Biblioteca Apostolica, MS Pal. lat. 493

Gellone Sacramentary. *See* Paris, Bibliothèque nationale de France, MS lat. 12048

Genesis, Caedmonian. *See* Oxford, Bodleian Library, MS Junius 11

Gospel Books/Gospels

 Armagh? *See* London, British Library, MS Harley 1023

 Armenian, of 966. *See* Baltimore, Walters Art Museum, MS 537

 Armenian, of 1193. *See* Venice, Mekhitarian Library of the Monastery of San Lazzaro, MS 1635

 Armenian, of 1230. *See* Venice, Mekhitarian Library of the Monastery of San Lazzaro, MS 325

 Barberini. *See* Vatican City, Biblioteca Apostolica, MS Barberini lat. 570

 Dimma. *See* Dublin, Trinity College, MS 59

 Durham Cathedral. *See* Durham, Cathedral Library, MS A.II.17

 Durrow. *See* Dublin, Trinity College, MS 57

 Echternach. *See* Paris, Bibliothèque nationale de France, MS lat. 9389

 Greek. *See* Washington, D.C., Smithsonian Institution, Freer Gallery of Art

 Kells. *See* Dublin, Trinity College, MS 58

 Lindisfarne. *See* London, British Library, MS Cotton Nero D.IV

 MacDurnan. *See* London, Lambeth Palace Library, MS 1370

 Maeseyck. *See* Maeseyck, Church of St. Catherine, Treasury, s.n.

 Matilda. *See* New York, The Pierpont Morgan Library, MS M.492

 Mulling. *See* Dublin, Trinity College, MS 60

 Rabbula. *See* Florence, Biblioteca Medicea Laurenziana, MS Plut. I, 56

 St. Augustine. *See* Cambridge, Corpus Christi College, MS 286

 St. Chad. *See* Lichfield, Cathedral Treasury, s.n.

 St. Gall. *See* St. Gall, Stiftsbibliothek, Cod. 51

 Trier. *See* Trier, Domschatz, Cod. 61

 Vatican. *See* Vatican City, Biblioteca Apostolica, MS lat. 3806

 Washingtonianus. *See* Washington, D.C., Smithsonian Institution, Freer Gallery of Art

Gospel Lectionary. *See* Trier, Stadtbibliothek, Cod. 24

Institutiones divinarum et secularium litterarum of Cassiodorus. *See* Bamberg, Staatsbibliothek, MS patr. 61

Institutiones grammaticae of Priscian. *See* Leyden, Universiteitsbibliotheek, MS BPL 67, St. Gall, Stiftsbibliothek, Cod. 904

Jumièges, Robert of, Sacramentary. *See* Rouen, Bibliothèque municipale, MS Y.6

Kells, Book of. *See* Dublin, Trinity College, MS 58

Liébana, Beatus of. *See* New York, The Pierpont Morgan Library, MS M.644

Lectionary, Gospel. *See* Trier, Stadtbibliothek, Cod. 24

Letter of Ausonius. *See* London, British Museum, Papyrus 2492

Lindisfarne Gospels. *See* London, British Library, MS Cotton Nero D.IV

MacDurnan Gospels. *See* London, Lambeth Palace Library, MS 1370

Maeseyck Gospels. *See* Maeseyck, Church of St. Catherine, Treasury, s.n.

Marvels of the East. *See* Oxford, Bodleian Library, MS Bodley 614

Matilda Gospels. *See* New York, The Pierpont Morgan Library, MS M.492

Missal, Gallican. *See* Vatican City, Biblioteca Apostolica, MS Pal. lat. 493

Mulling, Book of. *See* Dublin, Trinity College, MS 60

Ormesby Psalter. *See* Oxford, Bodleian Library, MS Douce 366

Papnuthius, letter to. *See* London, British Museum, Papyrus 2492

Priscian, *Institutiones grammaticae*. *See* Leyden, Universiteitsbibliotheek, MS BPL 67, St. Gall, Stiftsbibliothek, Cod. 904

Psalters

 Irish, eleventh century. *See* Cambridge, St. John's College, MS 59

 Ormesby. *See* Oxford, Bodleian Library, MS Douce 366

 St. Louis. *See* Leyden, Universiteitsbibliotheek, MS lat. 76A

Rabbula Gospels. *See* Florence, Biblioteca Medicea Laurenziana, MS Plut. I, 56

Robert of Jumièges, Sacramentary of. *See* Rouen, Bibliothèque municipale, MS Y.6

Sacramentaries

 Gallican Missal. See Vatican City, Biblioteca Apostolica, MS Pal. lat. 493 (Gallican Missal)

 Gellone. *See* Paris, Bibliothèque nationale de France, MS lat. 12048

 Robert of Jumièges. *See* Rouen, Bibliothèque municipale, MS Y.6

St. Augustine, Gospel Book. *See* Cambridge, Corpus Christi College, MS 286

St. Chad, Book of. *See* Lichfield, Cathedral Treasury, s.n.

St. Gall, Gospels of. *See* St. Gall, Stiftsbibliothek, Cod. 51

St. Louis, Psalter of. *See* Leyden, Universiteitsbibliotheek, MS lat. 76A

Trier Gospels. *See* Trier, Domschatz, Cod. 61

Virgil, *Aeneid*. *See* Vatican City, Biblioteca Apostolica, MS Pal. lat. 1631

Virgil, *Ecologues, Georgics, Aeneid*. *See* Vatican City, Biblioteca Apostolica, MS lat. 3867

CREDITS

Every effort has been made to trace copyright owners and photographers. The Morgan Library apologizes for any unintentional omissions and would be pleased in such cases to add an acknowledgment in future editions.